Magic Lantern Guides®

Canon
EOS 5D
Mark II

Michael Guncheon

LARK BOOKS

A Division of Sterling Publishing Co., Inc.
New York / London

Editor: K. Helmkamp
Book Design and Layout: Michael Robertson
Cover Design: Thom Gaines – Electron Graphics

Library of Congress Cataloging-in-Publication Data

Guncheon, Michael A., 1959-
 Canon EOS 5D Mark II / Michael Guncheon. -- 1st ed.
 p. cm. -- (Magic lantern guides)
 Includes index.
 ISBN 978-1-60059-536-3 (pbk. : alk. paper)
 1. Canon digital cameras--Handbooks, manuals, etc. 2.
Photography--Handbooks, manuals, etc. 3. Single lens reflex
cameras--Handbooks, manuals, etc. 4. Photography--Digital
techniques--Handbooks, manuals, etc. I. Title.
 TR263.C3G95 2009
 771.3'2--dc22

 2009001437

10 9 8 7 6 5 4 3 2 1

First Edition

Published by Lark Books, A Division of
Sterling Publishing Co., Inc.
387 Park Avenue South, New York, N.Y. 10016

Distributed in Canada by Sterling Publishing,
c/o Canadian Manda Group, 165 Dufferin Street
Toronto, Ontario, Canada M6K 3H6

Distributed in the United Kingdom by GMC Distribution Services,
Castle Place, 166 High Street, Lewes, East Sussex, England BN7 1XU

Distributed in Australia by Capricorn Link (Australia) Pty Ltd.,
P.O. Box 704, Windsor, NSW 2756 Australia

This book is not sponsored by Canon.

If you have questions or comments about this book, please contact:
Lark Books
67 Broadway
Asheville, NC 28801
(828) 253-0467

Manufactured in the USA

ISBN 13: 978-1-60059-536-3

For information about custom editions, special sales, premium and corporate purchases, please contact Sterling Special Sales Department at 800-805-5489 or specialsales@sterlingpub.com.

Contents

High Performance
Digital Photography

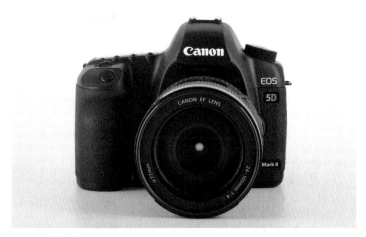

Canon EOS 5D Mark II

When Canon introduced the second-generation 5D, many people were surprised. The addition of high definition video recording capability in a digital SLR took the industry by storm. Announced at the international Photokina photography exhibition in Cologne, Germany, the already-popular full-frame camera showed that Canon had been working hard to bring a new and improved 5D to market. This is not just a slightly improved EOS 5D, it is a completely redesigned camera with improvements on almost every aspect of the 5D.

↻ *Advanced sensor and image processing technology have greatly improved the the quality of photos captured with the Canon EOS 5D Mark II.*

Introduced in September of 2008, the EOS 5D Mark II body measures 6.0 x 4.5 x 3.0 inches (152 x 113.5 x 75 mm) and weighs 28.6 ounces (810 g) without the lens. The new full-frame sensor increases the pixel count from 12.8 to 21.1 megapixels. The sensor also incorporates improved circuitry and an advanced color filter that increases sensitivity and improves color fidelity. A key feature of this new CMOS sensor is low power consumption that allows for HD video recording through the Live View shooting feature.

At the heart of the image processing circuitry is a brand-new DIGIC 4 image processor. This special chip is the latest in a long line of Canon-designed image processors. The DIGIC 4 provides even faster image processing than ever before with higher sensitivity and lower noise.

As a matter of convenience (and for easier reading), in this book I often refer to the Canon EOS 5D Mark II as the 5D Mark II. The original camera was known as the 5D not the 5D Mark I, so when the two cameras are compared it is accurate to refer to the 5D and the 5D Mark II.

Some photographers have purchased the 5D Mark II as an upgrade from the EOS 30D, EOS 5D, 1D Mark II, or 1Ds Mark II. Others, however, are making their first high-quality digital camera investment. For those photographers new to digital SLR photography, this book begins with an assortment of basic topics and concepts. Experienced digital photographers (or anyone who has read guides to other Canon EOS digital SLRs) already familiar with these terms and concepts should skip ahead to the detailed sections on camera operations beginning on page 27.

Canon created this high-performance camera so that it would meet the requirements of professionals and advanced amateurs. Since photographers with a wide range of backgrounds use this camera, the first chapter starts with some basic information about digital photography. While this book thoroughly explores all of the 5D Mark II's features, you certainly don't need to know how to operate every one of them.

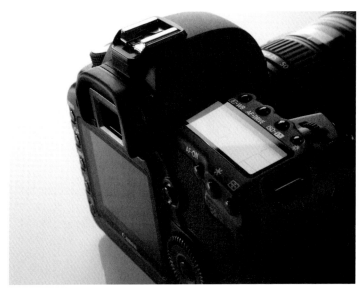

The EOS 5D Mark II is one of Canon's most evolved digital products to date. This full-frame model is the first to offer high-definition video capture in a single-lens-reflex camera, and is the first camera maker to offer this technology.

Once you comprehend what a feature does, you may decide it is not necessary to master it in order to achieve your desired photographic results. Learn the basic controls. Explore any additional features that work for you. Forget the rest. At some point in the future you can always delve further into this book and work to develop your 5D Mark II techniques and skills. Just remember that the best time to learn about a feature is before you need it.

Digital cameras do some things differently than traditional film cameras, making them exciting and fun to use no matter whether you are an amateur or a pro. For digital beginners, many of these differences may seem complicated or confusing. Though most of the features found on a traditional Canon EOS camera are also available on the 5D Mark II, there are many controls and operations unique to digital. Other features have been added to increase the camera's

versatility for different shooting styles. The goal of this guide is to help you understand how the camera operates so that you can choose the techniques that work best for you and your style of photography.

Differences between Digital and Film Photography

Just a few years ago it was easy to tell the difference between photos taken with a digital camera and those shot with a traditional film camera: Pictures from digital cameras just didn't measure up in quality. This is no longer true. With the 5D Mark II, you can make prints of at least 16 x 20 inches (40.6 x 50.8 cm) that will match an enlargement from 35mm film.

While there are differences between film and digital image capture, there are many similarities as well. A camera is basically a box that holds a lens that focuses the image. In traditional photography, the image is recorded on film and later developed with chemicals. In digital photography, however, the camera converts the light to an electronic image. A digital camera can do more to the captured image in terms of internal processing.

Film vs. the Sensor

Both film and digital cameras expose pictures using virtually identical methods. The light metering systems are based on the same technologies, the sensitivity standards for both film and sensors are similar, and the shutter and aperture mechanisms are the same. These similarities exist because both film and digital cameras share the same function: To deliver the amount of light required by the sensitized medium (film or image sensor) to create a picture you will like.

However, image sensors react differently to light than film does. From dark areas (such as navy blue blazers, asphalt, and shadows) to midtones (blue sky and green grass) to bright areas (such as white houses and snowy slopes), a digital sensor responds to the full range of light equally, or linearly. Film, however, responds linearly only to midtones (those blue skies and green fairways). Therefore, film blends

tones very well in highlight areas, whereas digital sensors often wash out at the brightest tones. Digital typically responds to highlights in the same way as slide film, and to shadows as does print film.

The LCD Monitor

One of the major limitations of film is that you really don't know if your picture is a success until the film is developed. You have to wait to find out if the exposure was correct or if something happened to spoil the results (such as the blurring of a moving subject or stray reflections from flash). Sure, you could shoot a Polaroid, but this requires added gear and locating packages of Polaroid film. Even so, the shot you get with the Polaroid image is not the same as the final shot on film.

With most digital SLR cameras, you can review your image on an LCD monitor (a screen found on the back of the camera) within seconds of taking the shot. Though you may not be able to see all the minute details on this small screen, the display provides a general idea of what has been recorded so you can evaluate your pictures as soon as you shoot them.

If you have ever used a point-and-shoot compact digital camera you have probably been spoiled by its ability to show a live image on the LCD from the image sensor. Because of the way the mirror system works in an SLR, all the light from the lens is reflected up into the optical viewfinder when you compose your shot. The mirror actually prevents light from hitting the image sensor until you take the picture. With Canon's new Live View shooting mode, the mirror is locked up and the image sensor produces an image on the LCD monitor. This same technology is also used to record high definition video.

The Histogram

Whether you shoot film or digital, the wrong exposure will cause problems. Digital cameras do not offer any magic that lets you beat the laws of physics: Too little light makes dark

images; too much makes overly bright images. Fortunately, the LCD monitor gives an essentially instantaneous look at your exposure. While this small version of your image isn't perfect, it gives you a good idea of whether or not you are setting exposure properly.

With traditional film, many photographers regularly "bracket" exposures (shoot the same image several times while changing settings; for example, increasing or decreasing shutter speed on consecutive shots) in order to ensure they get the exposure they want. You can still bracket with digital if you want—the 5D Mark II can do it automatically for you—but there is less of a need because you can check your exposure as you shoot. The 5D Mark II's histogram function helps in this evaluation. This feature, which is unique to digital photography, displays a graph that allows you to immediately determine the range of brightness levels within the image you have captured.

Film vs. Memory Cards

Memory cards have some distinct advantages over film, including reusability and storage capacity.

Images captured by a digital camera are stored on removable memory cards. They offer the following advantages over film:

- **More photos:** Standard 35mm film comes in only two sizes: 24 and 36 exposures. Memory cards come in a range of capacities and all but the smallest are capable of holding more exposures than film (depending on the selected file type).

- **Reusable:** Once you make an exposure with film, you have to develop and store the negative and print. Due to a chemical reaction, the emulsion layer is permanently changed and the film cannot be reused. With a memory card, you can remove images at any time, opening space for additional photos. This simplifies the process of organizing your final set of images. Once images are transferred to your computer (or another storage medium—burning them to a CD or DVD is recommended), the card can be reused.

- **Durable:** Memory cards are much more durable than film. They can be removed from the camera at any time (as long as the camera is turned off) without the risk of ruined pictures. They can even be taken through the carry-on inspection machines at the airport without suffering damage.

- **Small size:** In the space taken up by just a couple rolls of film, you can store or carry multiple memory cards that can hold hundreds of images.

- **Greater image permanence:** The latent image on exposed but undeveloped film is susceptible to degradation due to conditions such as heat and humidity. Security precautions at airports increase the potential for damage to travelers' film. But digital photography allows greater peace of mind. Not only are memory cards durable, their images can also be easily downloaded to storage devices or laptops. With this flexibility comes the chance that images can be erased—so make sure you make backups.

ISO

ISO is an internationally used method for quantifying film's sensitivity to light. Once an ISO number is assigned to a film, you can count on its having a standard sensitivity, or speed, regardless of the manufacturer. Low numbers, such as 50 or 100, represent a relatively low sensitivity; films with these speeds are called slow films. Films with high numbers, such as 400 or above, are more sensitive and are referred to

as fast. ISO numbers are mathematically proportional to the sensitivity to light. As you double or halve the ISO number, you double or halve the film's sensitivity to light. For example, 800 speed film is twice as sensitive to light as 400 speed, and it is half as sensitive to light as 1600 speed.

Technically, digital cameras do not have a true ISO. The sensor has a specific sensitivity to light. Its associated circuits change its relative "sensitivity" by amplifying the signal from the chip. For practical purposes, however, the ISO setting on a digital camera corresponds to film. If you set a digital camera to ISO 400, you can expect a response to light that is similar to an ISO 400 film.

Unlike film, changing ISO picture-by-picture is easy with a digital camera. By merely changing the ISO setting, you use the sensor's electronics to change its "sensitivity." It's like changing film at the touch of a button. This capability provides many advantages. For example, you can be indoors using an ISO setting of 800 so you don't need flash, and then you can follow your subject outside into the blazing sun and change to ISO 100. The 5D Mark II camera offers an extremely wide range of ISO settings, from 100 to 6,400. Extended ISO mode increases that range from 50 to 25,600. This is a 3-stop improvement on the original 5D.

Noise and Grain
Noise in digital photography is the equivalent of grain in film photography. It appears as an irregular, sand-like texture that, if large, can be unsightly and, if small, is essentially invisible. (As with grain, this fine-patterned look is sometimes desirable for certain creative effects.) In film, grain occurs due to the chemical structure of the light-sensitive materials. In digital cameras, noise occurs for several reasons: sensor noise (caused, for example, by heat from the electronics and optics), digital artifacts (caused when digital technology cannot deal with fine tonalities such as sky gradations), and JPEG artifacts (caused by image compression). Of these, sensor noise is the most common.

Digital noise has been an issue for photographers, and Canon has addressed this issue with an upgraded sensor. The improved sensor technology makes it easier to get better detail in dark areas of an image and results in a higher-quality image.

In both film and digital photography, grain or noise emerges when you use high ISO settings. And, on any camera, noise is more obvious with underexposure. The 5D Mark II's newly designed image sensor combines the individual pixel size of the flagship 1Ds Mark III with a new design drawn from the recently introduced 50D. The color filter employed at each pixel has been redesigned to allow more light into each photosite. What does this all really mean? Bigger, more sensitive pixels create images with far less noise than any previous Digital EOS camera including the 1Ds Mark III!

The 5D Mark II also features an on-chip noise-reduction system to further reduce noise. The sensor's output circuitry has also been improved for noise reduction. And although digital cameras typically experience increased noise during long exposures in low-light conditions, the 5D Mark II has settings to reduce this noise.

File Formats

A digital camera converts the continuous (or analog) image information from the sensor into digital data. This data may be saved into one of two different digital still photography file formats—RAW or JPEG.

One very useful feature of digital SLRs is their ability to capture a RAW file. RAW files are image files that include information about how the image was shot but have little processing applied by the camera. They also contain 14-bit color information, the maximum amount of data available from the sensor. (It is a little confusing that the RAW file format is actually a 16-bit file, though the data from the sensor is 14-bit.) The 5D Mark II uses the same advanced RAW format developed for the Canon EOS-1D Mark II—the CR2 file—which includes more metadata (data about the image) than before.

The 5D Mark II also includes two new RAW file sizes called sRAW1 and sRAW2. The 5D Mark II's sRAW1 file has approximately one half of the pixel count of a regular 5D Mark II RAW file (about 10 megapixels) and is a little over half the file size (in megabytes) of the 5D Mark II RAW file. The sRAW2 option is about a quarter of the pixel count (5.2 megapixels) and a little less than a third of the file size. The sRAW file sizes are for photographers who don't need the high resolution required for enlargements but still want the image processing offered with a RAW workflow. For example, a wedding photographer might use sRAW for candids.

JPEG (Joint Photographic Experts Group) is a standard format for image compression and it is the most common file created by digital cameras. Digital cameras use this format because it reduces the size of the file, allowing more pictures to fit onto a memory card. It is highly optimized for photographic images.

Both RAW and JPEG files can produce excellent results. The unprocessed data of a RAW file can be helpful when you are faced with tough exposure situations, but the small

size of the JPEG file is faster and easier to deal with. It is important to consider that while a JPEG image might look great right out of the camera, a RAW file may need quite a bit of adjustment before the image looks good. The 5D Mark II offers the option to record both formats at the same time so you have the flexibility to choose your file format later— at the expense of storing fewer photos per memory card.

Video File Format
The 5D Mark II uses a video codec called H.264 to record video. This video compression scheme is also known as MPEG-4 Part 10 or AVC. MPEG stands for Moving Pictures Experts Group and is akin to the JPEG committee. This compression method is highly efficient at compressing large amounts of video data. The 5D Mark II records 30 video frames every second so a lot of data must be compressed in order to fit it all on a small memory card. There are two resolution options for recording video: high definition, which has a resolution of 1920x1080, and standard definition at 640x480.

Digital Resolution
When we talk about resolution in film, we simply refer to the detail the film can see or distinguish. Similarly, resolution in the context of lenses refers to the lens' ability to separate elements of detail in a subject. Unfortunately, resolution is not as simple a concept when it comes to digital photography.

Resolution in the digital world is expressed in different ways depending on what part of the digital workflow you are working in. For example, resolution for digital cameras indicates the number of individual pixels that are contained on the imaging sensor. This is usually expressed in megapixels. Each pixel captures a portion of the total light falling on the sensor. It is from these pixels that the image is created. Thus, a 10-megapixel camera has about 10 million pixels covering the sensor. On the other hand, when it comes to inkjet printing, the usual rating of resolution is in dots per inch (dpi). Dpi describes how many individual dots of ink exist per inch of paper area, a very different concept.

Although it may be confusing, it is important to remember that a digital image's resolution is completely different than a printer's resolution.

Dealing with Resolution: The 5D Mark II offers four different resolution settings, from 5.2 to 21.1 megapixels. Although you don't always have to choose the camera's maximum resolution, generally it is best to use the highest setting available so you get the most detail possible from your camera. You can always reduce resolution in the computer, but you cannot recreate detail if you never captured the data to begin with.

Keep in mind that you paid for the megapixels in your camera! The lower the resolution with which you choose to shoot, the less detail your picture will have. This is particularly noticeable when making enlargements. The 5D Mark II has the potential of making great prints at 16 x 20 inches (40.6 x 50.8 cm) and larger, but only when the image is shot at maximum resolution.

Digital camera files generally enlarge very well in programs like Adobe Photoshop CS4, especially if you recorded them in RAW format first. (Recall that there is more data with which to work in the RAW format.) The higher the original shooting resolution, the larger the print you can make. However, if the photos are specifically for email or webpage use, you do not need to shoot with a high resolution in order for the images to look good on screen.

The Color of Light
Anyone who has shot color slide film in a variety of lighting conditions has horror stories about the resulting color. Color reproduction is affected by how a film is "balanced," or matched, to the color of the light. Our eyes adapt to the differences, but film does not.

In practical terms, if you shoot a daylight-balanced (outdoor) film while indoors under incandescent lights, your image will have an orange cast. For accurate color reproduction

in this instance, you change the film or use a color correction filter. One of the toughest popular lights to balance is fluorescent. The type and age of the bulbs effects their color and how that color appears on film, usually requiring careful filtration. Though filters help to alter and correct the color of light, they also darken the viewfinder, increase the exposure, and make it harder to focus and compose the image.

Digital cameras have changed all of this. A digital camera acts more like our eyes and it creates images with fewer color problems. This is because color correction is managed by the white balance function, an internal setting built into all digital cameras. The camera uses electronic circuits to neutralize whites and other neutral colors without using filters. This technology can automatically check the light and calculate the proper setting for the light's color temperature. White balance can also be set to specific light conditions, or custom set for any number of possible conditions. Thanks to this technology, filters are rarely a necessity for color correction, making color casts and light loss a non-issue.

Cost of Shooting
While film cameras have traditionally cost less than digital cameras, an interesting phenomenon is taking place that makes a digital camera a better overall value. Memory cards have become quite affordable. Once a card is purchased, it can be used again and again. Therefore, the cost per image decreases as the use of the card increases. Conversely, the more pictures you take with film, the more rolls you have to buy (and process), and the more expensive the photography becomes.

When you use a digital camera there is virtually no cost to shooting a large number of photos. The camera and memory card are already paid for, whether one, ten, or a hundred images are shot. This can be liberating because photographers can now try new ways of shooting, experiment with creative angles never attempted before, and so much more.

Features and Functions

In an effort to appeal to a broad spectrum of buyers, today's high-performance digital SLRs (D-SLRs) are equipped with myriad features. You may find you do not need or will not use all of them. This book will give you an understanding of all the features on the 5D Mark II, as well as help you best use those that are most important to you. Don't feel guilty if you don't use every option packed into the camera. On the other hand, remember that you can't "waste film" with a digital camera. Shoot as much as you want and then erase those images that don't work. This means you can literally try out every feature on your camera to see how it functions. This is a quick and sure way to learn to use your camera, and it allows you to choose those features that are most useful to you.

The Canon EOS 5D Mark II offers a high degree of technological sophistication and incredible performance. In many ways it sets the bar for other D-SLRs in this price range. With a sensor that contains 21.1 megapixels (MP), the 5D Mark II shoots 3.9 frames per second (fps) and up to 14 RAW frames consecutively when used with a high-speed CompactFlash card. When you shoot JPEG and use a high-speed UDMA memory card you can keep shooting at 3.9 fps until the card is full. The camera also offers quick start-up, fast memory card writing speeds, and 25 custom functions to match your shooting style.

The first step to taking great photos with the 5D Mark II is to familiarize yourself with its features and functions and how to access and control them.

The 5D Mark II achieves remarkable strength and durability due to its stainless steel chassis and magnesium alloy body. While more expensive to manufacture, this construction creates a relatively lightweight, yet strong, housing. The magnesium also doubles as a shield for electromagnetic interference. Canon has increased the dust- and water-resistant performance compared to the original 5D. The memory card door and battery compartment covers, as well as the LCD and camera buttons, have been designed with special weather sealing material, and silicone rubber is used around the top and rear covers and controls. Even the hotshoe has been redesigned to resist water. If you attach the Speedlite 580EX II, water resistance is not diminished. The shutter has been improved from the original 5D to reduce creation of dust and increase durability to 150,000 shutter cycles.

Note: When the terms "left" and "right" are used to describe the location of camera controls, it is assumed that the camera is being held in shooting position.

Note: The 5D Mark II features the Canon EF lens mount. Introduced in 1987, it accepts all standard Canon EF lenses. If you are upgrading from a Canon digital SLR that does not use a full-frame sensor—for example, a 40D or Digital Rebel—and you use EF-S lenses, they will not work on the 5D Mark II. EF-S lenses are designed specifically for smaller-format APS-C sized sensors, and can only be used on cameras built expressly to accept them.

Overview of Features

- Canon-designed and Canon-built 21.1 megapixel full-frame size CMOS sensor.
- DIGIC 4 image processor for high-speed, low-noise performance.
- 14-bit analog-to-digital (A/D) conversion.
- High definition video recording, 1920x1080 at 30 fps (progressive) recording with audio.
- New, larger, brighter, and sharper 3 inch (7.62 cm) color display with anti-reflective and scratch-resistant coatings, and automatic control of display brightness.
- Quick Control Screen for fast access to camera settings.
- Shoots 3.9 fps in One-Shot or AI Servo autofocus. Up to 14 RAW frames consecutively and unlimited JPEGs.
- ISO range of 100 – 6,400 extendable to 50 – 25,600.
- Integrated sensor cleaning system and Canon "Dust Delete Data" detection.
- Shutter lag time about 73 milliseconds (ms), mirror black-out 145 ms, camera start up 0.1 sec.
- 35-zone metering sensor.
- High-speed shutter, up to 1/8000 sec. with flash sync up to 1/200 sec.
- 9 user-selectable autofocus points, 6 autofocus assist points.
- AF micro-adjustment and focus tracking sensitivity with AI servo AF.
- Auto Lighting Optimizer for automatic adjustment of scene brightness and contrast.
- Lens peripheral illumination correction for automatic compensation of light fall-off at the corners of the image.
- Wireless image transfer with optional WFT-E4A wireless file transmitter.
- Fully compatible with entire EOS system of lenses, flash, and other accessories (except EF-S lenses).
- Two silent shutter modes when capturing images.
- Newly designed lithium-ion battery with high capacity and on-camera battery life display. Battery life: 850 shots @ 73°F (23°C) and 750 shots @ 32°F (0°C).
- Battery memory system for management of multiple batteries.

Canon EOS 5DII – Front View

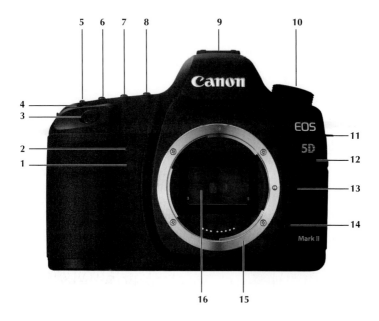

1. 📷⏱ *Self-timer lamp*
2. *Remote control sensor*
3. *Shutter button*
4. 📷 *Main dial*
5. 🔅 *LCD panel illumination button*
6. ISO·⚡ *ISO speed setting/Flash exposure compensation button*
7. AF·DRIVE *AF mode selection/Drive mode selection button*

8. ⊙·WB *Metering mode selection/White balance selection button*
9. *Hot shoe*
10. *Mode dial*
11. *Strap mount*
12. *Microphone*
13. *Lens release button*
14. *Depth-of-field preview button*
15. *Lens mount*
16. *Mirror*

Canon EOS 5DII – Rear View

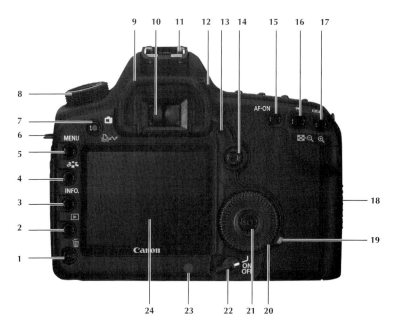

1. 🗑 Erase button
2. ▶ Playback button
3. INFO. Info/Trimming Orientation button
4. ⌇⁓ Picture Style selection button
5. MENU Menu button
6. Strap mount
7. 📷 / 🖨⌇ Live View shooting/Print/Share button
8. Mode dial
9. Eyecup
10. Viewfinder
11. Hot shoe
12. Dioptric adjustment knob
13. Speaker
14. ⁛ Multi-controller

15. AF-ON AF start button
16. ✱ /🔳⊖ AE lock/ FE lock button/Index/ Reduce button
17. 🔳/⊕ AF point selection/ Magnify button
18. Card slot cover
19. Access lamp
20. ⊙ Quick Control dial
21. ⚙ Setting/Movie shooting button
22. Power/Quick Control dial switch
23. Light sensor
24. LCD monitor

31

Canon EOS 5DII – Top View

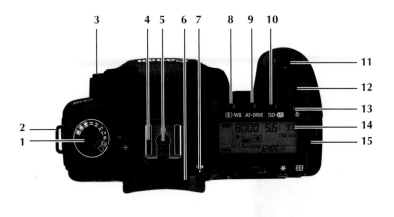

1. Mode dial
2. Strap mount
3. Lens release button
4. Hot shoe
5. Flash-sync contacts
6. Eyecup
7. Dioptric adjustment knob
8. ⊛·WB Metering mode selection/White balance selection button
9. AF·DRIVE AF mode selection/ Drive mode selection button

10. ISO·⚡ ISO speed setting/ Flash exposure compensation button
11. Shutter button
12. ⚙ Main dial
13. ☼ LCD panel illumination button
14. LCD panel
15. Strap mount

Camera Controls

The EOS 5D Mark II uses icons, buttons, and dials common to all Canon cameras. Specific buttons are explained below with the features they control. The 5D Mark II often uses two controls to manage several functions.

Note: Several buttons use blue icons. A blue label indicates the control's function in playback mode.

Shutter Button

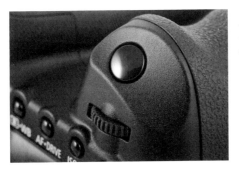

The shutter button on the 5D Mark II is able to control autofocus, autoexposure, and flash metering.

The 5D Mark II features a soft-touch electromagnetic shutter release. Partially depressing the shutter button activates such functions as autoexposure and autofocus, but this camera is fast enough that there is minimal speed advantage in pushing the button halfway before exposure. If you deal with moving subjects, however, it helps if you start autofocusing early, so the camera and lens have time to find your subject. Pressing the shutter button halfway is also useful if you want to quickly exit menus and get the camera back to shooting mode instantly. With the optional BG-E6 battery grip mounted on the 5D Mark II, there is a second shutter button available when shooting vertically. There is also a vertical shooting switch on the battery grip that turns off the shutter button so you don't accidentally trigger it when you shoot horizontally.

Main Dial 🔆

Located behind the shutter button on the right top of the camera, the Main dial allows you to use your "shooting" finger to quickly adjust settings like aperture and shutter speed. It is also used to alter other camera settings like AF modes, AF points, metering modes, and ISO speed. When you use the camera's menus, the Main dial 🔆 allows you to cycle through menu tabs. During image playback the Main dial is used to jump through images 10 at a time.

The Main dial works alone when you set shutter speed and aperture. Just press the shutter button halfway to engage the exposure meter and then rotate 🔆 to adjust the aperture or shutter speed. For a number of other adjustments, the Main dial works in conjunction with buttons that are either pressed and released, or are held down while the Main dial is turned. For example, to adjust ISO speed, press ISO•✸ then rotate 🔆 . As with many settings, as you adjust the ISO speed it is displayed in several places: the LCD panel on the top of the camera, the viewfinder, and the LCD monitor on the back of the camera.

The BG-E6 battery grip has an additional 🔆 for use when you shoot vertical compositions. It is only active when the battery grip is attached and the vertical grip on/off switch is in the "On" position.

Metering Mode/White Balance Button ⊙•WB

For quick access to white balance and metering selections, use this button.

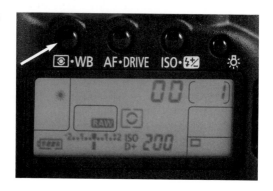

34

If you are composing an image that has important highlights and shadows throughout the frame, as in the image above, use Evaluative metering mode can help achieve a proper exposure (see page 167).

The Metering mode selection/white balance selection button is located behind the Main dial ⌒ . When it is pressed, use ⌒ to select from four different metering modes: Evaluative ⊙ , Partial ◎ , Spot ⊡ , and Center-weighted average ☐ . (See page 166 to learn more about metering in the 5D Mark II.)

To adjust white balance, after pressing ⊙·WB use the Quick Control dial ◯ . The nine white balance options are: Auto AWB , Daylight ☀ , Shade ⌂ , Cloudy ☁ , Tungsten ☀ , White fluorescent ☲ , Flash ⚡ , Custom ◲ , and Color temperature K . (See page 98 for information about choosing the right white balance setting.)

As you make adjustments you can view the settings on the LCD panel on the top of the camera or on the LCD monitor on the back of the camera. The ⊚·WB button does not work when the camera is in fully automatic modes □ and Ⓒ .

AF-Drive Button AF·DRIVE

The AF-Drive button gives the user control over the Autofocus mode, the Drive mode, and the self-timer.

The AF mode selection/Drive mode selection button AF·DRIVE is located behind ⌒ and immediately to the right of ⊚·WB. To select an AF (autofocus) mode, make sure your lens is in AF mode and press the AF·DRIVE button. Use ⌒ to choose from One Shot ONE SHOT, AI Focus AI FOCUS, and AI Servo AI SERVO. (See page 155 for more about AF on the 5D Mark II.) When the camera is in one of the full automatic modes— □ and Ⓒ —AF mode is locked to AI FOCUS mode.

The term "Drive mode" is a throwback to film days when a photographer had to advance the film after every shot. Professional photographers would add a "motor drive" to their camera so that they could take photos in rapid succession without having to manually cock the shutter to advance the film. To select the Drive mode, press AF·DRIVE and use ◯ to select from Single shooting □ , Continuous shooting ⤵ , Self-timer: 10 sec. ⏱⟳ , and Self-timer: 2 sec. ⏱⟳2 . The two timer icons include a remote icon ⏱ . When you use a Canon wireless remote, RC-1 or RC-5, choose one of these modes. ⏱⟳2 delays the shutter release for 2 seconds after you press the button on either wireless

remote. ⏱⚡ has no delay when you use the RC-1. It is important to remember that the only way to cancel the self-timer once it has started counting down is to press AF•DRIVE.

The drive mode can be adjusted while the 5D Mark II is in one of its two fully automatic modes but the options are more limited. In ☐ (Full Auto), you can only choose from the Single shooting ☐ or Self-timer: 10 sec. ⏱⚡ drive mode. When the camera is set for [CA] (Creative Auto) you also have access to Continuous shooting ⊒ .

AF and Drive mode settings are displayed during adjustment on the LCD panel and on the LCD monitor.

Note: When you shoot with your eye away from the eyepiece (e.g. timer mode), stray light entering the viewfinder from the back of the camera can cause inaccurate exposure metering. Canon supplies a viewfinder cover located on the camera strap. It is necessary to remove the rubber eyecup on the viewfinder to attach the cover.

ISO Speed Setting/Flash Exposure Compensation Button
ISO•⚡

Use this button to quickly access ISO settings. See page 224 to learn how it can help with flash photography.

The ISO speed setting/Flash exposure compensation button ISO•⚡ is located behind the Main dial to the right of AF•DRIVE. After you press the ISO Speed setting button, use the Main dial 🔄 to adjust ISO speed. The range varies depending on how you have set Custom Function I–3 (ISO Expansion). Normally it ranges from 100 – 6,400 and also has an Auto

mode. With ISO Expansion on, the ISO range is 50 – 25,600 including Auto. The lowest ISO in this mode is labeled L to further remind you that the camera is in ISO Expansion. The two highest ISO settings in this mode are labeled H1 and H2, representing 12,800 and 25,600 respectively.

To adjust flash exposure compensation ⚡ , press ISO·⚡ and then use ◎ to override automatic flash exposure in 1/3 stop increments. Increments can be changed to 1/2 stop in Custom Function I–1 (Exposure level increments). (Learn more about flash exposure compensation on page 224.)

As mentioned previously there are three places where you can look when you adjust either of these settings: the viewfinder, the LCD panel on the top of the camera, or the LCD monitor on the back of the camera. When the 5D Mark II is in a fully automatic mode—either ☐ or ⒸⒶ —this button does not function. When the camera is in ISO Auto no flash exposure compensation is applied.

LCD Illumination Button ☀·

When using the 5D Mark II in low light levels, use the LCD illumination button to read the panel.

This button, located to the right of the ISO/Flash exposure compensation button ISO·⚡ and behind ⚙ , is pressed to illuminate the LCD panel on the top of the camera. It stays illuminated for 6 seconds.

Mode Dial

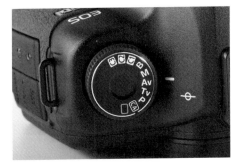

The Mode Dial determines the amount of creative control the user has over the camera, and what aspects the user can control.

The Mode Dial, located on the top of the camera, to the left of the viewfinder, is used to select the 5D Mark II shooting mode. It is useful to think of this control as having three sections.

Automatic

The first section is the automatic section and it contains two settings: Full Auto ☐ and Creative Auto [CA] . When it is set for Full Auto the 5D Mark II turns into a "point and shoot." There is very little you can adjust on the camera other than file size/resolution and whether you want to use the self-timer. This is a useful mode if you hand the camera to someone else to take a picture. Very few buttons will operate so the camera can't be put accidentally into the "wrong" mode.

Creative Auto [CA] gives you access to a few more settings than Full Auto, including Picture modes and Continuous drive modes. It also opens up two simple-to-use exposure adjustments available through the Quick Control Screen. Instead of worrying about which aperture or shutter speed to use, press straight down on the Multi-controller ⊹ and then use the same control as a joystick to navigate to the Background adjustment. This is a slider that allows you to choose whether you want the background in your image to be blurry or sharp. (A blurry background is useful when you shoot portraits of people standing in front

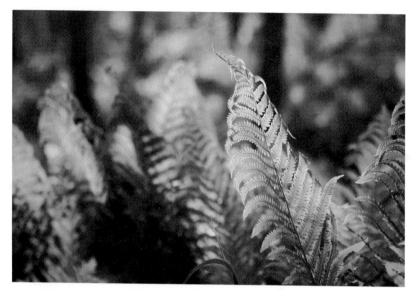

Creative Auto can help with busy backgrounds, such as in the above example. The fern leaf is in sharp focus against the background of similar leaves, but blurring the background makes the subject pop.

of a busy background.) When you set the Background adjustment to Sharp, the 5D Mark II picks an appropriate aperture (f/stop) so that a greater part of your photo is in focus. There is also a simple exposure compensation adjustment accessed the same way and appropriately called Exposure. When you move the adjustment to the left, the exposure is darker; to the right, lighter. These two controls are only available in CA mode.

Creative

The next section on the Mode dial is what I call the Creative section. While Creative isn't an official Canon name for this section of the 5D Mark II's Mode Dial, they use the term for this area on some of their other cameras. A more appropriate name might be Exposure, as you will see shortly. There are five settings in this section and they are common to all SLRs, film or digital, Canon or another manufacturer. While the

icons or acronyms may differ slightly among cameras, they all perform the same duties. The five choices are Program AE **P** , Shutter-priority AE **Tv** , Aperture-priority AE **Av** , Manual exposure **M** , and Bulb **B** . It is important to note that while the two Automatic settings control many camera adjustments—like white balance, focus, and ISO—the five creative options only affect exposure settings. Exposure modes are covered in detail on pages 173-185.

Camera User Settings

This last section allows you to use memories that store various camera settings. They are labeled **C1** , **C2** , and **C3** . The user memory stores more than just shooting modes; it remembers many menu settings and even custom functions. Once you get used to using your 5D Mark II you'll find that this is a powerful tool for quickly setting up your camera in different shooting situations. You might have one setting for taking portraits and another for shooting at night. The possibilities are endless. Note that even when you select one of these user settings, you are still able to temporarily override any of the settings. Learn how to set up the user settings on page 185.

AF Point Selection/Magnify Button ⊞/⊕

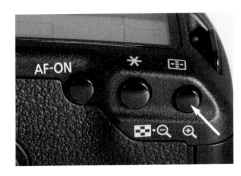

This button magnifies the images on the LCD monitor, as well as selects and changes the AF point in the viewfinder.

The outside button on the upper right back of the camera is the AF Point selection/Magnify button ⊞/⊕. Press the AF point selection button ⊞/⊕ to display the currently selected AF point in the viewfinder, on the LCD panel and

41

the LCD monitor. Nine AF points can be selected by pressing and releasing ⊞/⊕, and using ◯ , ❖ , or ᗰ . When all of the peripheral AF points are indicated, the 5D Mark II automatically selects the AF point. When you use either ◯ or ᗰ , the AF selection rotates through all of the AF points. If you use ❖ , you can toggle the control in the direction of the AF point you want to select. Press straight down on ❖ to toggle between the center AF point and automatic AF point selection. Use Custom Function III–3 to bypass ⊞/⊕ and use either ◯ or ❖ directly. When the 5D Mark II is in one of the fully automatic shooting modes— ☐ or ㎝ —the camera is set for automatic AF point selection and ⊞/⊕ does not function in shooting mode.

When ⊞/⊕ is used during Live View shooting; it can be used to magnify the focus frame. With the first press of ⊞/⊕ the display magnifies about 5x and a second press magnifies the display about 10x. Press the button a third time and it returns the display to normal view.

During image playback, the function of this button changes. Press ⊞/⊕ to magnify the image from 1.5 – 10x the original size. To move around the magnified image, use the multi-controller ❖ . Use ▶ to return to an unmagnified display.

Note: You can only magnify the image during image playback, not during image review (which happens immediately after image capture).

This button is also used during direct camera printing to crop the image before printing. Press ⊞/⊕ to decrease the trimming frame—more of the image is cropped. Use ❖ to move the trimming frame around the image.

This button is duplicated on the optional BG-E6 battery grip to allow for easy access while holding the camera in a vertical shooting position. (In this case, the corresponding button is in the same relative position as the one intended

for horizontal shooting.) The vertical shooting version is only active when the vertical grip on/off switch is in the "On" position.

AE Lock/FE Lock/Index/Reduce Button ✳/⊞·Q

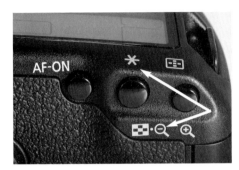

The ✳ / ⊞·Q button locks an exposure and/or flash exposure setting, allowing the user to reframe the image without changing the exposure reading.

The AE lock/FE lock/Index/Reduce button ✳/⊞·Q is to the left of the AF Point selection/Magnify button ⊞/⊕. Press AE lock ✳/⊞·Q to lock the exposure at the current setting. Press AE lock ✳/⊞·Q again to re-lock the exposure setting. The ✳ icon displays in the lower left corner of the viewfinder to indicate that the exposure is locked. To maintain exposure lock over multiple shots, keep pressing ✳/⊞·Q.

Note: The exposure that is locked depends on the metering mode selected. With Center-Weighted Average Metering □ , Spot Metering ⊡ , and Partial Metering ⊙ , the exposure lock uses the center AF point. With Evaluative Metering ▣ , AE lock is set for the selected AF point, whether selected manually or by the camera. If the lens is in manual focus, the center focus point is used.

When you use flash, ✳/⊞·Q doubles as a flash exposure lock. With a Speedlite mounted on the camera, press ✳/⊞·Q and the shutter speed display in the viewfinder briefly changes to **FEL**. Next, the flash fires, an exposure setting locks and ⚡* displays in the viewfinder. If the 5D Mark II determines that the exposure setting is incorrect, the ⚡ part of ⚡* blinks in the viewfinder.

When the 5D Mark II is in one of the fully automatic shooting modes— ☐ or ⓒⒶ — ✶/◫·◯ does not function in shooting mode.

You can also use ✶/◫·◯ to display more than one image. During playback press ✶/◫·◯ once to display a grid of four images (index display); press ✶/◫·◯ again to display a 9-image grid. In both displays a blue border surrounds the currently selected image. Use ⬡ or ⬙ to move the blue highlight through the grid. Press ◫/◯ once to return to single image display from the 4-image index display; press ◫/◯ twice to return to single image display from the 9-image display. During playback, if pressing ◫/◯ has magnified the image, use ✶/◫·◯ to reduce the magnification.

This button is also used during direct camera printing to crop the image before printing. Press ✶/◫·◯ to increase the trimming frame—less of the image is cropped. Use ⬙ to move the trimming frame around the image.

This button is duplicated on the optional BG-E6 battery grip to allow for easy access while holding the camera in a vertical shooting position. (In this case, the corresponding button is in the same relative position as the one intended for horizontal shooting.) The vertical shooting version is only active when the vertical grip on/off switch is in the on position.

AF Start Button AF-ON

This button quickly locks the AF system's focus so the user can reframe or recompose a shot.

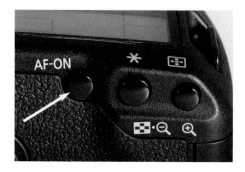

The AF start button **AF-ON** is located to the left of the AE lock/FE lock/Index/Reduce button ✳/▦·◦. When the lens is in auto focus mode and the 5D Mark II is in One Shot AF, use AF start to lock focus. When pressed, a focus confirmation light ● appears in the lower right section of the viewfinder and the camera beeps, indicating that focus lock has been achieved. If the 5D Mark II is unable to acquire proper focus lock, the indicator flashes and the camera doesn't beep.

Note: You will not be able to take a picture until focus has been confirmed.

When the camera is set for AI Servo AF, press AF start to initiate continuous focus tracking, starting with the center focus point (when in automatic AF point selection) or with the manually selected AF point. Because focus is tracked continuously ● does not light and the camera does not beep, even when focus has been achieved. When the 5D Mark II is in one of the fully automatic shooting modes— ☐ or ⒸⒶ —this button does not function. It does function in these modes when the camera is in Live View mode.

Because the autofocus sensors are located in the viewfinder area, when the 5D Mark II is in Live Shooting mode, the AF sensors are blocked so there are three options for autofocus: AF Quick **AFQuick** , AF Live **AFLive** , and Face Detection **AF ʹᴸ:** (see page 198). When you use any of these, it is important that you continue to hold down **AF-ON** until the camera beeps and the autofocus is locked. Depending on your Live View AF selection, the confirmation is indicated as the red AF point displaying (in **AFQuick** mode), the Live View AF point turning green (**AFLive** mode), or the face detection frame turning green (**AF ʹᴸ:** mode).

Note: When you record video the **AF-ON** button does not function when Live View AF mode is set for **AFQuick** .

45

This button is duplicated on the BG-E6 battery grip to allow for shooting while holding the camera in a vertical shooting position. The vertical shooting version is only active when the vertical grip on/off switch is in the on position.

Dioptric Adjustment Knob

If the AF indicators in the viewfinder do not look sharp, use the dioptric adjustment knob until they look in focus.

The dioptric adjustment knob is used to help photographers who have vision problems that prevent them from focusing on the image presented in the viewfinder. While some may be able to use this adjustment in order to shoot without glasses, it really depends on what kind and level of correction you require. (The correction is not big enough for me.) You can attach additional dioptric adjustments using Canon's E series dioptric adjustment lenses. To properly set the dioptric adjustment, focus your eyes on the viewfinder's readout, not the scene, and turn the adjustment knob until the readout is in focus.

Note: The numbers used for specifying the amount of dioptric adjustment (in the case of the 5D Mark II, 3 to +1) are not the same measurements used for eyeglass correction. For example, if you have reading glasses that are a +1, this is not the same as a +1 dioptric adjustment on the 5D Mark II.

Live View/Print/Share Button 📷 / 凸〜

The Live View shooting/Print/Share button 📷 / 凸〜 is located to the left of the viewfinder. When the 5D Mark II is set for Live View shooting (see page 195) use this button to display the Live View on the LCD monitor. Press it again to turn the Live View display off. If you press this button while

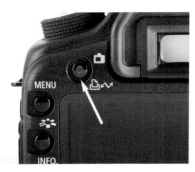

The Live View/Print/Share button is a quick way to set the 5D Mark II to the Live View setting.

the camera is recording video, the camera stops recording and turns off the Live View display.

When the 5D Mark II is connected to a printer, this button lights up when a good connection is established between the camera and the printer. Once connected, press this button to quickly print the currently displayed image.

When the camera is connected to a computer, use 📷 / ⎘ to start downloading your images.

Menu Button MENU

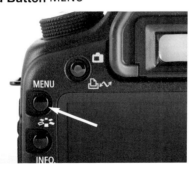

The Menu button allows access to all of the 5D Mark II's setup, shooting, and playback menus.

The **MENU** button is below and to the left of 📷 / ⎘ . Use this button to access any of the camera menus and also to exit menus and sub menus. For a detailed explanation of all menus, see the Camera Menus chapter, beginning on page 115.

Picture Style Button ⩘▰▰

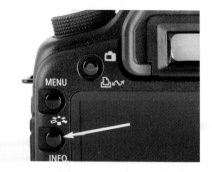

The ⩘▰▰ button gives direct access to Canon's Picture Style menu, which contains a selection of six predetermined and three user-defined camera settings for specific subjects.

The Picture Style selection button ⩘▰▰ , located below the MENU button, is a quick way to access the six built-in image effect settings (Picture Styles) and the three user-defined styles. Press ⩘▰▰ to display the list of Picture Styles and then use either ⊙ or ⌂ to highlight the Picture Style or user-defined styles you want to use. Press INFO. to make modifications to the Picture Styles and ⓢ or the shutter release button to accept the setting. You can also access Picture Styles with ⩘▰▰ during Live Shooting. This button does not function when the 5D Mark II is in ☐ or ⒸⒶ mode, but you can access a limited number of Picture Styles when in ⒸⒶ mode via the Quick Control Screen (see page 91). To learn more about Pictures Styles and their adjustments, see pages 91-96.

Info/Trimming Orientation Button INFO.

The first duty of the Info/Trimming button is to cycle through the various display modes during image review and playback. The display modes include: single image display; single image display with image size information and current/total number of images captured; shooting information display which includes the image, a histogram, and extensive metadata about the image; and lastly a dual histogram display that includes the image and shows both the RGB and brightness histogram, along with a pared down shooting information display. Press INFO. repeatedly to cycle through these four options.

The INFO. button accesses two displays on the LCD monitor, as well as access other important data, such as the number of images on the memory card and the remaining space available.

When you shoot, **INFO.** cycles through two different displays on the LCD monitor: a Camera Settings display and a Shooting Functions display. The Camera Settings display covers items like Picture Style, Color space, White Balance shift or bracketing, and rotation settings, just to name a few. This is also the best place to check to see how many more images can be stored on the Compact Flash card. (This number is an approximation.)

The Shooting Functions display mimics the LCD panel on the top of the camera. This is useful when the 5D Mark II is in a position where you are not able to see the top of the camera, yet want to see shooting settings like drive mode, AF mode, or exposure settings. The Shooting Functions display also allows you to access the Quick Control Screen (see page 63). If you change the [INFO. button] setting in ⚙️ , rather than cycling through the Camera Settings or Shooting Functions displays you can limit **INFO.** to bring up just one or the other.

During direct camera-to-printer printing, press **INFO.** to change the trimming frame from horizontal to vertical orientation.

Playback Button ▶

Use the Playback button to display images. When images have been magnified with the ⊞/⊕ button, use Playback to exit the magnified view.

The Playback button ▶ , located to the left of the LCD monitor and below **INFO.**, puts the camera into playback mode and displays the last image captured. Press the button again to return the 5D Mark II into shooting mode. You can also use the Playback button to exit from magnified playback of images. To playback video, first press ▶ , then press ⑤ to start playback.

Erase Button 🗑

Use the 🗑 button to delete images, extend image review, and protect images on the memory card.

The erase button 🗑 , located below ▶ , is used to delete an image or video during either review or playback. When you press the Erase button, you are given the choice to Erase or Cancel. Protected images can't be erased. You can select multiple images for deletion by first going to ⊡ [Erase Images], scrolling through your images

50

using ⊙ (🔄 to jump through images ten at a time), then pressing (SET) to select each image you want to delete. When all images have been selected, press 🗑 to delete them.

You can also use 🗑 to lengthen the review time after image capture. If you normally work with a short review time, press the Erase button to keep the just-captured image on the LCD monitor until you press the shutter release button, or (SET) or 🗑 to cancel the delete function.

Multi-Controller ⊹

The Multi-controller makes it easy to navigate through the 5D Mark II menu selections and change camera settings.

The Multi-controller, located below and to the right of the viewfinder, is similar in function to the mouse on a computer. You can move the control in eight directions and also push it in. Press the button in the center during AF selection to select the center AF point. You can use the Multi-controller to select other AF points, to adjust white balance settings, to move around a magnified playback image, or to move the focus frame when you use Live View shooting. With practice, you can use this one control to navigate through the menu system, pressing up and down to cycle through the options for each menu and pressing left and right to move across the menu tabs.

New to the 5D Mark II is the Quick Control Screen. When the LCD monitor displays the Shooting Functions, press ⊹ straight down to turn on the Quick Control Screen.

Use ✲ or ⚙ to change the setting, then press straight down on ✲ to exit the Quick Control Screen. (See page 63 for more on the Quick Control Screen.)

Quick Control Dial ⊙

This dial, in easy reach of the user's thumb when holding the camera in shooting position, aids in the quick selection of menu functions and camera settings.

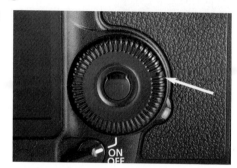

Think of this control as the scroll wheel on a mouse. When you press a button like ⊙·WB, use the Quick Control dial to scroll through the white balance settings. Other settings that are used in conjunction with the Quick Control dial include drive mode and flash exposure compensation. You have 6 seconds from the time you press a button and use the Quick Control dial to adjust a setting, before the camera returns to normal operation. You can also use the Quick Control dial to scroll through menu options. In many menu settings ⊙ is used to scroll through function settings, too.

While you shoot, if the power switch is set for ⏌ and the camera is in **P** , **Tv** , or **Av** exposure mode, you can turn the Quick Control dial to adjust exposure compensation. If the camera is in **M** mode and the Power/Quick Control Dial switch is set for ⏌ , the Quick Control dial is used to set aperture.

Setting/Movie Button ⑤ET

If the Quick Control Dial ⊙ is like the scroll wheel on a computer mouse, the Setting/Movie shooting button ⑤ET , centered in the Quick Control Dial, is like the mouse button. Use it to select menu settings and to accept settings during

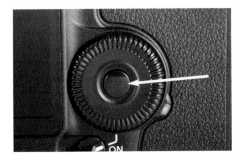

The Setting/Movie button is used to select menu settings and as a start and stop button when recording video.

other operations. The button is also used to start and stop video recording once the Live View function has been enabled with ⬛ / ⬛〜 . It can also be programmed for other Shooting mode functions using Custom Function IV-3. The functions include Image quality, Picture Style, menu display, image playback, Quick Control screen, and Record movie. Record movie allows you to immediately start recording without having to press ⬛ / ⬛〜 to enter Live View shooting mode first.

Note: Once the 5D Mark II is in Live View mode, it takes over any Custom Function programming of the ⑤ⅇ⒯ button.

Power/Quick Control Dial Switch

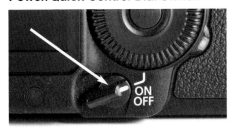

This switch allows the user to choose how the Quick Control dial functions.

The Power/Quick Control Dial switch, located below the Quick Control Dial, is a three-position switch with the obvious on and off settings. The up-most position ⤴ enables exposure compensation via ⊙ . When exposure mode is set for **M** it also allows you to adjust aperture.

The 5D Mark II includes features aimed at ease of use in addition to the features that control the camera's output. The LCD monitor brightness adjustment, for example, automatically adjusts the brightness of the display screen based the overall light of an area—this is especially handy when shooting in dark or dim situations, such as an internally lit fountain at night.

Note: If you turn the camera off while images are still being written to the memory card, the camera waits until all images are stored before powering down.

Non-Control Features

There are a few non-controls on the back of the camera that you should be aware of: automatic LCD monitor brightness adjustment, the card reader access lamp, the built in microphone, and the audio speaker.

Introduced with the 5D Mark II is the automatic adjustment of the LCD monitor brightness. When you shoot in dark areas the LCD dims; in bright areas it adjusts to full brightness. The light sensor that controls this adjustment is below and slightly to the left of center of the LCD monitor. If you notice the LCD monitor dimming when it shouldn't, make sure your fingers are not covering the sensor.

When the 5D Mark II writes to the memory card, the access lamp near the edge of ⊙ blinks. It is important that you do not interrupt the writing process by opening the memory card door. Although the camera attempts to prevent the camera from powering down while it writes to the card, it is a good idea to develop the habit of paying attention to this indicator before you shut down the camera or open the memory card or battery doors.

When recording video, the 5D Mark II records audio either using an externally connected microphone or the built-in microphone. The built-in microphone is located on the front of the camera immediately below the 5D logo. When you play back video, the 5D Mark II outputs audio from a small speaker to the lower right of the viewfinder. Be sure to keep this area finger free in order to hear the sound properly.

Menus Overview

The 5D Mark II has several menus for adjusting shooting functions and playback settings, as well as setting up the operation of the camera. There is also a Custom Function menu, as well as My Menu that you can customize.

Once you press the **MENU** button, located on the back of the camera to the left of the viewfinder, the menus are displayed on the LCD monitor. The menu structure consists of nine menu columns or tabs. The first two columns, color-coded red, are the Shooting menus ◘˙ and ◘˙ . They deal with image capturing functions. The next two columns (color-coded blue) are the Playback menus ▣˙ and ▣˙ . They allow you to adjust options for displaying images on the LCD monitor and to control image transfer and printing. The next three columns, color-coded yellow, are the Set-up menus ॥ , ॥˙ , and ॥˙ that deal with a variety of camera setup functions. Next is the Custom Functions menu ◘ , color-coded orange, that allows you to tailor the 5D Mark II to your shooting style. The last tab, color-coded green, is the My Menu tab ⚒ . This is a personalized custom

menu that you can build from any of the other menu options, including the Custom Functions menu. Navigate across the menu tabs via either � or ☀ . Once you have selected the proper menu tab, use ◯ or ☀ to move up and down through the menu options.

Note: When the 5D Mark II is in either of the full automatic modes, ☐ and CA , the ◻ᶦ , ⚐ , and ◻ menu tabs do not appear. In addition, some of the menu items in the tabs that are displayed are no longer available.

Camera Activation

Power Switch
The 5D Mark II's power switch is located just below the Quick Control dial on the back of the camera.

Auto Power Off
All digital cameras can power down after a period of inactivity to conserve power. The 5D Mark II has an [Auto power off] selection in the Set-up 1 menu 🔧 that can be used to shut off power after a duration of idleness spanning from 1 minute to 30 minutes. If you do not want the camera to power down automatically, set this feature to Off and the camera will remain on as long as the power switch is activated.

Auto power off helps to minimize battery depletion, but you may find it frustrating if you try to take a picture and find that the camera has shut itself off. For example, you might be shooting a football game and the action may stay away from you for a couple of minutes. If Auto power off is set to 1 min., the camera may be off as the players move toward you. When you try to shoot, nothing will happen while the camera powers back up. You may miss the important shot. In this case, you may want to change the setting to 4 min. or 8 min. so the camera stays on when you need it on.

You access the Auto power off setting through the camera's menus. Press the **MENU** button (on the back of the camera to the left of LCD monitor) and use 🗒 or ✣ to select the Set-up 1 menu ⚹ —color-coded yellow. Use ◯ to select [Auto power off], then press ⓢⓔⓣ . Choose among seven options, ranging from 1 minute to 30 minutes (including the Off option that prevents the camera from turning off automatically). Use ◯ or ✣ to highlight the desired time and press ⓢⓔⓣ to select it.

Resetting Controls

You can restore the camera to its original default settings by going to [Clear Settings] in the Set-up 3 menu ⚹ . You can also use this menu to clear out the copyright information that is automatically embedded in each file. The copyright information is set up using the EOS utility program that came with your camera (see page 269). You can clear all the Custom Functions settings by using the [Clear All Custom Func.] option in the Custom Functions menu 📷 (see page 136).

The Viewfinder

The 5D Mark II uses a newly developed eye-level, reflex viewfinder with a fixed pentaprism. Images from the lens are reflected to the viewfinder by a quick return, semi-transparent half-mirror. The mirror lifts for the exposure, then rapidly returns to keep viewing blackout to a very short period. (Viewfinder blackout time is about 145ms at 1/60 second or faster shutter speeds.) The mirror is also dampened so mirror bounce and vibration are reduced. The viewfinder shows approximately 98% of the actual image area captured by the sensor. The eyepoint is about 21 millimeters, which is good for people with glasses.

The viewfinder features an interchangeable, precision matte focusing screen. It uses special micro-lenses to make manual focusing easier and to increase viewfinder brightness.

The Viewfinder

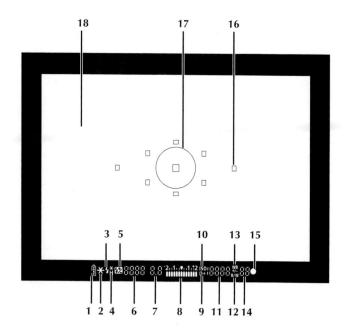

1. Battery check
2. ✳ AE lock/AEB in progress
3. 🔆 Flash ready/improper FE lock warning
4. 🔆H High speed sync
5. 🔆 Flash exposure compensation
6. Shutter speed/FE lock(FEL)/ Busy(buSY)
7. Aperture/"FuLL CF"- card full warning/"Err CF"-card error warning/"no CF"- no card warning

8. Exposure level indicator
9. **D+** Highlight tone priority
10. ISO speed
11. ISO speed
12. **B/W** Monochrome shooting
13. ⁺⁄⁻ White balance compensation
14. Max. burst
15. ● Focus compensation light
16. AF points
17. ⊡ Spot metering circle
18. Focusing screen

The viewfinder provides 0.71x magnification and includes superimposition display optics to make information easy to see in all conditions. The display includes a great deal of data about camera settings and functions. The camera's nine auto-focus (AF) points can be superimposed on the focusing screen. The solid band at the bottom of the screen shows autoexposure (AE) lock, AE bracketing (AEB) in-progress, Flash-ready/Improper flash exposure (FE) lock warning, High-speed sync, FE lock, FE bracketing in-progress, shutter speed, aperture, exposure compensation, FE compensation, White balance correction, Maximum burst, exposure level, exposure compensation amount, flash exposure compensation amount, Automatic Exposure Bracketing range, and AF/MF (auto/man-ual focus) confirmation (a circle appears on the far right when the camera is in focus). Introduced with the 5D Mark II is additional viewfinder information for battery level, ISO speed, monochrome shooting indicator, and highlight tone priority tally **D+** . The information panel in the viewfinder also gives you indicators when the camera is busy, when the mem-ory card is full, when there is an error writing to the card or if there is no card in the camera.

Depth of field can be previewed through the viewfinder by using the Depth-of-field preview button, near the lens on the lower right front of the camera. This stops down the aperture to the picture-taking aperture so that depth of field can be appraised.

The LCD Panel

The 5D Mark II offers an LCD panel that provides infor-mation about various camera settings. The panel is located on the top of the camera to the right of the viewfinder. It includes information about metering and drive settings, white balance and ISO speed, exposure settings, and image recording quality. It offers a battery life indicator (with more fine detail than the original EOS 5D), exposure compensa-tion, flash exposure compensation, highlight tone priority and much more.

The LCD Panel

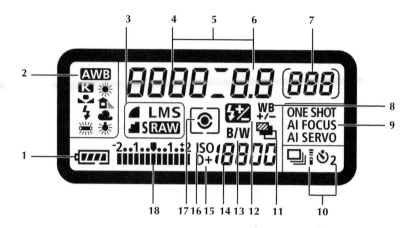

1. 🔋 Battery check
2. 🔲 White balance
3. ◢L Image recording quality
4. Shutter speed/(buSY)
5. AF point selection/card full warning/card error warning/ no card warning/error code/cleaning image sensor
6. Aperture
7. Shots remaining/shots remaining during WB bracketing/self timer countdown/bulb exposure time
8. 🔲 White balance correction
9. AF mode
10. 🔲 Drive mode
11. 🔲 AEB
12. 🔲 Flash exposure compensation
13. B/W Monochrome shooting
14. ISO speed
15. D+ Highlight tone priority
16. ISO
17. 🔲 Metering mode
18. Exposure level indicator/ exposure compensation amount/AEB range/Flash exposure compensation/ Card writing

The LCD panel can be illuminated in dark conditions by pressing the LCD Illumination Button ☀ , located to the right of the ISO speed/Flash Exposure compensation button ISO·⚡.

The LCD Monitor

The LCD monitor allows access to all camera menus and settings, custom functions, images stored on the memory card, Live View shooting, and recording video.

The LCD monitor is probably the one feature of digital cameras that has most changed how we photograph. Recognizing its importance, Canon has put an excellent 3.0 inch (7.62 cm), high-resolution LCD monitor on the back of the camera. With about 920,000 pixels, this screen has excellent sharpness, making it extremely useful for evaluating images. In addition, Canon has added new anti-reflective, scratch-resistant coatings to the surface of the monitor to provide for outstanding image playback. It may seem like a small screen, but the colorspace of the display approaches that of inkjet printers.

You can adjust the brightness of the LCD monitor to any of seven levels with the Set-up 2 menu ♶ (color coded yellow). Press the **MENU** button and advance to ♶ using 🎛 or ✤ , select [LCD brightness] (the first menu option) and press ⑤ . The last image captured, together with a grayscale chart, appears on the LCD monitor. You can adjust a sliding scale with ◯ or ✤ . Once you have selected the brightness setting you want, press ⑤ to select it and exit the brightness setting menu. Introduced with the 5D Mark II is the ability to have the camera control LCD monitor brightness automatically. In the same menu setting, use 🎛 to select either Auto or Manual.

The LCD monitor on the 5D Mark II can also display a graphic representation of exposure values, called a histogram (see page 171). The ability to see both the recorded picture and an exposure evaluation means that under- and overexposures, color challenges, lighting problems, and compositional issues can be dealt with on the spot. Flash photography in particular can be checked, not only for correct exposure, but also for other factors such as the effect of lighting ratios when multiple flash units and/or reflectors are used. No Polaroid film test is needed. Instead, you can see the actual image that has been captured by the sensor.

In addition, the camera can rotate images in the LCD monitor. Some photographers love this feature, some hate it, but you have the choice. The Auto rotate function (see page 131) displays vertical images properly without switching the camera to a vertical position . . . but at a price. The image will be smaller on the LCD monitor. On the other hand, turning the Auto rotate feature off keeps the image as big as possible, but it appears sideways in the LCD monitor.

You can also magnify an image from 1.5x to 10x in the monitor in 15 steps and the enlarged photo is scrollable (using ✤) so you can inspect all of it. While the image is magnified, you can use the Quick Control dial ◯ to scroll back and forth through your other images or 🎛 to jump through your images ten at a time. This way you can

compare details in images without having to re-zoom in on the image. Press ▶ to return the image playback to normal size.

Quick Control Screen

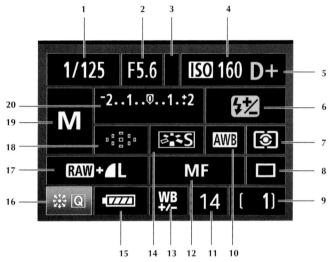

1. Shutter speed
2. Aperture
3. ✳ AE lock
4. ISO speed
5. **D+** Highlight tone priority
6. 🗲 Flash Exposure compensation
7. ⊙ Metering mode
8. 🖳 Drive mode
9. Possible shots
10. AWB White balance
11. Max. burst
12. AF mode
13. WB White balance compensation
14. Picture Style
15. Battery status
16. Quick control mark
17. Image-recording quality
18. AF point
19. Shooting mode
20. Exposure compensation/ AEB

When not in menu mode or playing back an image, the 5D Mark II displays the shooting settings on the LCD monitor. This display is similar to the information that is shown on the top LCD panel with one major difference. By pushing straight down on ✳ you can turn this display into an

interactive camera-setting menu called the Quick Control screen. Once displayed, press ✳ up or down, left or right to highlight each of the displayed shooting parameters. When a parameter is highlighted use ◯ or 🔄 to change the value that appears on the LCD monitor. With most of the parameters ◯ and 🔄 operate identically, but when exposure compensation/exposure bracketing is highlighted, ◯ changes the exposure compensation value, while 🔄 changes the exposure bracketing range.

This new Quick Control screen is a useful tool when you can see the top LCD panel and it offers quick access to some settings that would require multiple button presses. For example, to set auto exposure bracketing you would need to first press **MENU**, use 🔄 to select 📷 , and use ◯ to select [Expo. comp./AEB]. Press (SET) to enter the submenu, use 🔄 to set the bracketing range, and then press (SET) to accept the setting. Setting image recording quality would require similar steps. With the Quick Control screen, you merely press ✳ , use it again to select the auto exposure bracketing icon, then use 🔄 to select the bracketing range.

When you use the Quick Control screen it is not necessary to press (SET) to accept the setting. Press ✳ or the shutter release button to exit and the setting is accepted. But the (SET) button can be used with the Quick Control screen to call up the normal menu options for that parameter (if there is one). You might use the (SET) button if you want to see a list of all the possible ISO speeds, or if you don't remember which control to use to adjust the autoexposure bracketing range.

Note: In ☐ (Full Auto), you can only use the Quick Control screen to choose image recording quality and to select Single shooting ☐ drive mode or Self-timer: 10 sec. ⏱ drive mode. When in CA (Creative Auto) you have access to Continuous shooting ⧈ , a limited selection of Picture Styles and special background and exposure adjustments.

Press INFO. to turn off the shooting settings display. Press INFO. a second time to display the camera settings display. This includes information that is not visible on the top LCD panel or in the viewfinder. Some of this information includes Picture Style (with its parameters), color space, white balance correction, current bracketing setting, file name prefix, auto focus micro adjustment, auto rotate display, date/time, the number of shots remaining on the memory card, and what shooting mode each Camera User setting (**C1** , **C2** , **C3**) is set for. Press INFO. to go back to the shooting settings display.

Power

The LP-E6 lithium ion battery monitors its available capacity for the most accurate battery power information—very important when shooting Live View or recording video.

The 5D Mark II is powered by the 1800mAh LP-E6, a lithium ion (Li-ion) rechargeable battery with built-in intelligence for capacity monitoring. Milliamp hours (mAh) indicate a battery's capacity to hold a charge. Higher mAh numbers usually mean longer-lasting batteries.

Although the camera is designed for efficient use of battery power, it is important to recognize that power consumption is highly dependent on how long features such as Live View, video recording, autofocus, and the LCD monitor, are used. The more the camera is active, the shorter the battery life, especially with regard to the LCD monitor, Live View shooting and video recording. Be sure to have backup batteries. And it is always a good idea to shut off the camera if you are not using it.

Canon estimates that at 73°F (23°C), the battery will last approximately 850 shots (200 with Live View). Lower temperatures will reduce the number of shots. For example, at 32°F (0°C) the number of shots drops to 750 (180 with Live View). When shooting with Live View, at 73°F (23°C) the camera will operate for about 2 hours, but only for 1 hour and 50 minutes at 32°F (0°C). In addition, it is never wise to expose your camera or its accessories to heat or direct sunlight (i.e., don't leave the camera sitting in your car on a hot day or a cold one!).

You can use the protective cover that comes with the battery to indicate whether or not a battery is charged. The battery cover has a small opening that can display part of the battery label that is colored blue if the cover is attached in one direction. If you flip the cover 180°, the small window will show the gray color of the battery case. Position the cover one way on your charged batteries and the opposite way on the depleted ones.

Note: For safety, always place the protective cover on the battery when it is not installed on the 5D Mark II. Never put an uncovered battery in your pocket where it could short out if there are metal objects also in your pocket.

The LP-E4 battery is rated at 7.2 volts and it takes approximately 2.5 hours to fully charge it on the LC-E6 charger included with the camera. The LC-E6 can run on voltages from 100 VAC to 240 VAC with powerline frequencies of 50 or 60 hertz, so a converter/transformer is not necessary, nor should it be used. Instead, use a foreign plug adaptor in areas outside North America. Once the battery is charged, remove it from the charger—it is NOT a good practice to keep the battery on the charger for long periods of time.

Unfortunately, rechargeable batteries lose a small percentage of their charge every day. For maximum performance, charge the battery the day you are going to use it. If you do not plan to use the 5D Mark II for an extended period of time, remove the battery from the camera, place the protective

cap on the battery and close the battery compartment cover on the 5D Mark II.

Battery Management

The LP-E6 is able to communicate with the 5D Mark II in order for the camera to display information about remaining capacity, shutter count on the current charge and battery performance. The battery's current capacity is displayed on the top LCD panel and in the viewfinder. The battery icon is used to display any one of six levels of battery charge, from fully charged ▆▆▆▆ , to little or no charge ⊏⊐ . During Live View shooting, the battery capacity status can be displayed on the LCD monitor by cycling through the display overlay options with INFO. .

To display detailed battery information, use the Set-up 3 menu 🎥 , select the [Battery info.] menu option and press (SET) . The display indicates the remaining battery level as a percentage, the number of shutter actuations (or more accurately, pictures taken, since the count does not include shutter actions that are performed as part of self-cleaning), and how well the battery is performing. The shutter count resets when the battery is recharged. Lithium ion batteries have a finite number of charge/discharge cycles, and as the battery ages the performance indicator will show how well the LP-E6 is accepting a charge. When the indicator is red (1 bar), the battery should be replaced.

Note: In order to use the battery management system and get the best power performance with the 5D Mark II, use Canon LP-E6 batteries.

The 5D Mark II is able to keep track of six different battery packs so that you know what their current capacity is and when they were last used—provided they didn't lose power by being used in a second 5D Mark II. In order to have the 5D Mark II manage multiple batteries they need to be "registered." To register a battery, install it in the 5D Mark II, go to the Set-up 3 menu 🎥 , select the [Battery info.] menu option and press (SET) , then press INFO. . Use ◯

to select [Register] and press (SET) , use ◎ to select OK, then and press (SET) . The battery's serial number will be displayed on the LCD monitor. Repeat this procedure for each battery. Make sure you label the batteries with the last few digits of the serial number so you can quickly identify them. If you have registered six batteries you will need to use this same menu screen to delete a battery before you can add another.

Note: There is an area on the ends of the battery for a label. Do not place a label on any other part of the battery. An incorrectly placed label can damage the battery compartment of the 5D Mark II.

Battery Grip

The BG-E6 battery grip, an optional accessory for the 5D Mark II, allows you to double the battery capacity of the camera. To use the BG-E6, carefully remove the battery compartment cover and the LP-E6 battery. The BG-E6 connects to the camera the same way the battery does and secures to the camera using the tripod socket.

You can insert one or two LP-E6 batteries in the battery grip. The 5D Mark II will sense the batteries and the battery information screen will display information on both batteries. The BG-E6 also comes with an AA battery holder (BGM-E6) that allows you to power the 5D Mark II with six regular alkaline AA batteries. Because there are so many types of AA batteries (Lithium, Alkaline, Nickel Metal Hydride), and since each battery type has a different performance curve, Canon has specified Alkaline batteries so that the battery capacity display works properly when using AA batteries.

The battery grip has special features for vertical shooting. Instead of having to hold the camera awkwardly—one hand above your forehead, elbow up in the air—the battery grip duplicates several of the most commonly used camera controls so that you can take vertical pictures with the 5D Mark II as comfortably as horizontals. The controls that are duplicated in the vertical shooting position are: shutter release

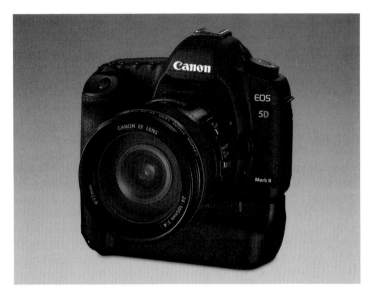

The B6- EG battery grip, seen here attached to the base of the 5D Mark II, is an optional accessory that increases the camera's frames per second and drive mode capabilities.

button, main dial, AF-ON, ✱/▣·⊖, and ▦/⊕. In addition, there is a switch to turn off the operation of these vertical shooting controls in case you accidentally press them when shooting horizontals.

Alternate Power Options

An optional AC adapter kit, ACK-E6, is useful for long duration shooting and video recording. It attaches to the 5D Mark II through a DC coupler that looks similar to an LP-E6. You must first open the cord notch, which is covered with a rubber filler panel, so that you can run the cable out of the battery compartment and close the battery compartment cover.

Note: Normally the 5D Mark II can tell when you remove battery power from the camera because it can sense when the battery compartment door is opened. This helps it ensure that the camera is properly shut down. When you use the AC adapter, you can remove power from the camera without touching the battery compartment door by just unplugging the ACK-E6. This can lead to file corruption on your memory card. Always connect and disconnect the power to the ACK-E6 with the camera power switch in the off position.

An optional car battery charger (CBC-E6) and cable CB-570 is available to charge the LP-E6 using an automobile's electrical system.

Date/Time

Date and time are set in the Set-up 2 menu ⚙ . Use the Quick Control dial ⚙ to select [Date/Time]. Press (SET) to enter the adjustment mode. Once there, use the Quick Control dial ⚙ to select the month, date, year, hour, minute, and second to adjust. Press (SET) to enter the adjustment mode, then use the Quick Control dial to adjust the setting. Press (SET) to accept the setting. You can also change the format of the date display from month-day-year to year-month-day, or day-month-year. When the date, time, and format are correct, highlight [OK] and press (SET) to enter your selections and exit the adjustment mode.

A CR1616 lithium button battery is used to maintain the date and time settings in the 5D Mark II when the LP-E6 is removed from the camera. The battery life of the CR1616 is about 5 years. If the date and time setting dialog appears when you install the LP-E6, the date and time battery needs to be replaced. The CR1616 is located just below the terminal connectors (HDMI, USB, PC, etc.) on the left side of the camera. A small Phillips-head screwdriver is required to remove the screw, located between the Mic and HDMI connector. Make sure that you replace the battery with another Lithium CR1616 battery.

The Sensor

The 5D Mark II has a newly designed 21.1 megapixel CMOS sensor (5616 x 3744 pixels). It is a "full-frame sensor" (36 x 24mm) and is the same size as a 35mm film frame. When using 35mm lenses, the 5D Mark II does not have any of the field-of-view differences or "cropping factors" that smaller sensor D-SLRs have. This means that if you are used to shooting with a 14mm wide angle lens on a 35mm film camera, then you will be used to shooting a 14mm on the 5D Mark II.

Low noise characteristics are extremely important to advanced amateur and professional photographers who want the highest quality image possible. The 5D Mark II gives an extraordinarily clean image with exceptional tonalities that can be enlarged with superior results.

Several other factors contribute to the improved imaging quality. Canon has worked hard on the design and production of their sensors. The microlens configuration has been improved to increase light-gathering ability, improve light convergence, and reduce light loss. The area that is sensitive to light on each pixel has also been increased. New color filter material is being used to reduce light loss and assure color fidelity. A new image-processing chip, the DIGIC 4, increases image detail and image processing speed. The analog-to-digital conversion is handled in 14 bits per color, a substantial increase from the 12 bits for the original 5D.

In addition, the 5D Mark II has an improved low-noise, high-speed output amplifier, as well as power-saving circuitry that allows for fast continuous shooting (burst mode) of about 3.9 fps. With such low noise, the sensor offers more range and flexibility in sensitivity settings. ISO settings range from 100 – 6400 normally and expand to 50 – 25,600 in ISO expansion mode via Custom Function I-3 (see page 138).

The on-chip RGB primary color filter uses a standard Bayer pattern over the sensor elements. This is an alternating arrangement of color with 50% green, 25% red, and 25%

blue, and full color is interpolated from the data. In addition, infrared cut-off and low-pass filters are located in front of the sensor. This multi-layered filter system is designed to prevent the false colors and the wavy or rippled look of surfaces (moiré), which can occur when photographing small, patterned areas with high-resolution digital cameras. In addition the top-most low-pass filter utilizes a new Fluorine coating to further keep dust from adhering to the surface of the filter.

Mirror Lockup

For critical work on a tripod, such as shooting long exposures or working with macro and super telephoto lenses, sharpness is improved by eliminating the vibrations caused by mirror movement. This is accomplished by locking up the mirror prior to exposure, using the 5D Mark II's Mirror lockup function. However, it also means the viewfinder will be blacked out and the drive mode will operate in Single ☐ .

The Mirror lockup is set with Custom Function III-6 (see page 147). Once set, the mirror locks up when the shutter button is pressed. Press the shutter button again to make the exposure. If, after 30 seconds, you don't press the shutter, the mirror flips back down.

Use a remote switch or the Self-timer to keep all movement to a minimum. With the Self-timer, the shutter goes off two or ten seconds after the mirror is locked up (depending on which self-timer is set), allowing vibrations to dampen. When using the Self-timer with Bulb exposure and Mirror lockup, you must keep the shutter depressed during the entire Self-timer countdown; otherwise you will hear a shutter sound but the image will not be captured.

Memory Cards

The 5D Mark II's full frame sensor captures larger image files and therefore requires more memory for image storage.

The Canon EOS 5D Mark II uses CompactFlash (CF) memory cards. You will need sizeable cards to handle this camera's image files; anything less than 1GB will fill up too quickly, particularly if you are shooting RAW+JPEG. Memory cards are sturdy, durable, and difficult to damage. But one thing they don't like is heat; so make sure you store them properly.

Note: Memory cards are not affected by current airport screening systems.

The 5D Mark II supports CF cards with Ultra Direct Memory Access or UDMA. UDMA is an improved way of accessing (reading and writing) the data on the card. This technology is not just inherent in Compact Flash cards, it also needs to be designed into the camera—as it is with the EOS 5D Mark II. UDMA is specified in terms of speed rating or modes. The modes range from 0 – 6. Mode zero is about 16 million bytes per second (MB/sec) and mode 6 is about 133 MB/sec. These are theoretical speeds, particularly since Mode 6 cards aren't available yet. But the current cards have an extremely fast access speed of 45MB/sec. In order to achieve the maximum burst speed and continuous shooting performance specified for the 5D Mark II you'll need to use UDMA CF cards.

To remove the memory card from your camera, simply slide open the Card slot cover on the right rear of the body. Push the Card eject button at the bottom of the Card slot to

eject it. Even though the 5D Mark II automatically shuts off when the memory card door is opened, it is good practice both to turn the camera off before removing the card, and to make sure the Access lamp just to the right of ⊙ is not illuminated. This habit of turning the camera off will allow the camera to finish writing to the card. If you should open the card slot and remove the card before the camera has written a set of files to it, there is a good possibility you will corrupt the directory or damage the card. You may lose not only the image being recorded, but also potentially all of the images on the card.

Note: If you are using the ACK-E6 AC adapter kit to power the 5D Mark II, make sure you turn the camera off using the camera power switch before unplugging the AC adapter from its power source.

When you take a picture, the 5D Mark II assigns a file name to the image. The filename has eight characters. The first three characters are alphanumeric and are identical for each image recorded: IMG_ if you work in the sRGB color space; _MG_ if you work in the Adobe RGB color space (The color space option is found in Shooting 2 menu 🎥). The last four digits of the filename are strictly ascending numbers, beginning with 0001 when you first start to use the camera. You have three choices in how the camera numbers the images on the card: (1) they can run continuously from 0001 to 9999, even when you change cards; (2) they can be reset to 0001 every time you change cards; (3) you can manually reset the numbering.

The continuous file numbering option stores all of the images in one folder on the card. Once image 9999 is recorded, you will get a message, _Err CF._ At that point you have to replace the CF card or change the numbering options.

Note: Even if you delete images, the maximum number for an image is 9999.

74

With the Auto reset option, numbering is reset to 0001 each time a memory card is inserted into the camera.

The manual reset option allows you to create a new folder and reset the file numbering to 0001. The maximum number of folders is 999. At 999, you will get a message (Folder number full) on the LCD monitor.

There is no advantage to one particular method of numbering; it is a personal preference depending on how you manage your images. Continuous numbers can make it easy to track image files over a specific time period. Creating folders and resetting numbers lets you organize a shoot by location or subject matter. To select Continuous, Auto reset, or Manual reset, go to the Set-up 1 menu **Iʮ** and select [File numbering].

You can also force the 5D Mark II to create new folders at any time. Highlight the [Select folder] option in **Iʮ** and press ⑤ᴇᴛ . On the Select folder screen you'll see each folder that currently exists on the CF card, together with the number of images in each folder. At the bottom of the list you'll see an option to create a folder. Highlight this option and press ⑤ᴇᴛ to create a new folder. This is a useful way of pre-organizing your images for download. If you create folders at each new location you shoot, when you are downloading your images they will already be grouped by location.

Formatting Your Memory Card

Caution: Formatting erases all images and information stored on the card, including protected images. Be sure that you do not need to save anything on the card before you format. (Transfer important images to a computer or other down-loading device before formatting the card.)

Before you use a memory card in your camera, it is important to format it specifically for the 5D Mark II. To do

so, go to the Set-up 1 menu **ᴵᵞ'** , then highlight [Format] using the Quick Control dial ◎ . Press ⑤ᴱᵀ and the Format menu appears on the LCD monitor. The screen displays the card's size and how much of it is presently filled with data. Use the Quick Control dial ◎ to move the choice to [OK], press ⑤ᴱᵀ , and formatting begins. A screen displays formatting progress. Keep in mind that formatting erases all of the images on the card, whether they were previously protected or not!

Note: It is important to format the CF card routinely to keep its data structure organized. However, never format the card in a computer. A computer might use different file structures than digital cameras use and the card may become unreadable for the camera or it may cause problems with your images.

Cleaning the Camera

A clean camera minimizes the amount of dirt or dust that could reach the sensor. A good kit of cleaning materials should include the following: a soft camel hair brush to clean off the camera, an antistatic brush and micro-fiber cloth for cleaning the lens, a pack towel (available at outdoor stores) for drying the camera in damp conditions, and a small rubber bulb to blow debris off the lens and the camera.

Always blow and brush debris from the camera before rubbing with any cloth. For lens cleaning, blow and brush first, then clean with a very clean micro-fiber cloth. If you find there is residue on the lens that is hard to remove, you can use lens-cleaning fluid, but be sure it is made for camera lenses. Never apply the fluid directly to the lens, as it can seep behind the lens elements and get inside the body of the lens. Apply with a cotton swab, or just spray the edge of your micro-fiber cloth. Rub gently to remove the dirt, and then buff the lens with a dry section of the cloth.

You don't need to be obsessive, but remember that a clean camera and lens help ensure that you don't develop

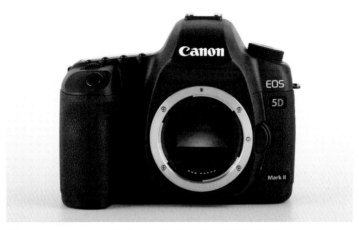

The sensor is housed directly behind the 5D Mark II's lens housing and is exposed when there is no lens attached to the camera body. It is best to keep the camera pointed down when changing lenses to prevent dust from collecting on the sensor.

image problems. Dirt and residue on the camera can get inside when changing lenses, causing problems if they end up on the sensor. Dust on the sensor will appear as small, dark, out-of-focus spots in the photo (most noticeable in light areas, such as sky). Canon has designed the 5D Mark II so if you take the lens off when the camera's power is still on, it automatically turns off the circuitry involved with the image sensor in order to minimize sensor dust problems. (It prevents a dust-attracting static charge from building up). But I still recommend that you turn the camera off when changing lenses.

There are a number of things you can do to minimize the risk of dust getting into your camera. When you change lenses, avoid environments that are dirty or dusty. If you cannot, you have to decide whether the right lens is worth the possibility of having dust specks on all of your future images. Try to block the wind to minimize the chance of

dust getting blown into the camera opening. Point the camera opening down when you change a lens to use gravity to help keep contaminants from entering the camera. Keep a body cap on the camera, and lens caps on lenses, when not in use. Be careful when storing the lens cap while you are shooting. Placing a plastic cap into a linty pocket is a great way to pick up specks and deliver them to the front of your lens. You should regularly vacuum your camera bag so that dust and dirt aren't stored with the camera.

Dust Reduction

Canon's integrated cleaning system, first introduced by Canon with the Digital Rebel XTi, has been redesigned for the 5D Mark II. It is a multipart system that attacks the dust that can be a problem for cameras with removable lenses. The camera seeks to deal with dust in three stages: prevention, cleaning, and removal from captured images via software.

Prevention
The first part of the system starts with the construction used in the camera. The shutter unit itself has been designed so it creates little dust. This is also true of the body cap. Static charge on any surface is a dust magnet. Think of how much dust collects on the screen of your television or computer display (CRT). Have you ever wondered how a vertical surface could attract that much dust? It is the charge buildup on the surface of the picture tube. The low-pass filter, the first optical layer in the image sensor assembly, utilizes a new fluorine coating to deter dust from sticking to the filter. The image sensor layers (infrared absorption glass, low-pass filters) are sealed to minimize dust entering the assembly.

Sensor Cleaning
Any dust that gets through these first defenses is attacked by a self-cleaning system. Two small piezoelectric elements are attached to the low-pass filter. These elements vibrate rapidly when a small voltage is applied to them. The ultrasonic

vibrations cause the low-pass filter to shake. Dust that is on the filter is displaced and settles into an absorbent material surrounding the low-pass filter. This process can be done automatically or manually, and the actual cleaning cycle takes about 4 seconds. During this manual activation, the ultrasonic vibrations are engaged and the shutter system is cocked several times to dislodge any dust that might settle on the curtains of the shutter. While this process might seem like it uses a lot of battery power, the piezoelectric elements are very power efficient.

By default, this process is engaged every time you turn the camera on or off. Cleaning the sensor when you turn the camera on seems obvious—you want to avoid dust before you take a picture. Cleaning when you turn the camera off is not as obvious. Dust is more difficult to "shake off" if it has been sitting on the low-pass filter for long periods of time, though the new fluorine filter helps. By cleaning the sensor on power off, there is less chance that dust is sitting on the sensor unit when the camera isn't being used. (Cleaning the sensor at power up and power down is another good reason to turn off the camera before changing lenses.)

You can manually engage the self-cleaning process through the Set-up 2 menu . Use the Quick Control Dial to select [Sensor cleaning] and press to bring up the Sensor cleaning submenu. Press again to choose [Clean now]. You'll hear the shutter actuate three times and a message on the LCD monitor will read, "Sensor cleaning." When the process is complete, you will be returned to the Sensor cleaning submenu.

The piezoelectric elements generate a little bit of heat during the cleaning process. Immediately after the cleaning cycle has run, the [Clean now] option is grayed out while the piezoelectric element cools down. The camera specs say the cleaning operation can re-occur within 3 seconds of a previous cleaning, or five times in a row without waiting 10 seconds. As a safeguard, the [Clean now] menu item cannot be selected during this time.

Note: For the most effective sensor cleaning, keep the camera in a normal shooting position – with lens horizontal, not tilted up or down.

Another option in the Sensor cleaning menu choices is [Auto cleaning]. This allows you to turn off the sensor cleaning on power up and power down. At first you might wonder why you would want to turn this off, but the reason may become clear when you start using Dust Delete Detection. Once you've mapped out where the dust might be on the sensor before a big shoot, you might not want dust to move when you turn the camera on and off.

Manually Cleaning the Sensor

The third option in the sensor cleaning menu is [Clean manually]. The 5D Mark II allows you access to clean the sensor manually, but you must take certain precautions. You must do this carefully and gently, indoors and out of the wind. Your battery must be fully charged so it doesn't fail during cleaning (or you can use the optional AC adapter). The sensor unit is a precision optical device, so if the gentle cleaning described below doesn't work, you should send the camera to a Canon Service Center for a thorough cleaning.

To clean the sensor, turn the camera on and go to the Set-up 2 menu 🎥 . Use the Quick Control dial ⚪ to select [Sensor cleaning] and press (SET) . Use the Quick Control dial ⚪ to highlight [Clean manually]. Press (SET) and the LCD monitor displays the Clean manually dialog screen, explaining that the mirror will lock up and that you need to power off the camera after cleaning. [OK] and [Cancel] options are presented. Use the Quick Control dial ⚪ to select [OK] and press (SET) . The LCD monitor turns off, the mirror locks up, and the shutter opens. Take the lens off. Then, holding the camera face down, use a blower to gently blow any dust or other debris off the bottom of the lens opening, and then off the sensor. Do not use brushes or compressed air because these can damage the sensor's sur-

face. Turn the camera off when done. The mirror and shutter will return to normal. Put the lens back on.

Note: Canon specifically recommends against any cleaning techniques or devices that touch the surface of the imaging sensor.

Caution: Never leave a digital SLR without a body cap for any length of time. Lenses should be capped when not in use and rear caps should always be used when a lens is not mounted. Also, make sure you turn off the camera when you change lenses. These practices will help to prevent dust from reaching the sensor.

Dust Delete Detection

The third part of Canon's dust reduction system starts in the camera and finishes in Digital Photo Professional. By "photographing" the dust on the sensor, the processor in the camera is able to embed coordinates of the dust in the image file. Digital Photo Professional then reads the embedded data and "erases" the dust spots in the image.

In order to capture the Dust Delete Data, it is necessary to shoot a reference frame (similar to shooting for custom white balance; see page 102). Press **MENU** and choose the Shooting 2 menu 🖿 . Select [Dust Delete Data] and press (SET) . The LCD monitor displays the date when the Dust Delete Data was last updated (the date is blank if the camera has been reset). Use the Quick Control dial ⊙ to highlight [OK], then press (SET) . The camera initiates a self-cleaning cycle as described above. After the cleaning cycle, the LCD monitor asks you to take a picture. The viewfinder displays ----- where you would normally see the aperture and ISO readings. The camera automatically sets itself to Av, f/22, 1/2 sec or faster. You should set the lens for manual focus and the lens focus to infinity. The lens should be 50mm or longer. Stand about 1 foot (30 cm) away from a white, well-lit, patternless surface. Fill the viewfinder with the white surface and press the shutter button.

The LCD monitor displays a busy message and progress bar. About 6 seconds later the LCD monitor displays "Data obtained" or "Could not obtain the data. Obtain again?" There are two possible reasons that the Dust Delete Data could not be captured. The first is that there is not any significant dust on the sensor (sometimes common with new cameras)—in other words, the self-cleaning element is working. The second reason is that the surface was not photographed properly. Possible problems include not enough light, too much light, the surface didn't fill the screen, or the focus wasn't set right. Try to obtain the data again. If, after several attempts, you still receive the message, then there probably isn't any significant dust on the sensor.

Note: There is no need to have a memory card in the camera, since an actual image is not stored.

Getting Started in 10 Basic Steps

There are ten things you should check in order to make your work with the camera easier from the start. These steps are especially useful if you have not yet become familiar with the camera. You will probably modify them with experience.

1. **Set [Auto power off] for a reasonable time:** The camera comes preset to a 1-minute power off time period. This can be frustrating when the camera has turned itself off just as you are ready to shoot. Perhaps it is more realistic to try 4 minutes. Change this time period in the Set-up 1 menu **ℏ** (see page 120).

2. **Adjust the eyepiece:** Use the Dioptric adjustment knob to the right of the viewfinder to make the focus through your eyepiece as sharp as possible. It is necessary to remove the eyecup to access the dioptric adjustment. I think it is easiest to adjust when the camera is on. Lightly press the shutter button to display viewfinder information. Focus on the readouts in the viewfinder. Never try to make this adjustment by focusing on a scene that is imaged by the lens.

3. **Customize the** (SET) **button:** Use Custom Function IV-3 to program (SET) to quickly access one of several key camera settings, such as image quality, picture style, quick record movie, and image playback (see page 150).

4. **Choose an image size of** RAW **or** ◢L : This determines your image file size and quality. You choose this by using the [Quality] option in the Shooting 1 menu ◘˙ to select the image size recorded on the memory card (see page 116). If shooting JPEG always use the highest quality (least compression).

5. **Set your preferred shooting mode:** Use the mode dial on the top left of the camera to select any of the 5D Mark II's shooting modes: **P** , **Tv** , **Av** , **M** , **B** , or one of the fully automatic modes ☐ or CA (see pages 173-183).

6. **Select a Drive mode:** Drive is selected by pressing the AF·DRIVE button on the top right of the 5D Mark II. View the top LCD panel and use ⊕ to select from Single ☐ , continuous shooting ⤴ , Self-timer 10 sec. delay ⁞☊ , and Self-timer 2 sec. delay ⁞☊2 . The top LCD panel indicates the mode the camera is in (see page 161).

7. **Choose AF mode:** Autofocus (AF) mode is set by pressing the AF·DRIVE button on the top right of the 5D Mark II. First make sure your lens is in AF mode by setting the lens focus switch to AF. Then use ⏚ and view the top LCD panel or the LCD monitor to choose from **AI SERVO**, **AI FOCUS**, or **ONE SHOT**. A good place to start on this camera is **AI SERVO** (see page 159).

8. **Select white balance (WB):** AWB is a good place to start because the 5D Mark II is designed to generally do well with it. To set, press ⊙·WB to display the current white balance setting on the LCD panel and the LCD monitor. Use ⊕ to scroll through the white balance options: Auto white balance AWB , daylight ☀ , shade ☗ ,

cloudy 🌥 , tungsten ☀ , white fluorescent ▦ , flash ⚡ , custom ◣ , or color temperature 🄺 (see pages 98-104).

9. **Pick an ISO setting:** With the 5D Mark II, you can get away with higher settings than with other digital cameras. The 5D Mark II has the lowest noise of any camera that Canon has made to date. Press the ISO Speed set button ISO·⚙ on the top right of the camera. The current ISO speed will be displayed on the top LCD panel, on the LCD monitor and in the viewfinder. Use ⚙ to adjust ISO speed (see page 164).

10. **Set camera for reasonable review time:** This camera comes with a default review time (the period of time the picture is displayed on the LCD monitor after taking the photo) that is quite short—merely two seconds. That's not enough time to analyze anything. I recommend the eight-second setting, which you can always cancel by pressing the shutter release. If you are really worried about using too much battery power, just turn off the review function altogether. Go to the Shooting menu 1 ▣ to change the review time (see page 116).

To view your images immediately after pressing the shutter button, ⇨
set the image review time to something that allows you to see the
photo long enough. The default image review time is two seconds,
and for most circumstances is not long enough really see the image.
Photo © Marianne Skov Jensen

In-Camera Processing and File Formats

The 5D Mark II records both JPEG and RAW files. There has been a mistaken notion that JPEG is a file format for amateur photographers while RAW is a format for professionals. This is really not the case. Pros use JPEG and amateurs use RAW. (Technically, JPEG is a compression scheme and not a format, but the term is commonly used to denote format and that is how we will use it.)

There is no question that RAW offers some distinct benefits for the photographer who needs them, including the ability to make greater changes to the image file before the image degrades from over processing. Keep in mind that RAW format is not a standard like JPEG. Each camera manufacturer has their own RAW format, sometimes even differing between camera models. The 5D Mark II's RAW format (called CR2 and originally developed by Canon for the EOS-1D Mark II) includes revised processing benefits to make it more flexible and versatile for photographers than previous versions. It can also handle more metadata and is able to store processing parameters for future use.

One image quality advancement that the 5D Mark II has over the original 5D is the use of 14-bit analog-to-digital (A/D) conversion of the image data. These two extra bits allow for smooth tonal gradations, improved dynamic range, better color fidelity, and improved shadow and highlight details.

With the 5D Mark II's improved image processing, it is easier to capture detail in shadow and highlights in the same frame, shown in the example here.

There are many photographers who have embraced the RAW file format and have integrated it into their workflow. However, there are times when you just don't need the file size that comes with a RAW file, but you still want the processing power of RAW files. Canon has implemented the sRAW file to satisfy this need for smaller files. Other than image size, the sRAW file is identical to a RAW file. So if you are shooting candids or images for small prints, sRAW can be the file format of choice.

New to the 5D Mark II are two sRAW files sizes: sRAW1 and sRAW2. sRAW1 is a 10 megapixel file (3861 x 2574) while sRAW2 is a 5.2 megapixel file (2784 x 1856). The 14.8MB sRAW1 file size can produce a quality 11 x 17 inch (27.9 x 43.2 cm) print while the 10MB sRAW2 file size is more than adequate for 8 x 10 (20.3 x 25.4 cm).

However, RAW is not for everyone. It requires more work and more time to process than other formats. For the photographer who likes to work quickly and wants to spend less time at the computer, JPEG may offer distinct advantages and, with the 5D Mark II, even give better results. This may sound radical considering what some "experts" say about RAW relative to JPEG, but I suspect they have never shot an image with an EOS 5D Mark II set for high-quality JPEG capture.

The reason the 5D Mark II delivers such exceptional images using JPEG is because of Canon's unique DIGIC Imaging Engine (DIGIC for short). Canon has long had exceptionally strong in-camera processing capabilities, and the latest version of their high-performance processor, called DIGIC 4, builds on the technology from previous Canon models.

The DIGIC 4 processor intelligently translates the image signal as it comes from the sensor, optimizing that signal as it is converted into digital data. In essence, it is like having your own computer expert making the best possible adjustments as it processes the captured RAW data for you. It works on the image in-camera, after the shutter is clicked

Shooting RAW files is the best way to ensure you retain the maximum amount of image data captured by the sensor, but shooting JPEG is a more efficient workflow from capture to sharing. Using the RAW+JPEG image size is a nice solution; just make sure you a large memory card.

and before the image is recorded to the memory card, improving color balance, reducing noise, refining tonalities in the brightest areas, and more. In these ways it has the potential to make JPEG files superior to unprocessed RAW files, reducing the need for RAW processing.

The DIGIC 4 is designed to effectively manage the huge amount of data produced by the EOS 5D Mark II, resulting in image data processing that is appreciably faster than earlier units. Color reproduction of highly saturated, bright objects is also much improved. Auto white balance is better, especially at low color temperatures (such as tungsten light). In addition, false colors and noise, which have always challenged digital capture, have been reduced (something that RAW files cannot offer). The ability to resolve detail in highlights is also improved.

DIGIC 4 also affects the 5D Mark II's ability to write image data to the memory card in both JPEG and RAW. Write speed is now faster, enabling the camera to take advantage of the benefit offered by high-speed UDMA memory cards (see page 73 to learn more about UDMA). It is important to understand that a high-speed memory card does not affect how quickly the camera can take pictures. Rather, it affects how fast it can transfer images from its buffer to the card.

Besides speed, the DIGIC 4 also brings several new features to the 5D Mark II. These include the Auto Lighting Optimizer, Peripheral Illumination Correction and Face Detection for focus and metering in Live View shooting.

Speed

There are factors, however, that affect how many shots per second the camera can take. Having a high-megapixel sensor with its comparatively large amount of data has usually meant a slower camera. Yet this is not true of the 5D Mark II. The 5D Mark II can shoot images at 3.9fps, and the number of JPEG images it can shoot in a row at this speed is only limited by the size of the card when using a UDMA memory card. If you are not using a UDMA memory card, the total JPEG image count becomes 78. When you shoot RAW, the maximum number of frames in a row is 14 with UDMA and 13 without.

During Continuous shooting drive mode, each image is placed into a buffer (special temporary memory in the camera) before it is recorded to the memory card. The faster the memory card, the faster the buffer is emptied, allowing more images to be taken in sequence. If the buffer becomes full, the camera stops shooting until the card writing catches up. During this time, "buSY" appears in the viewfinder.

The camera itself has very fast response times: a 0.1 second startup time on power up, a 72 millisecond (ms) lag time for shutter release, and a viewfinder blackout of only 145 ms (at 1/60 shutter speed or higher).

Picture Styles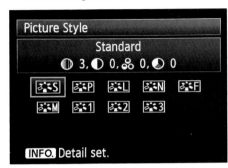

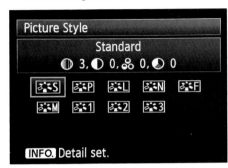

The 5D Mark II's Picture Styles allow you to shoot and not worry about the in-camera processing. Choose the style that matches best to your subject, and experiment.

In addition to the optimizing technology of DIGIC 4, you can choose specific ways in which the camera performs further image processing. This is especially helpful if you print image files directly from the camera without using a computer, or when you need to supply a particular type of image to a client. Some compare Picture Styles to choosing a particular film for shooting.

The easiest way to select a Picture Style is to use the Picture Style button. Another way is via the Quick Control screen if it is displayed on the LCD monitor. Press straight down first, then press it left/right or up/down to highlight the current Picture Style setting. Then use either or to scroll through the six different Picture Style options and three User Defined options. Once you get to the Picture Style you want to use, press or the shutter button (half-way) to exit the Quick Control screen. If you want to see all of the Picture Style options (and their current settings) on the LCD monitor rather than just scrolling through them one at a time, press while the Picture Style is highlighted. This brings up a list of all the styles. Then use or to highlight the Picture Style you

want to use. This screen gives you additional information about how the parameters of each style are set. You can exit this screen by pressing ⑤ⓔⓣ or lightly tapping the shutter release button.

There is also a third way to access Picture Styles. When you select the Picture Style option in ◘: and press ⑤ⓔⓣ , you can bring up the Picture Style sub menu. This display allows you to use ◯ to scroll through the styles. One difference in accessing Picture Styles using this method is that you must press ⑤ⓔⓣ in order for the 5D Mark II to accept your selection.

Note: Use Custom Function IV-3 (see page 150) to program ⑤ⓔⓣ to display the Picture Style screen.

All of the Picture Styles (except Monochrome) control the degree of processing applied to four aspects of an image: Sharpness, Contrast, Saturation, and Color tone. The styles are applied permanently to JPEG files. With RAW files, the Picture Style is applied during "processing" using Canon's Digital Photo Professional software. To make further adjustments to a particular Picture Style, when the camera displays a Picture Style screen press INFO. . Sharpness, contrast, saturation, and color tone are represented by a selection point on a slider-type scale. For Monochrome (black-and-white), the parameters for Filter effect and Toning effect are added, while Saturation and Color Tone are removed.

Contrast increases or decreases the contrast of the scene captured by the camera. Saturation influences color richness or intensity. Color tone helps the photographer decide how red or how yellow to render skin tones, but will also affect other colors. Sharpness refers to the amount of sharpening that is applied to the image file by the camera. A setting of zero means that no sharpening is applied to the image. Sharpness is generally required at some point in digital photography. Digital photography uses a low pass filter in front of the image sensor to reduce the moiré and aliasing produced by the image sensor's pixel grid. Unfortunately, the

low pass filter introduces a small amount of image blur. Image sharpening compensates for this blur.

> *Note:* If you access the adjustments via the 📷 Picture Style submenu, the screen is different than if you access it from the Quick Control screen. The Quick Control screen method only lets you adjust the currently selected style; the other method allows you to adjust any Picture Style, whether or not it is currently selected. There are also some subtle differences in how easily you can adjust each parameter, but they are truly subtle and you should try out each method to see which one you prefer.

It is important to understand that the contrast, saturation and color tone menu sliders allow for further adjustment of the Picture Style and do not represent the value set for the Picture Style. For example, if you look at the value for the contrast slider for all of the Picture Styles you'll notice that they are all set for 0. This does not mean that all of the Picture Styles have the same contrast processing. The sliders simply provide an opportunity for you to "fine-tune" the Picture Style.

The adjustment slider for sharpness is different in this regard. The setting you see is the amount of sharpness applied to the style. You'll notice that as you look at each Picture Style's default settings, the sharpness parameter is the only one that changes from style to style.

The different Picture Styles are:

Standard: During in-camera processing, color saturation is enhanced, and a moderate amount of sharpening is performed on the image. Standard offers a vivid and crisp image with a normal amount of contrast.

Portrait: An emphasis on pleasing skin tones is the goal of this style. While the contrast is the same as Standard, skin tones have a slightly warmer look. Sharpening is reduced in order to produce a pleasing soft skin texture.

▣L **Landscape:** Saturation is high, with an emphasis on blues and greens. There is also a boost in saturation in the yellows. The image is sharpened even more than the Standard mode, to emphasize details. Don't be afraid to use this during cloudy days to help bring out more color.

▣N **Neutral:** If you plan on "processing" the image either through Canon's Digital Photo Professional software or some other image editor, this may be the mode to choose. There is virtually no image sharpening. Color saturation is lower compared to other modes and contrast is lower too. Since other Picture Styles increase saturation, Neutral may be a good mode to choose when you shoot in bright or contrasty situations. Picture details may be more prevalent with this setting. Don't rule it out for candid portraits that occur in bright lighting situations.

▣F **Faithful:** When you need to accurately capture the colors in the scene, this is the mode. Saturation is low, and almost no sharpening is applied to the image. Contrast is also toned down. Accurate color reproduction is achieved when the scene is lit with 5200K lighting. Otherwise you might think of this setting as similar to Neutral except the color tone is a bit warmer than Neutral. Like Neutral, this style is designed with further in-computer image processing in mind.

▣M **Monochrome:** This style allows you to record pure black-and-white images to the memory card. (As with the other Picture Styles, the change is permanent with JPEG— you can't get the color back.) Sharpness is the same as the Standard style. Filter effects and Toning effects replace Saturation and Color Tone.

The parameters for Filter effects offer four tonal effects that mimic what different colored filters do with black-and-white film. A fifth setting, N:None, means no filter effects are applied. Each color choice in the Filter effect menu lightens the colors similar to the selection, while the colors opposite your selection on the color wheel record darker. Choices are:

If you are shooting with the intention of creating black-and-white images, try out the Monochrome Picture Style ⬛ᗰ *. The LCD monitor displays the image in black and white which is helpful for correction when you are still on the scene, however it does write the image to the memory card without color information.*

- **Ye:Yellow** is a modest effect that darkens skies slightly and gives what many black-and-white aficionados consider the most natural looking of black-and-white filters. Or:Orange is next in intensity, but is better explained if you understand the use of red.

- **R:Red** is dramatic, making rather light anything that is red, such as flowers or ruddy skin tones, while blues become dark. Skies turn quite striking and sunlit scenes gain in contrast (the sunny areas are warm-toned and the shadows are cool-toned, so the warms get lighter and the cools get darker).

- **Or:Orange** is in between yellow and red in its effect.

- **G:Green** makes Caucasian skin tones look more natural and foliage gets bright and lively in tone.

Of course, the great thing about digital is that if you aren't sure what any of these effects do, you can take the picture and see the effect immediately on the LCD monitor.

Toning effect adds color to the black-and-white image so it looks like a toned black-and-white print. Your choices are: N:None, S:Sepia, B:Blue, P:Purple, and G:Green. Sepia and blue are the tones we are most accustomed to seeing in such prints.

User Def. 1-3: Each user-defined style allows you to take a "base setting" of a particular picture style and modify it to meet your own photographic needs. This allows you to keep the standard picture styles, but also create and register a different set of parameters that you can apply to image files.

You can also download custom Picture Styles from Canon's Picture Style website:

http://web.canon.jp/imaging/picturestyle/file/index.html
or
http://www.usa.canon.com/content/picturestyle/file/index.html

These custom styles can be uploaded into any of the 5D Mark II's three user-defined styles by using the USB connection to the camera. (It also requires Canon's EOS Utility software, included with the camera.) Use Canon's Digital Photo Professional software to change custom styles after-the-fact in RAW images.

Note: Downloaded Picture Styles can only be loaded into the User-defined styles and are deleted when you reset all camera settings using [Clear settings] in the Set-up 3 menu ⚙ .

Picture Style Editor software, included with the software that comes with the 5D Mark II, allows you to create your own custom Picture Styles.

As mentioned previously, each Picture Style parameter is flexible. To change a Picture Style parameter once the Picture Styles are displayed on the LCD monitor, use ◌ to select the Picture Style you want to adjust, then press INFO. to go to the Detail setting screen. Use the Quick Control dial ◌ or Multi-controller ✣ to highlight the parameter you want to adjust and press (SET) to enter adjustment mode. The white arrow shows the current setting. The gray arrow shows the default setting for that style. Use the ◌ or ✣ to adjust the parameter. You must use (SET) to accept the setting. If you leave this menu screen without pressing (SET), the adjustment is cancelled. Use MENU to exit the detail setting mode.

Note: Any parameter setting different from the default is highlighted in blue. At the bottom of the setting screen, the [Default set.] option can be used to return the current parameter to the original setting.

While specific situations may affect how you adjust these Picture Style parameters, here are some suggestions to consider:

Create a hazy or cloudy day setting: Make one of the user-defined sets capture more contrast and color on days when contrast and color are weak. Increase the scale for contrast and saturation by one or two points (experiment to see what you like when you open the files on your computer or use the camera for direct printing). You can also increase the red setting of Color tone (adjust the scale to the left).

Create a portrait setting: Make a set that favors skin tones. Start with the Portrait Style as your base, then reduce contrast by one point while increasing saturation by one point (this is very subjective—some photographers may prefer less saturation) and warming skin tones (by moving Color tone toward the red, or left, side) by one point.

Create a Velvia (an intensely colored slide film) look: Start with Standard style, then increase the Contrast two points, Sharpness one point, and Saturation by two points.

As in the above image, candles give off an orange light (compared to the white light of sunlight). You can use the White balance function to remove the orange color cast, or you can use it to increase the color tone of the image for a more creative effect.

White Balance

White balance is an important digital camera control. It addresses a problem that has plagued film photographers for ages: how to deal with the different color temperatures of various light sources. While color adjustments can be made in the computer after shooting, especially when shooting RAW or sRAW, there is a definite benefit to setting white balance properly from the start. The 5D Mark II helps you do this with an improved Auto white balance setting that makes colors more accurate and natural than earlier digital SLRs could produce. In addition, improved algorithms and the DIGIC 4 processor make Auto white balance more stable as you shoot a scene from different angles and focal lengths (which is always a challenge when using automatic white balance). Further, white balance has been improved to make color reproduction more accurate under low light levels.

While Auto white balance 〔AWB〕 gives excellent results in a number of situations, many photographers find they prefer the control offered by presets and custom settings. With nine separate white balance settings, plus white balance compensation and bracketing, the ability to carefully control color balance is greatly enhanced in the 5D Mark II. It is well worth the effort to learn how to use the different white balance functions so you can get the best color with the most efficient workflow in all situations (including RAW). This is especially important in strongly colored scenes, such as sunrises or sunsets, which can fool Auto white balance.

The basic settings are simple enough to learn and should become part of the photographic decision-making process. The more involved Custom white balance setting is also a valuable tool to understand. Use it to render the truest color in all conditions (see page 102).

To set white balance, press ⊙·WB to display the white balance screen on the LCD monitor. Next, use the ○ to choose the white balance setting you need. You can also display the white balance options on the LCD monitor by using the Shooting 2 menu 🗅 .

White balance settings fall within certain color temperature values. The values correspond to a measurement of how cool (blue) or warm (red) the light source in the scene is. The measurement is in degrees Kelvin, abbreviated as K.; the higher the number, the bluer the light source. Conversely the lower the number, the redder the light source.

Auto: Color temperature range of approximately 3000-7000K 〔AWB〕
This setting examines the scene for you, interprets the light it sees (in the range denoted above) using the DIGIC 4 processor (even with RAW), compares the conditions to what the engineers have determined works for such readings, and sets a white balance to make colors look neutral (i.e., whites appear pure, without color casts, and skin tones appear normal).

Auto is a useful setting when you move quickly from one type of light to another, or when you hope to get neutral colors and need to shoot fast. Even if it isn't the perfect setting for all conditions, it often gets you close enough so that only a little adjustment is needed later using your image-processing software. However, if you have time, it is often better to choose from the white balance settings listed below, because colors will be more consistent from picture to picture. While Auto is well-designed, it can only interpret how it "thinks" a scene should look. If your wide-angle and telephoto shots of the same subject change what is seen by the camera in terms of colors, the camera readjusts for each shot, often resulting in inconsistent color from shot to shot.

Daylight: Approximately 5200K ☀
This setting adjusts the camera to make colors appear natural when shooting in sunlit situations between about 10 A.M. and 4 P.M. (middle of the day). At other times, when the sun is lower in the sky and has more red light, the scenes photographed using this setting appear warmer than normally seen with our eyes. It makes indoor scenes under incandescent lights look very warm indeed.

Shade: Approximately 7000K 🏠
Shadowed subjects under blue skies can end up very bluish in tone, so this setting warms the light to make colors look natural, without any blue color cast. (At least that's the ideal—individual situations affect how effectively the setting performs.) The Shade setting is a good one to use any time you want to warm up a scene (especially when people are included). Experiment to see how you like this creative use of the setting.

Cloudy: Approximately 6000K ☁
Even though the symbol for this setting is a cloud, you can think of it as the Cloudy/twilight/sunset setting. It warms up cloudy scenes as if you had a warming filter, making sunlight appear warm, but not quite to the degree that the Shade setting does. You may prefer the Cloudy setting to Shade when shooting people, since the effect is not as

strong. Both settings work well for sunrise and sunset, giving the warm colors that we expect to see in such photographs. However, the Cloudy setting offers a slightly weaker effect. You really have to experiment a bit when using these settings for creative effect. Be sure to make the final comparisons on a computer.

Tungsten light: Approximately 3200K ☀

Tungsten light is designed to give natural results with quartz lights (generally balanced to 3200K). It also reduces the strong orange color that is typical when photographing lamp-lit indoor scenes with daylight-balanced settings. Since this control adds a cold tone to other conditions, it can also be used creatively for this purpose (to make a snow scene bluer, for example).

White fluorescent light: Approximately 4000K ☀

The Auto setting often works well with fluorescents but, under many conditions, the White fluorescent light setting is more precise and predictable. Fluorescent lights usually appear green in photographs, so this setting adds magenta to neutralize that effect. (Since fluorescents can be extremely variable, and since the 5D Mark II has only one fluorescent choice, you may find that precise color can only be achieved with the Custom white balance setting.) You can also use this setting creatively any time you wish to add a pinkish warm tone to your photo (such as during sunrise or sunset).

Flash: Approximately 6000K ⚡

Light from flash tends to be a little colder than daylight, so this warms it up. According to Canon tech folks, this setting is essentially the same as Cloudy (the Kelvin temperature is the same); it is simply labeled differently to make it easier to use. I use both Flash and Cloudy a lot, finding them to be good, all-around settings that give a slight but attractive warm tone to outdoor scenes.

Custom: Approximately 2000-10,000K ⬛🔺

A very important tool for the digital photographer, Custom is a setting that even pros often don't fully understand. It is a very precise and adaptable way of getting accurate or creative white balance. It has no specific white balance K temperature, but is set based on a specific neutral tone in the light in the scene to be photographed. However, it deals with a significantly wider range than Auto. That can be very useful.

To save a Custom setting, you need a white (or neutral gray) target that the camera can white balance on. To start, take a picture of something white (or a known neutral tone) that is in the same light as your subject. You can use a piece of paper or a gray card. It does not have to be in focus, but it should fill the image area. (Avoid placing the card on or near a highly reflective colored surface.) Be sure the exposure is set to make this object gray to light gray in tone, and not dark (underexposed) or washed out white (overexposed). I like to use a card or paper with black print on it rather than a plain white card. This way, if I can see the type, I haven't overexposed the image.

Next, go to the Shooting 2 menu 📷 , use the Quick Control dial 🔘 or Multi-controller ✣ to highlight [Custom WB] and press (SET) . A full screen display of the last image captured is shown on the LCD monitor. A custom white balance icon is overlaid on the image to remind you that the 5D Mark II is in custom white balance selection mode. Use the 🔘 to select a different image if needed (the ⚙ can be used to jump through images). Press (SET) to select the displayed image for custom white balance, then use the 🔘 or ✣ to highlight [OK] and press (SET) .

If the 5D Mark II is set to use a white balance other than Custom, a note appears on the LCD monitor to remind you to change the white balance to custom. This tells you that there is one more step to this process: you still need to choose the Custom setting for white balance. The custom white balance setting only affects future shots; it will not change the image that you selected for custom white balance.

Note: If the camera is set for the Monochrome Picture Style when the reference image is taken, the 5D Mark II will display "Unselectable image" when you try to set Custom White balance. This is because all of the color has been removed from the image so the white balance circuitry has nothing to evaluate.

The procedure described above produces neutral colors in some very difficult conditions. However, if the lighting is mixed in color (for example, the subject is lit on one side by a window and on the other by incandescent lights), you only get neutral colors for the light the white card was in. If you shoot in reduced spectrum lights, such as sodium vapor, you will not get a neutral white under any white balance setting.

You can also use Custom white balance to create a special color for a scene. In this case, you white-balance on a color that is not white or gray. You can use a pale blue, for example, to generate a nice amber color. If you balance on the blue, the camera adjusts the color to neutral, which in essence removes blue, so the scene has an amber cast. You can use different strengths of blue for varied results. You can also use any color you want for white balancing—the camera works to remove (or reduce) that color, meaning the opposite color becomes stronger. (For example, use a pale magenta to increase the green response.)

Because the reference images are stored on the memory card, you can develop a library of images to use for setting custom white balance. For example, if you are shooting in different rooms with different color temperature white balance, you can store a white balance for each room. You could even use a separate (small) memory card that you can quickly pop into the 5D Mark II that just has white balance shots on it. This way you don't have to scroll through a number of images to change white balance.

Color temperature: Approximately 2500K – 10000K **K**
With this setting you can directly set the color temperature in degrees Kelvin. This can be useful if you use a color temperature meter or know the color temperature of the illumination source. Also consider using this setting to dial in a white balance, particularly when using Live View shooting mode.

Note: When you first experiment with white balance, using Live View and adjusting the white balance is a great way to see how the various settings affect the image.

White Balance Correction

The 5D Mark II goes beyond the capabilities of many cameras in offering control over white balance: a white balance correction feature is built into the camera. Think of it as exposure compensation for white balance. It is like having a set of color balancing filters in four colors (blue, amber, green, and magenta) and in varied strengths. Photographers accustomed to using color conversion or color correction filters find this feature quite helpful in getting just the right color.

The setting is pretty easy to manage using the ◯ and the ✥ . First, go to the ◻ˑ , highlight [WB SHIFT/BKT] with the ◯ or ✥ and press ⑤ . A menu screen displays a graph with a horizontal axis from blue to amber (left to right) and a vertical axis from green to magenta (top to bottom). You move a selection point within the graph with the ✥ to "shift" the white balance. As you change the position of the selection point, a visual indicator appears on the graph and an alphanumeric display appears in the upper right of the screen showing a letter for each color (B,A,G, or M) and a number for each setting. For photographers used to color-balancing filters, each increment of color adjustment equals 5 MIREDS of a color-temperature changing filter. (A MIRED is a measuring unit for the strength of a color temperature conversion filter.) Remember to set the correction back to zero when conditions change. The bottom of the viewfinder status displays ISOˑ🔲 when white balance correction is engaged.

Note: You must press ⊛ or straight down on ✿ to accept the white balance shift setting. If you press **MENU** or the shutter release button, the white balance shift will not be changed.

White Balance Auto Bracketing

When you run into a difficult lighting situation and want to be sure of the best possible white balance settings, another option is white balance auto bracketing. This process is actually quite different than auto-exposure bracketing. With the latter, three separate exposures are taken of a scene; with white balance auto bracketing, you take just one exposure and the camera processes it to give you three different white balance options.

Note: Using white balance bracketing slightly delays the recording of images to the memory card.

This bracketing is accomplished up to +/- 3 levels. (Again, each step is equal to 5 MIREDS of a color correction filter.) You can bracket from blue to amber or from green to magenta.

The white balance bracketing is based on whatever white balance mode you have currently selected. The current white balance icon on the LCD monitor and the LCD panel flashes to let you know that white balance bracketing is set but there is no indicator in the viewfinder.

To access white balance auto bracketing, select [WB SHIFT/BKT] in the ◘ and press ⊛ . The graph screen with the horizontal (blue/amber) and vertical (green/ magenta) axes appears on the LCD monitor. Rotate the ☉ to adjust the bracketing amount: to the right (clockwise) to set the blue/amber adjustment, then back to zero and to the left (counter clockwise) for green/magenta. (You can't bracket in both directions.) You can also shift your setting from the center point of the graph by using the ✿ . Press ⊛ to accept your settings. To clear any white balance shift or bracketing, press **INFO.** .

Note: When you turn the 5D Mark II off, the white balance bracketing is reset to [None], but the white balance shift stays where you set it. Make sure to pay attention to the white balance shift icon in the viewfinder so you know when it is turned on.

White balance bracketing records an original image at the currently selected white balance setting, then internally creates an additional set of (1) a bluer image and a more amber image, or (2) a more magenta image and a greener image. Unlike exposure bracketing, you only need to take one shot—you do not have to set the drive setting to 🔳 or press the shutter release button multiple times. If you combine white balance bracketing with auto exposure bracketing (AEB), a total of nine images are produced.

The obvious use of this feature is to deal with tricky lighting conditions. However, it has other uses as well. You may want to add a warm touch to a portrait but are not sure how strong it should be. Select the Cloudy setting ☁ , for example, then use white balance bracketing to get the tone you're looking for. (The bracketing gives you the standard Cloudy white-balanced shot, plus versions warmer and cooler than that.) Or, you may run into a situation where the light changes from one part of the image to another. Here, you can shoot the bracket, then combine the white balance versions using an image-processing program. (Take the nicely white-balanced parts of one bracketed photograph and combine them with a different bracketed shot that has good white-balance in the areas that were lacking in the first photo.)

RAW and White Balance
Since the RAW format allows you to change white balance "after the shot," some photographers have come to believe that it is not important to select an appropriate white balance at the time the photo is taken. While it is true that Auto white balance and RAW give excellent results in many situations, this approach can cause consistency and workflow challenges. White balance choice is important because when you bring CR2 files into software for "processing," the files come

106

up with the settings you chose during the initial image capture. Sure, you can edit those settings in the computer, but why not make a good RAW image better by merely tweaking the white balance with minor revisions at the image-processing stage rather than starting with an image that requires major correction? There will be times when getting a good white balance setting is difficult, and that is when the RAW software white balance correction can be a big help.

5D Mark II File Formats

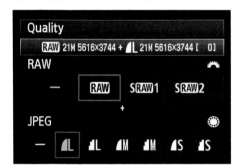

Choosing a file format is one of the first settings you should address on your new 5D Mark II.

The 5D Mark II records images as either JPEG or RAW files. It is important to understand how the sensor processes an image. It sees a certain range of tones coming to it from the lens. Too much light, and the detail is washed out; too little light, and the picture is dark. This is analog (continuous) information, and it must be converted to digital (which is true for any file format, RAW or JPEG). The complete data is based on 14 bits of color information, which is changed to 8-bit color data for JPEG, or simply placed virtually unchanged into a 16-bit file for RAW. (A bit is the smallest piece of information that a computer uses—an acronym for binary digit. Data of 8 bits or higher is required for true photographic color.) This occurs for each of three different color channels employed by the 5D Mark II: red, green, and blue. RAW files have very little processing applied by the camera. The fact that they contain 14-bit color information is a little confusing since this information is put into a file that is actually a 16-bit format.

Both 8-bit and 16-bit files have the same range from pure white to pure black because that range is influenced only by the capability of the sensor. If the sensor cannot capture detail in areas that are too bright or too dark, then a RAW file cannot deliver that detail any better than a JPEG file. It is true that RAW allows greater technical control over an image than JPEG, primarily because it starts with more data (14 bits in a 16-bit file), meaning there are more "steps" of information between the white and black extremes of the sensor's sensitivity range. These steps are especially noticeable in the darkest and lightest areas of the photo. So it appears the RAW file has more exposure latitude and that greater adjustment to the image is possible before banding or color tearing becomes noticeable.

JPEG format compresses (or reduces) the size of the image file, allowing more pictures to fit on a memory card. The JPEG algorithms carefully look for, and remove, redundant data in the file (such as a large area of a single color) while keeping instructions on how to reconstruct the file. JPEG is therefore referred to as a "lossy" format because data is lost. The computer rebuilds the lost data quite well as long as the amount of compression is low.

It is essential to note that both RAW and JPEG files can give excellent results. Photographers who shoot both use the flexibility of RAW files to deal with tough exposure situations, and JPEG files when they need fast and easy handling of images. Which format will work best for you? Your own personal way of shooting and working should dictate that. If you deal with problem lighting and colors, for example, RAW gives you a lot of flexibility in controlling both. If you can carefully control your exposures and keep images consistent, JPEG is more efficient.

RAW Exposure Processing

Working with JPEGs is easy and you can do it with any image-processing program. However, not all such programs can open RAW files; special software is required to convert from RAW. Canon supplies a dedicated software program

Canon's dedicated browser software, ZoomBrowser EX (or Image-Browser for Mac platforms) is designed especially for Canon's proprietary RAW files—CR2 files—and is a good option if you are looking for a browser to handle your image files.

with the 5D Mark II called ZoomBrowser EX (Windows) or ImageBrowser (Mac). Both programs are specifically designed for CR2 files and allow you to open and smartly process them.

You can also choose third-party processing programs that make RAW file conversions easier, such as Adobe's Photo-Shop and Lightroom, Apple's Aperture and Phase One's Capture One, just to name a few. These independent software programs are intended for professional use and can be expensive (although some manufacturers offer less expensive solutions). Their advantage tends to be ease-of-use for better processing decisions, although Canon's Digital Photo Professional (DPP), a high-level RAW conversion program, is quite powerful, and is included with the camera.

You can open a RAW file directly in many of these programs, make the conversions, and then continue to work on the file without leaving the program. You may have to update your Photoshop software if you have had it for a while, since the 5D Mark II is a recent introduction and it may not be supported in your version of software. Workflow is much improved and control over the RAW file is quite good, although some photographers still prefer the conversion algorithms of other programs.

A disadvantage to using a third party program is that it may not support Canon's Dust Delete Data system (page 81), which automatically removes dust artifacts in your images. Also, Picture Styles may not be supported in software other than Canon's.

Whatever method you choose to gain access to RAW files in your computer, you have excellent control over the images in terms of exposure and color of light. There is special metadata (shooting information stored by the camera) in the file containing the exposure settings you selected at the time of shooting. This is used by the RAW conversion program when it opens an image. You can then change the exposure values without causing harm to the file (within reason). Most RAW software allows batch processing. This allows you to adjust a group of photos to specific settings and can be a very important way to deal with multiple photos from the same shoot.

Note: While software appears to work miracles, you'll get the best results if you start out with a properly exposed image.

RAW Conversion Software
In addition to ZoomBrowser EX and ImageBrowser, Canon has developed a high quality image processing program call Digtal Photo Professional. This software, once optional, is included with the 5D Mark II and speeds processing quite noticeably.

A key new feature is the program's ability to save adjustments to a file that can then be reloaded and applied again to the original file or to other RAW files. The program includes a whole range of valuable controls, such as tone curves, exposure compensation, white balance, dynamic range, brightness, contrast, color saturation, ICC Profile embedding, and more. There is also a comparison mode that allows original and edited images to be compared side by side or in a split image.

DPP even has some batch processing features. It can allow continuous work on images while other files are rendered and saved in the background. Once images have been adjusted in DPP, they can be immediately transferred to Photoshop. There is no question that DPP really helps streamline the workflow of any photographer who needs to work with RAW.

Image Size and Quality

The 5D Mark II offers a variety of choices for image-recording quality, consisting of combinations of different file formats, resolutions, and compression rates. But let's be straight about this: Most photographers will shoot the maximum image size using RAW (including the new sRAW1 or sRAW2 formats) or the highest-quality JPEG setting. There is little point in shooting smaller image sizes except for specialized purposes. After all, the camera's high resolution is what you paid for!

The image size and quality setting is the first option in Shooting menu 1. The 5D Mark II offers several combinations of image size and quality, but consider setting it to the highest quality setting to get the most from the camera's sensor.

A higher compression level usually means less detail in an image file, especially if that image contains alot of small details from the foreground to background, such as the bamboo shoots in the photo shown here.

All settings for JPEG compression quality are selected in the Shooting 1 menu ⚙ under [Quality] or by using the Quick Control screen and highlighting the current file recording setting. Press ⑤ and two rows of settings appear. The top row, which is adjusted via ⚙, contains the three different RAW settings: RAW , SRAW1, and SRAW2. The first position is [Off]. Use that when you don't want to record any RAW files. The bottom row shows the three JPEG file sizes, along with the two JPEG compression options, for a total of six different options (◢L , ◢L , ◢M , ◢M , ◢S , and ◢S), plus off. Less compression (higher quality) is indicated by the smoother curve on the icon, while more compression (lower quality) is indicated by the stairstep look to the curve. The setting indicated in blue is the current one. Once you have made your selection on both rows, press ⑤ to accept the setting.

The 5D Mark II can also record both RAW and JPEG simultaneously. This can be useful for photographers who want added flexibility. When you shoot RAW+JPEG, the camera uses the same file numbering but the extensions change: .JPG for JPEG and .CR2 for RAW. You can then use the JPEG file, for example, for direct printing, quick usage, and to take advantage of the DIGIC 4 processor. And you still have the RAW file for use when you need its added processing power. The RAW file appears in your RAW conversion software with the same processing details as the JPEG file (including white balance, color matrix, and exposure), all of which can be easily changed in the RAW software.

Though RAW is adaptable, it is not magic. You are still limited by the original exposure, as well as the tonal and color capabilities of the sensor. Simply because RAW gives you more options to control the look of your images, is no excuse to become sloppy in your shooting. If you do not capture the best possible file, your results will be less than the camera is capable of producing.

Each recording quality choice influences the number of photos that can fit on a memory card. Most photographers shoot with large memory cards because they want the space required by the camera's high-quality files. It is impossible to give exact numbers of how many JPEG images can fit on a card because the compression technology is variable. You can change the compression as needed (resulting in varied file sizes), but remember that JPEG compresses each file differently depending on what kind of detail is in the photo and how much redundant data can be eliminated. For example, a photo with a lot of detail does not compress as much as an image with a large area of solid color.

Camera Menus
and the LCD Monitor

Using the Menus

A digital camera's menus are a necessary evil—there are simply a great number of settings that need to be controlled. Still, in some cameras, menus are not always easy to use. Canon has put a great deal of thought into the design of the 5D Mark II's menus so that they can be used efficiently. In addition, they can be set in 25 different languages.

Note: If you accidentally set the wrong language, remember that the language setting is in Set-up menu 2 **IƳ:** and it is the third item from the top.

All menu controls, or items, are found in seven menus that are grouped into three categories based on their use. These categories, intuitively named in order of appearance within the menu system, are Shooting ☐ , Playback ⯈ , and Set-up **IƳ** . In addition to these menus there are the Custom Functions menu ☐, and My Menu ☆ . My Menu is a highly useful feature that allows you to build your own menu screen (see page 124).

The 5D Mark II offers seemingly endless options for capturing, viewing, and manipulating your photos. Learning to navigate the menu system will give you more control over how the camera operates.

You gain access to the 5D Mark II's menu selections whenever you push **MENU**, located on the back of the camera to the upper left of the viewfinder. The menus are designated by their icon on a menu tab at the top of the menu screen on the LCD monitor. Move from menu tab to menu tab by using the Main dial 🖾 or the Multi-controller ✧ . Move up and down in a menu using the Quick Control dial ◯ or the ✧ . To select a desired menu option, press ⓢ . Some menu options use additional submenus. In these cases, use the same combination of the ◯ and ⓢ .

> *Note:* Since the Multi-controller ✧ can scroll through both menu tabs and menu choices, you can access any menu option in any menu with one button; however, it takes a bit of dexterity.

To "back out" of a menu, press **MENU**. To immediately exit any menu and return to shooting mode, slightly press the shutter release. (Note that when you exit this way, if you have not accepted a setting that requires pressing ⓢ , it is ignored.) The 5D Mark II remembers the last item highlighted in each different menu.

Shooting 1 Menu ◖

[Quality] (selects recorded image size from RAW to sRAW to L to S; also sets JPEG compression level for L, M, and S; both RAW and JPEG can be recorded simultaneously)

116

[Beep]	(signal for controls on or off)
[Shoot w/o card]	(this allows you to test the camera in the absence of a memory card)
[Review time]	(how long image stays on LCD monitor after shot)
[Peripheral illumin. correct.]	(accesses lens vignetting correction sub menu)

Shooting 2 Menu

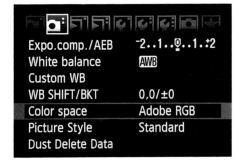

[Expo.comp./AEB]	(sets exposure compensation and exposure bracketing)
[White balance]	(sets current white balance)
[Custom WB]	(manually sets white balance)
[WB SHIFT/BKT]	(for bracketing and shifting white balance)
[Color space]	(sRGB or Adobe RGB)
[Picture Style]	(sets up different profiles for processing images in-camera, including 3 user-defined styles)
[Dust Delete Data]	(captures reference file for extracting dust in software)

The 5D Mark II's Playback menus include all the functions you need to review your images, along with several controls that allow you to manage your photos while they are still in the camera.

Playback 1 Menu

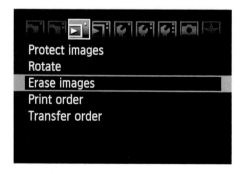

[Protect images]	(prevents images from being erased)
[Rotate]	(rotates recorded image)
[Erase images]	(erases unprotected images – select single images or by folder)

[Print order]	(specifies images to be printed using DPOF)
[Transfer order]	(specifies images to be downloaded to a computer)
[Image copy]	(copies images from one memory card to another)
[External media backup]	(copies image from memory card to external media via WFT-E4/E4A; only displayed when external media is connected with WFT-E4/E4A)

Playback 2 Menu ▶

[Highlight alert]	(overexposed areas of the image blink on the LCD monitor)
[AF point disp.]	(AF point used for image capture is overlaid on the playback image)
[Histogram]	(selects between Brightness and RGB histograms)
[Slide show]	(sets up quick slideshow presentation of images with image display time and repeat options)
[Image jump w/]	(selects whether to jump by 1 image, 10 images, 100 images, by date, by folder, by movies, by stills or, when in index mode, by screen)

Set-up 1 Menu

[Auto power off] (six time options, as well as off)

[Auto rotate] (selects between auto rotation of verticals in camera and on computer, just on the computer, or no rotation at all)

[Format] (very important; used to initialize and erase the card)

[File numbering] (three options – continuous, auto reset, manual reset)

[Select folder] (chooses or creates a folder for recording)

Set-up 2 Menu

[LCD brightness] (adjusts LCD monitor brightness - seven levels and Auto)

[Date/Time]	(adjusts date, time and date format)
[Language]	(25 options)
[Video system]	(NTSC or PAL for playback)
[Sensor cleaning]	(enables auto cleaning at power on and off, starts auto cleaning immediately, or sets up camera for manual cleaning)
[Live View/Movie func. set.]	(enables Live View for video and/or stills; sets display type during video recording; turns on/off audio recording; sets AF mode, movie size; turns on/off grid; enables silent shooting; and sets metering timer)

Set-up 3 Menu 🔧

[Battery info.]	(displays current capacity, number of shutter releases, and recharge performance of installed battery; registers/displays additional batteries)
[INFO. Button]	(changes operation of INFO.)
[External Speedlite control]	(sets Speedlite function settings, Speedlite custom function settings and clears Speedlite custom functions, depending on the Speedlite)
[Camera user setting]	(stores current camera settings to one of 3 user settings: C1 , C2 , C3)

| [Clear settings] | (resets camera to factory default or deletes copyright information) |
| [Firmware Ver. x.x.x.] | (displays current firmware and is used to start a firmware update) |

Custom Functions Menus

(Custom Functions details are covered later in the chapter)

[C.Fn I: Exposure]	(exposure, metering and flash sync options)
[C.Fn II: Image]	(noise reduction, tone priority, auto lighting optimizer)
[C.Fn III: Auto focus/Drive]	(focus drive, focus assist, AF point display, AF micro adjustment and mirror lockup options)
[C.Fn IV: Operation /Others]	(operating controls, focus screen, and image verification options)
[Clear all Custom Func. (C.Fn)]	(resets all custom function settings to factory defaults with the exception of Custom Function IV-5 for focus screens)

Canon's My Menu is completely customizable, allowing the user to choose the menu functions they access most frequently and add them to this list.

My Menu ★

[My Menu settings]　　　(Initially blank, defined by user)

Understanding menu system operation is necessary in order to gain full benefit from using the LCD monitor and the Custom Functions.

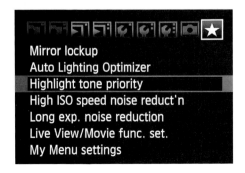

My Menu 🏮

When you first get your 5D Mark II, the My Menu display only has one selection, called [My Menu settings]. Through this selection you can build a custom menu of your own using any of the top-level choices in any of the menus, as well as any custom functions. My Menu can list up to six choices.

To build a menu, press **MENU** and use the Main dial 🎛️ or Multi-controller ✳️ to select My Menu 🏮 . Use the Quick Control dial 🎛️ to select [My Menu settings], then press ⚙️ . On the sub-menu select [Register] and press ⚙️ . A list of every top-level menu option is presented, followed by the custom function menu and then by the individual custom functions.

The My Menu settings screen displays the user-created list of top-level choices available from any of the other menus.

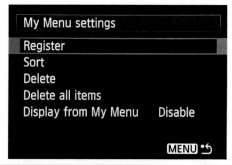

Note: Previously assigned menu options are grayed out.

Use the 🎛️ or ✳️ to select the desired option and then press ⚙️ . Highlight [OK] and press ⚙️ to add the function to My Menu. Repeat the process until you have selected the options you want, up to a maximum of six. Press **MENU** to exit the option selection screen. Press **MENU** to see the resulting My Menu.

The My Menu sub-menu allows you to sort your menu items. Select [Sort] from the [My Menu settings] menu and press ⚙️ . The Sort My Menu screen is displayed, showing the current order of your menu items. Use the 🎛️ or the ✳️ to highlight an item you wish to move. Press ⚙️

and an up/down arrow icon appears to the right of the item. Use the ⊙ or ✣ to move the item up or down in the list. Press ⓢⓔⓣ once the item is in the preferred position and either repeat these steps to change the position of other items or press **MENU** to exit the Sort My Menu screen.

If you have filled My Menu with six items and want to add a new one, you must first delete an existing item—there is no exchange function. Highlight [Delete] and press ⓢⓔⓣ , then use the ⊙ or the ✣ to highlight the item you wish to delete. Press ⓢⓔⓣ and a dialog asks you to confirm the deletion. Highlight [OK] and press ⓢⓔⓣ . Repeat this process to delete other My Menu items, then press **MENU** to exit the Delete My Menu screen. You can also use the [Delete all items] option to start with an empty My Menu.

To customize your 5D Mark II so that every time you press the **MENU** button My Menu is displayed (no matter which menu you were on last), highlight the [Display from My Menu] selection in the My Menu settings screen. Press ⓢⓔⓣ and then highlight [Enable] and press ⓢⓔⓣ .

There is a faster way than going through the camera menus to set up My Menu. If you connect the 5D Mark II to a computer, you can use the Canon EOS Utility (included with the camera) to quickly set up your My Menu options. Select [Camera settings/Remote shooting] from the main menu. Select ⚙ from the camera control window that appears. Then click on My Menu settings; a My Menu settings window pops up. The left side of the window shows the current My Menu setup. The right window shows all the potential items that you can add to the list.

It is a simple matter of highlighting an option on the right and then pressing the "add" button. There is also a "delete" button that you can press to remove items from the menu. There are also two sort buttons that can be used to arrange the order of the menu. Once you have made your selections and have placed them in the desired order, press the "Apply to camera" button to download the settings to the 5D Mark II.

The LCD Monitor

The LCD monitor is one of the most useful tools available when you shoot digital, giving immediate access to your images. You can set your camera so that the image appears for review on the LCD monitor directly after shooting the picture. It's better than a Polaroid print!

The 5D Mark II's 3.0 inch (7.62 cm) color LCD monitor is much brighter than the monitors of just a couple years ago, but it still takes a little practice to see it well in bright light. You can adjust the LCD's brightness in the Set-up 2 menu ꞋꞋꞋ . Select [LCD brightness] and press ⑤ , then use the Quick Control dial ◎ or Multi-controller ✥ to adjust the brightness level and press ⑤ to confirm.

The LCD monitor can be adjusted brighter or darker, depending on your preference.

New to the 5D Mark II is automatic control of the LCD brightness. A small sensor below and just to the right of the LCD monitor senses the ambient light hitting the back of the 5D Mark II and automatically adjusts brightness. To engage auto brightness control, while the LCD brightness screen is displayed, use ◎ or ✥ to select [Auto] and press ⑤ .You can further adjust the auto brightness control with ◎ or ✥ to one of three settings: [dark], [normal], or [bright].

When photographers compare a point-and-shoot digital camera with a larger digital SLR, they often notice that the smaller camera's LCD monitor can be turned on while

shooting. Digital point-and-shoot cameras have so-called "live" LCD monitors. Digital SLRs, however, use a mirror inside the camera (that blocks the path of light from subject to sensor) to direct the image from the lens to the viewfinder. During exposure the mirror flips up, exposing the sensor to light from the image. A live LCD monitor, on the other hand, must be able to see what is coming from the lens at all times in order to "feed" the LCD monitor. The 5D Mark II includes a Live View mode that locks the mirror in the up position and allows you to see what the image sensor sees (see page 195). This feature also allows the 5D Mark II to record high definition video.

LCD Image Review

You can choose to instantly review the image you just shot, and you can also look at all of the images you have stored on your memory card. Most photographers like the instant feedback of reviewing their images because it gives a confirmation that the picture is okay.

Set the length of time needed to review the images you have just captured. It is frustrating to examine a picture and have the LCD monitor turn off before you are through. You can set the review duration from among several choices that include [2 sec], [4 sec], [8 sec], or [Hold], all controlled by the [Review time] selection in the Shooting 1 menu (color code red). Also use this menu item to activate the [Off] option, preventing image review (you can still view images using Play ▶).

Setting review time for [2 sec] is a bit short—I prefer [8 sec]. You can always turn the review off sooner by lightly pressing the shutter button. The [Hold] setting is good if you like to study your photos, because the image remains on the LCD monitor until you press the shutter button. But be careful. It is easy to forget to turn off the monitor when you use this selection, wearing down the batteries.

Playback

Reviewing images on the LCD monitor is an important bene-fit of digital cameras. To see not only your most immediate shot, but also any (or all) of the photos you stored on the memory card, press Playback ▶ on the back of the camera to the left of the rear LCD panel. The last image you captured appears on the LCD monitor. Cycle through the photos using the Quick Control dial ◎ . If you rotate the dial left, you move in reverse chronological order, starting with your most recent image. If you rotate the dial right you move forward through the images, beginning with the first image on the card.

The 5D Mark II also lets you display the review or play-back image in four different formats. Push **INFO.** , also found on the back of the camera, to the left of the LCD monitor. By default, image playback appears in the last display mode you used. Push **INFO.** repeatedly to cycle through the play-back options.

Single Image Display: The image for review covers the entire LCD screen and includes superimposed data for the shutter speed, the aperture, exposure compensation amount, whether the image is protected, the folder number, and the image number. If the image represents the first frame of a video file, an icon is displayed to remind you that if you press ⒮ the movie controls pop up, allowing you to play back the movie.

Single Image Display with Image Size: The same as above, with an additional display overlay in the image's lower left corner showing the image recording size and quality, together with the played back image's number and the total number of images on the card. If you are on a movie file, the display overlay shows MOV (indicating the image is from a movie file, not a still) and the size of the movie file (either 1920 or 640).

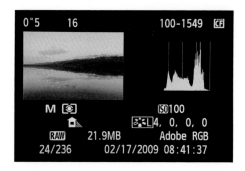

Shooting Information Display: The LCD monitor displays an approximately quarter-size image, a histogram of exposure, and complete shooting information including: shooting mode, metering mode, flash exposure compensation amount, auto focus microadjustment, ISO speed, highlight tone priority, color temperature, white balance mode, white balance correction, Picture Style, picture style settings, image recording size and quality, file size, image verification indicator, color space, playback image number, total number of images, and date and time. The histogram displays either brightness or RGB, depending on the histogram option in the Playback menu 2 ▶⁚ .

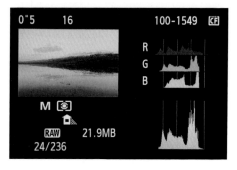

Histogram Display: A quarter-size image is displayed, along with both brightness and RGB histograms, the same information as the single image display, and the image size.

Lightly tap the shutter button to stop playback and return the 5D Mark II to shooting mode again. You can also press Playback ▶ to stop playback.

Note: When the camera is in Shooting mode, use **INFO.** to toggle between the shooting settings display, no display and the camera settings display. The shooting settings display also doubles as the Quick Control screen (see page 63).

Automatic Image Rotation

The Automatic image rotation feature has three settings that allow you to choose how you view vertical images on the camera, the computer, or both.

Included in the 5D Mark II is an option to automatically rotate vertical images during playback. When selected and the camera is held in a horizontal position, vertical images appear up-and-down in the LCD monitor, rather than side-ways. This command is in the Set-up 1 menu ⚹ . Use the Quick Control dial ◯ or Multi-controller ✛ to select [Auto rotate] and press ⑤ . Then choose the auto rotate option you want and press ⑤ .

On◯🖥 - This mode rotates the image when displayed on the LCD monitor and embeds the image file with rotation information so that your computer can rotate the image for proper display.

On🖥 - With this setting the image is not rotated on the camera display, but the rotation data is embedded in the image files.

Off - The image is not rotated on the 5D Mark II display, nor is the image embedded with rotation data.

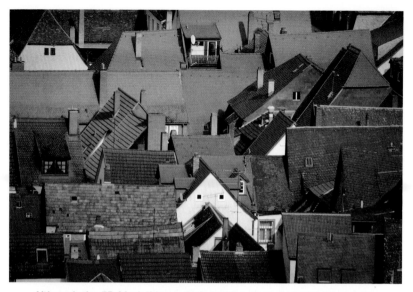

Although the 5D Mark II is equipped with a large, bright LCD monitor for image review, it is often necessary to magnify the image to ensure proper focus, depth of field, highlight or lowlight exposure, and other details that might not be easily seen. Magnify the image using the ⊞/⊕ button to carefully study your work.

Note: In order to rotate the image files on your computer, your software must be able to recognize the rotation data embedded in the image files.

You can decide for yourself if you like this feature; I really don't use it. Sure, the image is upright and you don't have to rotate the camera to view it. The problem is the size of the image. To get that vertical image to fit in the LCD monitor's horizontal frame, the picture is reduced considerably and becomes harder to see. I like to use the second option, **On**. This turns off auto rotate for playing back on the camera, but lets the computer know that the image should be displayed rotated on a computer.

Because you might still be holding the camera in a vertical position when reviewing the image (immediately after taking a picture), auto rotate has no immediate effect on the

image during image review. This helps avoid constantly rotating the camera back and forth while taking multiple vertical images.

Auto rotate must be turned on before you take a picture so the rotate data gets embedded in the image file. If you need to rotate the image because auto rotate was turned off, use the rotate function in the ▣˙ menu.

Note: Auto rotate has no effect when recording video. There really isn't a standard for vertical videos, so unless you have an extremely special application for shooting videos vertically, you should stick with a horizontal shooting mode.

Magnifying the Image

You can make the image larger on the LCD monitor by factors of 1.5x to 10x. This feature can be beneficial in evaluating sharpness and exposure details. Press Enlarge ⊞/⊕ (located on back of the camera in the top right corner) repeatedly to progressively magnify the image. Press Reduce ▦·⊖, located immediately to the left of Enlarge ⊞/⊕, to shrink the magnification. Press Playback ▶ to quickly return to the full-size image.

Use the Multi-controller ⸭ to move the magnified image around within the LCD monitor so you can examine different sections of the picture. The Quick Control dial ◯ moves from one image to another at the same magnified view so, for example, you can compare the sharpness of a particular detail. Just like normal playback, the Main dial ⚙ jumps by a set number of images while keeping the image magnified.

Note: You do not have to be in the Single Image Display to use the magnify feature. For example, if you use the Shooting Information Display with Image Size, press Enlarge ⊞/⊕ to move all the data off the screen and zoom into the image.

Erasing Images

The 5D Mark II's process for erasing photos from the memory card is the same as that used by most digital cameras. When an image is displayed on the LCD monitor, push Erase 🗑 , located below the left corner of the LCD monitor. A screen appears with two options: [Cancel] and [Erase]. Use the Quick Control dial ⊙ to highlight [Erase] and press ⑤ to erase the displayed image. Protected images cannot be erased; they must be unprotected first. You can erase an image during playback or right after exposure, when the image appears in review. (See page 51 for details on using Erase for an extended image preview.)

Note: Once an image is erased, it is gone for good. There is NO undo. Make sure you no longer want an image before making the decision to erase it.

Image Protection

I consider this feature to be one of the most underused and underappreciated functions of a digital camera. At first, it seems like no big deal—why protect your images? You take care of the memory card and promptly download images to the safety of your computer.

But that's not what image protection is about. Its most important function is to allow you to go through your pictures one at a time on the LCD monitor, choosing which ones to keep, or "protect." All the others can be discarded.

Protection is very easy to use. Go to the Playback 1 menu ▶' , select [Protect images], and press ⑤ . The last recorded image displays in the LCD monitor with a key symbol next to the word SET at the top left of the photo. Go through your photos one by one, using the Quick Control dial ⊙ . Push ⑤ for each potential "keeper." An icon of a little key 🔑 appears at the top of the display. To unprotect an image, press ⑤ and the key icon disappears. Press **MENU** to exit Protection.

Once you have chosen the protected images, go to the Playback 1 menu ▣ˑ , select [Erase images] and press ⑤ . Choose [All images on card] (or [folder] if you just want to delete from a folder) and press ⑤ . Use the ◌ to select [OK] and press ⑤ . All the images on the card are erased except the protected ones. You have now performed a quick edit, resulting in fewer photos to deal with when you download to the computer. There is often downtime when shooting. Use it to edit your photos by "protecting" key shots.

Caution: Protecting images does not safeguard them from the "Format" function. When a card is formatted by the camera, ALL of the data on the card is erased.

TV Playback
In order to display your images and movies, the 5D Mark II has both an analog video and audio output, and an HDMI connector. Use the supplied cable for analog output to an analog television. Most HDTVs have an HDMI input. The 5D Mark II uses a mini HDMI connector, so you'll have to purchase an HDMI-to-HDMI mini-cable. You can find this cable at electronics retailers or you can purchase the Canon cable HTC-100. The INFO. button is used to change the format of the HDMI output.

Note: The analog and HDMI outputs cannot be used simultaneously. Also, when you use either video output, the LCD monitor does not operate.

If you travel you may need to change the video system in order to playback onto a television. First, go to the Set-up 2 menu ♎ and select the option for Video system. If you are in North America, be sure to choose [NTSC]. (In many other parts of the world, you need to select [PAL].) Make sure both the camera and television are turned off, and then connect the camera to the TV. Turn the TV on, then the camera. Now press Playback ▶ and the image appears on the TV. The aspect ratio of some televisions is different than the 5D Mark II's, therefore some TVs will cut off an image's edges.

Custom Functions

Like most sophisticated cameras, the 5D Mark II can be customized to fit a photographer's unique wishes and personality. Of course, the selection of exposure modes, type of metering, focus choice, drive speed, Picture Style, and so forth tailor the camera to a specific photographer's needs. However, the 5D Mark II allows for further customization and personalization to help the camera better fit your personality and style of photography. This is accomplished through the Custom Functions menu. While at first the number of custom functions may be overwhelming, learning a few at a time will make the 5D Mark II camera feel like a camera customized to your shooting style.

The 5D Mark II has four different Custom Function groups (C.Fn), numbered I-IV and found in the Custom Function menu ▪️ . Use the Main dial 🎛️ or the Multi-controller ✣ to select the Custom Functions menu ▪️ , then use the Quick Control dial ◯ or the ✣ to highlight the custom function group. Press (SET) to enter the Custom Function group. Once there, use the ◯ to navigate to the desired Custom Function, and press (SET) again. Now that you have chosen the specific Custom Function, use the ◯ again to highlight the option you want and press (SET) to accept the setting. You can use the ◯ to select another function within that group or press **MENU** to exit the custom function group. Before you exit the custom function setting, remember to press (SET) so the camera accepts your custom function setting.

Here is a brief summary and commentary on the various Custom Functions. Note that the first selection in each Custom Function is the camera's default setting. When you look at your camera's menus, the currently selected option is highlighted in blue.

C.Fn I: Exposure Group

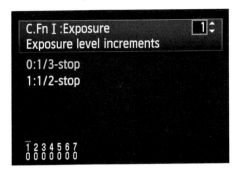

C.Fn I-1 Exposure level increments

This sets the size of incremental steps for shutter speeds, apertures, exposure compensation, flash exposure compensation, and auto exposure bracketing (AEB).

0: 1/3 stop set for shutter speed and aperture, 1/3 stop for exposure compensation and bracketing.

1: 1/2 stop for shutter speed and aperture, 1/2 stop for exposure compensation and bracketing.

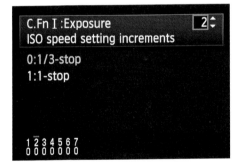

C.Fn I-2 ISO speed setting increments

Like exposure level increments, you can change the ISO speed increment

0: 1/3 stop

1: 1-stop

C.Fn I-3 ISO expansion

This setting allows you to extend the ISO speed range into the expanded ISO values.

0: Off – Normal ISO range of camera, 100-6,400

1: On – Expanded ISO range of camera, 50-25,600

Note: ISO 50 is represented by "L"
 ISO 12,800 is represented by "H1"
 ISO 25,600 is represented by "H2"

C.Fn I-4 Bracketing auto cancel

Used to allow the camera to cancel bracketing on power-off, when camera settings are cleared, when the flash is ready or when bulb exposure is selected. This includes both exposure and white balance bracketing. If this parameter is set to default [0:On], exposure bracketing is also cancelled if a flash is attached to the camera and is set to fire. If set to

[1:Off] and a flash is used, the bracketing is not executed but the amount of bracketing is remembered.

0: On

1: Off

C.Fn I-5 Bracketing sequence

This changes the order of the bracketed shots, both exposure and white balance. Either the first or middle shot is normal exposure. For white balance bracketing, [+] represents amber and green, [–] represents blue and magenta.

0: 0, -, +

1: -, 0, +

C.Fn I-6 Safety shift

Used for difficult exposure situations. If the camera is set for Av or Tv and Option 1 [Enable (Tv/Av)] is selected, during shooting the exposure is adjusted in order to produce proper exposure. For example, if you have selected Option 1 and

you shoot in Tv mode with a 1/125 shutter speed but the lens aperture can't open up to let in enough light, the camera changes the shutter speed in order to achieve a proper exposure.

0: Disable
1: Enable (Tv/Av)

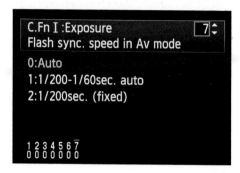

C.Fn I-7 Flash sync. speed in Av mode

Sets the flash sync in aperture priority mode either to automatic adjustment or a fixed setting. When set for default [0:Auto], you can use flash for slow shutter speeds. The slow shutter speeds can cause blurred elements in your scene. Option 1 limits the slow shutter speed to no slower than 1/60 so there is less blurring. To lessen blur even more, option 2 forces the 5D Mark II to always use 1/200 when a flash is attached to the hot shoe and powered up.

0: Auto
1: 1/200-1/60 sec. auto
2: 1/200 sec. (fixed)

C.Fn II: Image Group

C.Fn II-1 Long exp. noise reduction

This setting engages automatic noise reduction for long exposures. When noise reduction is used, the image's processing time is a little more than twice the original exposure. For example, a 20-second exposure takes an additional 20 seconds to complete.

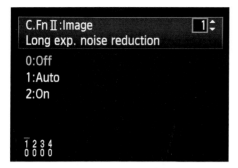

0: Off – Long exposure noise reduction is turned off

1: Auto – Noise reduction is turned on if the exposure is 1 second or longer and noise common to long exposures is detected.

2: On – Noise reduction is turned on for all exposures 1 second or longer.

Note: When the 5D Mark II performs long exposure noise reduction, you can take another picture provided the maximum burst counter in the viewfinder (bottom right) displays the number "1" or higher. When Live View shooting with long exposure noise reduction set to 2, the LCD monitor does not show an image and you cannot take another picture until the noise reduction procedure is complete.

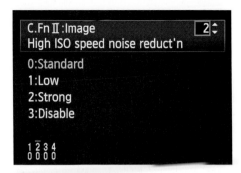

C.Fn II-2 High ISO speed noise reduction

The 5D Mark II normally applies some noise reduction to all images. When you choose higher ISO speeds there will be more noise. Use this setting to increase the amount of noise reduction that is applied to images shot at higher ISO speeds. If you choose "Strong," continuous shooting is not able to capture as many shots in a row (maximum burst).

0: Standard
1: Low
2: Strong
3: Disable

C.Fn II-3 Highlight tone priority

This is one of the 5D Mark II's more interesting features. Enable this option to expand dynamic range near the bright area of the tone curve. When enabled, the ISO speed range is 200-6400.

0: Disable
1: Enable

Note: When highlight tone priority is enabled, the ISO speed setting readouts in the viewfinder and on the LCD panel use small 00's, i.e. [2oo] versus [200].

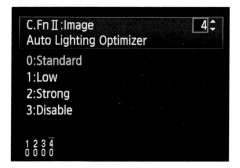

C.Fn II-4 Auto Lighting Optimizer

When enabled, the Auto Lighting Optimizer can help with underexposed images such as those caused by weak flash illumination or backlit subjects. It can also help increase contrast in otherwise flat images. The optimization is applied directly to JPEG images in the 5D Mark II; it is only applied to RAW images when processed with Digital Photo Professional software.

0: Standard
1: Low
2: Strong
3: Disable

C.Fn III: Autofocus/Drive Group

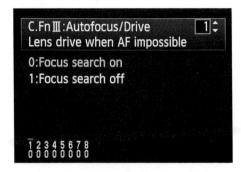

C.Fn III-1 Lens drive when AF impossible

If you use autofocus and the lens keeps hunting for proper focus, this setting lets you stop the camera's attempts to focus. If you use a long lens and autofocus results in an extremely out-of-focus setting, turn focus search off to minimize the problem.

0: Focus search on
1: Focus search off

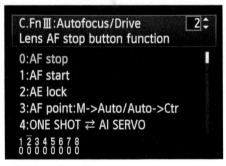

C.Fn III-2 Lens AF stop button function

The AF stop button is found on Canon IS super telephoto lenses.

0: AF stop – button operates normally
1: AF start – auto focus only happens when the AF stop button is pressed (the 5D Mark II cannot start AF)
2: AE lock – locks exposure

3: AF point:M-->Auto/Auto-->Ctr – while in manual AF point selection, when the AF stop button is held down it selects auto AF selection. This is useful when the subject you are tracking with AI Servo AF mode is out of the range of the manually selected AF point. If the camera is already in automatic AF point selection, holding down the AF stop button on the lens selects the center AF point.

4: ONE SHOT/AI SERVO – If you are in One-Shot AF mode, holding down the AF stop button switches the AF mode to AI Servo. If you are in AI Servo it switches to One-Shot.

5: IS start – if lens has stabilization turned on, AF stop button turns on stabilization. (Note: When this setting is used, IS is no longer engaged when the 5D Mark II's shutter is depressed halfway.)

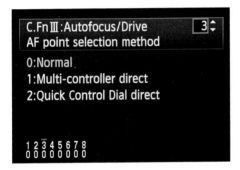

C.Fn III-3 AF point selection method

This function allows you to change how you can select AF points on the 5D Mark II.

0: Normal – this uses ⊞/⊕ to bring up the selection screen, and either ⬭ , ✵ , or ⌂ to select AF point.

1: Multi-controller direct – simply by pressing ✵ you can quickly choose an AF point without having to take your eye away from the viewfinder. To go back to auto AF point selection, press ⊞/⊕.

2: Quick Control Dial direct – by rotating ⬭ you can cycle through all of the AF points. This overrides

the use of ⊙ for exposure compensation when the camera power switch is set for ⌐ , so you'll need to hold down ⊞/⊕ while rotating ⚙ to set exposure compensation.

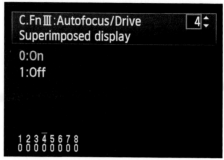

C.Fn III-4 Superimposed display

AF points normally light up red in the viewfinder. Use this function to turn off this feature if you find it distracting.

0: On
1: Off

C.Fn III-5 AF-assist beam firing

Some Canon Speedlights help the 5D Mark II achieve focus by emitting an AF-assist beam when shooting in low light. You can disable this feature with this function. Note that if the Speed-light's AF-assist beam firing is disabled on the Speedlight itself it will override this setting—the AF assist beam is not fired.

0: Enable - The AF-assist beam is emitted whenever appropriate
1: Disable - This cancels the AF-assist beam

C.Fn III-6 Mirror lockup

Mirror lockup is used to minimize camera shake during exposures. This Custom function turns Mirror lockup on or off.

0: Disable – The mirror functions normally
1: Enable – At first press of the shutter the mirror locks up; second press takes the picture and the mirror returns

C.Fn III-7 AF point area expansion

If you have difficulty tracking focus on moving objects, enable this option. Effective in AI Servo AF when the center AF point is selected, AF expansion adds the 6 Assist AF points. Now the camera has 7 AF points to track quickly moving subjects.

0: Disable
1: Enable

C.Fn III-8 AF Microadjustment

The 5D Mark II allows you to further refine the focus system. You can store adjustments for up to twenty different lenses or you can adjust focus for all lenses by the same factor. If you exceed 20 lenses, mount a previously stored lens and zero out the setting before entering the new lens' setting. To microadjust the focus for the currently mounted lens, highlight [Adjust by lens] and press **INFO.**, then use the Quick Control dial ⊙ to adjust the focus backwards or forwards in 20 step increments in each direction and press ⊛ . The amount that each step represents depends on the maximum aperture of the lens. Once set, take a picture and evaluate focus; repeat the procedure to adjust the focus as necessary.

0: Disable
1: Adjust all by same amount
2: Adjust by lens

Note: Clearing all custom functions does not erase the AF microadjustment data; it merely resets the selection to [Disable].

C.Fn IV: Operation/Others Group

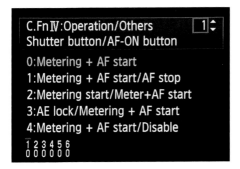

C.Fn IV:Operation/Others [1]↕
Shutter button/AF-ON button

0:Metering + AF start
1:Metering + AF start/AF stop
2:Metering start/Meter+AF start
3:AE lock/Metering + AF start
4:Metering + AF start/Disable
1 2 3 4 5 6
0 0 0 0 0 0

C.Fn IV-1 Shutter button/AF-ON button

With this function you can define how AF start **AF-ON** works with the shutter button. In the options listed below the first half of the option deals with the shutter button, the part after "/" is what AF start **AF-ON** does.

0: Metering + AF start – This is the normal operation. The shutter button, pressed half-way, controls metering and AF. AF start **AF-ON** can still be used before pressing the shutter.

1: Metering + AF start/AF stop – The shutter button starts the metering and AF but you can use AF start **AF-ON** to stop AF.

2: Metering start/Meter + AF start – The shutter starts metering but AF start **AF-ON** starts and stops AF. The shutter button only controls metering.

3: AE lock/Metering + AF start – The shutter button locks in exposure. AF start **AF-ON** turns on metering and auto focus. Useful for separate exposure and focus lock.

4: Metering + AF start/disable – While similar to option 0, this setting disables AF start **AF-ON** completely.

Note: Option 2 is useful when you are dealing with intermittently moving objects while in AI Servo Mode.

C.Fn IV-2 AF-ON/AE lock button switch

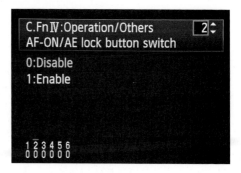

If the location of AE lock ✱ ▣·◌ isn't quite as easy to access while shooting, you can swap functions with AF start **AF-ON**.

0: Disable
1: Enable

Note: This also swaps the function of AE lock during image playback.

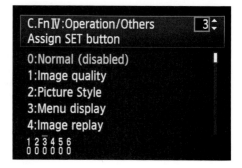

C.Fn IV-3 Assign SET button

This setting assigns different functions to (SET) .

0: Normal (disabled)
1: Image Quality – brings up the Quality selection screen to select Image type (RAW, sRAW, or JPEG, and image size and compression)

150

The 5D Mark II's Custom Function menu enables the camera to be almost completely customized. The user can even change button settings, such as changing the ⊛ button to bring up the Picture Styles menu. Photo © Andre Bergeron

2: Picture Style – brings up the selection screen for Picture Styles

3: Menu display – Same as pressing **MENU**

4: Image replay – acts like Playback ▶

5: Quick Control screen – turns on Quick Control screen (if not on) and enters setting mode where ✧ is used to select settings to be adjusted

6: Record movie (Live View) – immediately puts camera into video recording mode, without first having to engage Live View via ◻ / ⎙ .

Note: If Live View shooting has not been enabled via 🐾 option 6 has no effect on the ⊛ button.

C.Fn Ⅳ:Operation/Others 4
Dial direction during Tv/Av

0:Normal
1:Reverse direction

1 2 3 4 5 6
0 0 0 0 0 0

C.Fn IV-4 Dial direction during Tv/Av

When option 1 is selected, in Manual mode **M** both the Main dial and the Quick Control dial operate in reverse directions. In other exposure modes for exposure compensation, the Quick Control dial operates in the normal direction and the Main dial is reversed.

0: Normal
1: Reverse direction

C.Fn Ⅳ:Operation/Others 5
Focusing Screen

0:Eg-A
1:Eg-D
2:Eg-S

1 2 3 4 5 6
0 0 0 0 0 0

C.Fn IV-5 Focusing Screen

When you change focusing screens you have to let the 5D Mark II know what type of focus screen has been installed— the focus screen does not do it for you. See page 250 for more information about focus screens.

0: Eg-A (standard focusing screen)
1: Eg-D (focusing screen with grid)
2: Eg-S (Super Precision Matte screen)

152

C.Fn IV-6 Add original decision data

This function is used with the Original Data Security Kit OSK-E3. When turned on, the captured image is embedded with verification data. 🔒 is displayed during image review and playback if the LCD monitor has been set for using the Shooting Information Display (page 130).

0: Off
1: On

The last option on the Custom Function menu allows you to clear all custom functions. To clear all custom functions, highlight [Clear all Custom Func. (C.Fn)] and then press ⓈⒺⓉ . Use ⊙ or ✥ to highlight [OK] and then press ⓈⒺⓉ . When you clear all custom functions you reset all of them to default except for the focus screen setting—C.Fn IV-5. Although the data for AF microadjustment (C.Fn III-8) is not cleared, the function is disabled.

Camera Operation Modes

The 5D Mark II is a highly sophisticated and, in many ways, amazing digital camera. The innovations in design and technology that have been incorporated into this camera become evident as soon as you begin to operate its various systems and utilize its many functions. From tracking focus on moving subjects, to shooting multiple frames per second, to capturing great exposures in low light, the 5D Mark II is a well-engineered instrument, which will help you take extraordinary photographs.

Note: Live View operations, including video recording, are covered in the next chapter, starting on page 195.

Focus

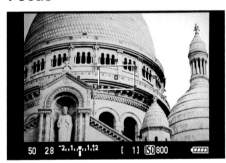

The 5D Mark II's AF system has nine visible sensors and six focus-assist points, as well as a cross-type sensor.

The 5D Mark II uses an AI (artificial intelligence) autofocus (AF) system based on a precision autofocus sensor system. The nine visible sensors are coupled with six focus-assist points, for a total of 15 AF points. The center AF point is the

↶ *Finding accurate focus in dark or dimly lit situations can be difficult, but Canon has designed a professional focusing system that can handle a variety of challenging shoots.*

most accurate. It is a cross-type sensor, meaning that it is sensitive to both horizontal and vertical details when used with a lens that is faster than f/5.6. The other eight AF points are sensitive to either horizontal or vertical edges. If you use a lens that is f/2.8 or faster, the center AF point is twice as sensitive as the other eight AF points.

The center AF point is located within the spot-metering circle visible in the viewfinder and the focus-assist points are arranged around it. The focus-assist points combine with the center focus point to turn the center of the viewfinder into a highly sensitive AF area. AF assist points function only during AI Servo AF.

Note: Although the 5D Mark II can display the regular AF points in the viewfinder, it can't display the focus-assist points. You can use Canon's software, ZoomBrowser EX (Windows) or ImageBrowser (Mac) to display all the AF points used to capture the image.

Microadjustment
In addition to using multiple AF points, focus micro adjustments can fine-tune AF in 20 steps in front of and 20 steps in back of the focus point. Micro adjustments for up to 20 individual lenses can be stored in the 5D Mark II's custom functions (see page 148 to read more about C.Fn III-8 AF Microadjustment). Every time you change lenses, the 5D Mark II recalls the appropriate focus micro adjustment setting for that lens model (it cannot recognize serial numbers). Extenders are recognized too. For zoom lenses, it is best to set the focus micro adjustment at the telephoto range of the lens.

The AF points work with an EV (exposure value) range of EV –0.5 to 18 (at ISO 100/73F), and are superimposed in the viewfinder. They can be used automatically (the camera selects them as needed), or you can choose one manually. AF modes are selected by the photographer and include One-Shot AF **ONE SHOT**, Predictive AI Servo AF **AI SERVO**, AI Focus AF **AI FOCUS** (which automatically switches between **ONE SHOT** and **AI SERVO**), and manual focus **MF** modes.

The 5D Mark II's AF microadjustment custom function (C.Fn III-8) allows the user to refine the focus system, storing adjustments in 20 step increments for individual lenses, improving focus quality and precision. Photo © Marianne Skov Jensen

The 5D Mark II has the ability to quickly employ statistical prediction while using multiple focusing operations to follow even an erratically moving subject. And yet, if the subject is not moving, the AI Servo AF focus control is notably stable—it will not allow the lens to change focus at all until the subject moves again.

New to the 5D Mark II is an AF Start button AF-ON that can start the AF process, metering, or both. Previously this was accomplished by changing the function of the AE lock button via custom functions; now there is a dedicated button.

When light levels are low, the camera activates AF-assist with any Canon Speedlite that can emit an AF-assist beam. The 580EX II Speedlite includes a powerful AF-assist beam, effective up to 33 feet (10.1 meters).

AF Modes

Choose the AF mode according to the subject you intend to photograph. Stationary subjects are best shot with One-Shot AF, while moving subjects might require AI Servo AF.

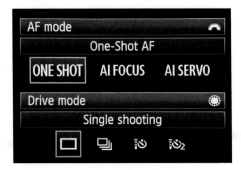

The camera has three AF modes, in addition to manual focus: One-Shot AF (AF stops and locks when focus is achieved, one shot at a time), AI Servo AF (which tracks subject movement and focuses continuously until the exposure is made), and AI Focus (which automatically switches between One-Shot AF and AI Servo AF).

Select the AF mode by pressing the AF mode selection button AF·DRIVE. Then, while viewing the LCD panel on the top of the camera or the LCD monitor on the back, use the Main dial to select from **ONE SHOT**, **AI FOCUS**, or **AI SERVO**. Press AF·DRIVE or lightly tap the shutter release to exit the AF selection mode.

Note: You can also set the AF mode using the Quick Control screen. With the shooting settings displayed on the LCD monitor, press and use it to highlight the current AF mode. Next, use the Quick Control dial or the Main dial to scroll through the AF mode options, or press to bring up the AF options. Use either or to make your selection, then tap the shutter release or to exit.

Each auto focus mode is used for different purposes:

- **One-Shot AF ONE SHOT:** This AF mode finds and locks focus when you press the shutter button halfway. Perfect for stationary subjects, it allows you to find and hold focus on

the important part of a subject. If the camera doesn't hit the right spot, simply change the framing slightly and press the shutter button halfway again to lock focus. Once you have found and locked the focus, you can move the camera to set the proper composition. The focus confirmation light glows steadily in the viewfinder when you have locked focus, and blinks when the camera can't achieve focus. Since this camera focuses very quickly, a blinking light is a quick reminder that you need to change something (you may need to focus manually).

- **AI Servo AF AI SERVO:** Great for action photography where subjects are in motion, AI Servo AF becomes active when you press the shutter button down halfway, but it does not lock focus. It continually looks for the best focus as you move the camera or as the subject travels through the frame. It is really designed for moving subjects, as both the focus and exposure are set only at the moment of image capture. This can be a problem when used for motionless subjects because the focus continually changes, especially if you are handholding the camera. If you use AI Servo AF on a moving subject, however, it is a good idea to start the camera focusing (depressing the shutter halfway) before you actually need to take the shot so the system can find the subject.

- **AI Focus AI FOCUS:** This mode allows the camera to choose between One-Shot and AI Servo. It can be used as the standard setting for the camera because it switches automatically from One-Shot to AI Servo if your subject should start to move. Note, however, that if the subject is still (like a landscape), this mode might detect other movement (such as a blowing tree), so it may not lock on the non-moving subject.

- **Selecting an AF Point:** You can have the camera select the AF point automatically, or you can use the Quick Control dial ○ , the Main dial 🗘 , or the Multi-controller ✤ to select a desired point manually. Manual AF point selection is useful when you have a specific composition in mind and the camera won't focus consistently where you want it. To manually select an AF point, simply push the AF point selection button ⊞/⊕ on the

upper right corner of the camera's back, and use the ⚙ or ◯ to rotate through the AF points. Points light up in the viewfinder as they are selected. As you scroll through the points, there is one selection where all of the points light up—this means that the camera picks the AF point. When you use the ✜ you can choose the AF points more quickly by pressing the control in the direction of the AF point you want to select. If you press ✜ twice in the same direction, it highlights all the points. At any time you can press the ✜ straight down to toggle between the center AF point and automatic selection.

You can return to shooting mode at any time during AF point selection by pressing the shutter release button half way or by pressing the AF mode selection button. You do not need to press ⑤ET to have the camera accept your selection.

Custom function group III is dedicated to adjusting focus operations (see page 144). Set Custom Function III-3 so you do not have to press AF•DRIVE before selecting the AF point with either ✜ or ◯ . Custom Function III-4 lets you turn off the viewfinder display of AF points. Use Custom Function III-8 to make microadjustments to the accuracy of autofocus on a lens-by-lens basis. With Custom Function III-7 you can take advantage of AF point expansion using AF assist points.

- **AF Limitations:** AF sensitivity is high with this camera. The 5D Mark II can autofocus in conditions that would be quite challenging for other cameras. Still, as the maximum aperture of lenses decreases, or tele-extenders are used, the camera's AF capabilities change. AF works best with f/2.8 and faster lenses.

It is possible for AF to fail in certain situations, requiring you to focus manually. This is most common when the scene is low-contrast or has a continuous tone (such as sky), conditions of extremely low light, strongly backlit subjects, and compositions that contain repetitive patterns. A quick way to

deal with these situations is to focus on something else at the same distance, lock focus on it (by keeping the shutter released pressed halfway), then move the framing back to the original composition. This only works while the camera is in One-Shot AF mode.

Drive Modes and the Self-Timer

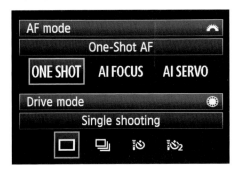

Choosing a Drive mode on the 5D Mark II is simple: press the AF·DRIVE *button and use the ⊙ to make the selection.*

The term "drive" comes from film cameras where profes-sional SLRs had an option to advance the film and reset the shutter with a motor drive. Even though the film is gone, mechanics are still needed in any digital SLR. The 5D Mark II offers several drive modes: Single ☐ , Continuous ⚏ , and two timers – a 10-second ⏱ and a 2-second ⏱₂ Self-timer. Select these by pressing the Drive mode selection button AF·DRIVE on the top right of the camera and use the ⊙ to choose a drive mode, as shown on the LCD panel or the LCD monitor.

Note: You can also set the Drive mode using the Quick Con-trol screen. With the shooting settings displayed on the LCD monitor, press ✛ and use it to highlight the current Drive mode. Next, use ⊙ or ⚙ to scroll through the Drive mode options, or you can press ⊛ to bring up the Drive options. Use either ⊙ or ⚙ to make your selection, then tap the shutter release or ⊛ to exit.

The Single drive mode ☐ is the standard shooting mode. One image is captured each time you press the shutter release.

The Continuous shooting mode ⊡ , coupled with the DIGIC 4 processor, offers high-speed shooting at 3.9 images per second. Note that shooting speed is dependent on shutter speed. The number of images that can be captured in a row—maximum burst—is highly dependent on the image size, format, memory card size, memory card speed, JPEG quality, picture style, ISO speed, and other factors, but the 5D Mark II can take 14 RAW images in a row when using a UDMA card. When you shoot JPEG you can just about keep shooting until the card is full.

The self-timers offer two-second ⏱☉2 and ten-second ⏱☉ delays. They can be used in any situation where you need a pause between the time you press the shutter button and the time the camera actually fires. The two-second timer ⏱☉2 helps when you shoot slow shutter speeds on a tripod and can't (or don't want to) use a cable release. The delay allows camera vibrations to settle down before the shutter goes off. For the best isolation from camera vibrations, also use the mirror lock up custom function (see page 147).

The self-timer icons include a remote icon ⏱ . When you use a Canon wireless remote, RC-1 or RC-5, choose one of these modes. ⏱☉2 delays the shutter release for two seconds after you press the button on either wireless remote. ⏱☉ has no delay when you use the RC-1. It is important to remember that the only way to cancel the self-timer once it has started counting down is to press AF•DRIVE.

Note: Since neither wireless remote has an AF-ON button, the AF modes do not work in Live View when you use a wireless remote. (See page 195 for more on Live View operation.)

The self-timer is helpful in situations where you must use a slow shutter speed to capture the proper exposure, are on a tripod, or you don't want camera shake that might accompany pressing the shutter button, such as for the above image.

Note: If you use the timers so you can be away from the camera when the picture is taken, make sure you engage the eyepiece shutter lever on the upper right of the viewfinder eyepiece. This covers the viewfinder eyepiece and prevents light from entering it. Otherwise stray light entering the viewfinder may cause improper metering and lead to poor exposure.

Exposure

No matter what technology is used to create a photo, it is always preferable to have the best possible exposure. Digital photography is no exception. A properly exposed digital file is one in which the right amount of light reaches the camera's sensor and produces an image that corresponds to the scene, or to the photographer's interpretation of the scene. This applies to color reproduction, as well as tonal values, and subject contrast.

ISO

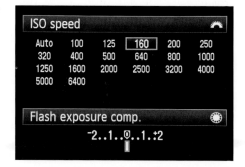

The first step in getting the best exposure with film cameras was setting the ISO film speed. This provided the meter with information about the film's sensitivity to light, so it could determine the proper exposure for the image. Digital cameras adjust the "apparent" sensitivity of the image sensor to settings that can be compared to film of the same ISO speed. (The change in sensitivity actually involves amplifying the electronic sensor data that creates the image.)

The 5D Mark II offers ISO sensitivity settings of 100-6,400 that can be expanded to 50-25,600 by using Custom Function I-3. The expanded ISO setting is not a free ride. When set for L (ISO 50), the ISO setting reduces the 5D Mark II's dynamic range. When set for H1 (ISO 12,800) or H2 (ISO 25,600) additional noise is present in the image. Additional noise reduction can be engaged when the 5D Mark II is set for high ISO by using Custom Function II-2.

ISO is one control worth knowing so well that its use becomes intuitive. It can be set quickly by pressing the ISO·⚡ button, just behind the shutter release button, and then using the Main dial 📷 to change the setting. The LCD monitor shows all of the ISO speed options, and the LCD panel also displays the setting. The ISO speed is also displayed in the viewfinder during ISO speed selection and while shooting, so you can adjust ISO speed without taking your eye from the viewfinder.

Note: You can also set the ISO speed using the Quick Control screen. With the shooting settings displayed on the LCD monitor, press ✷ and use it to highlight the current ISO setting. Then use ◯ or ◠ to scroll through the ISO options, or you can press ⓢⓔⓣ to bring up the ISO options and then use either ◯ or ◠ to make your selection. Tap the shutter release or press ⓢⓔⓣ to exit.

Since sensitivity to light is easily adjusted using a digital SLR and since the 5D Mark II offers clean images with minimal to no noise at any standard setting, use ISO freely to adapt rapidly to changing light conditions.

Low ISO settings give the least amount of noise and the best color (with the exception of the expanded ISO L setting). Traditionally, film increased in grain and decreased in sharpness with increased ISO. This is not entirely true with the 5D Mark II because its image is extremely clean. Some increase in noise (the digital equivalent of grain) is apparent as the higher ISO settings are used, but it is minimal until the higher settings of 800 and higher are chosen. Little change in sharpness is seen. Even the settings of 800 and higher offer very good results. This opens your digital photography to new possibilities to use slow lenses (lenses with smaller maximum lens openings, which are usually physically smaller as well) and in shooting with natural light.

By default, the ISO settings occur in 1/3-stop increments (100, 125, 160, 200, and so on). Use Custom Function I–2 to change the ISO steps to 1 stop (100, 200, 400 etc.). Several key ISO settings are: 100 to capture detail in images of nature, landscape, and architecture; 400 and 800 when more speed is needed, such as handholding for portraits when shooting with a long lens; and 1600 and higher when you really need a lot of speed under low-light conditions.

If you use highlight tone priority, Custom Function II-3, to increase detail in bright areas of the image, the ISO range shortens to 200-6,4000. This is the case even if you have selected ISO expansion with Custom Function I-3.

There is one more ISO speed setting that is not a speed but a range of speeds that the 5D Mark II sets automatically. When the ISO speed is set to Auto and the exposure mode is anything but **M** or **B** , the camera chooses an ISO speed from a range of 100-3,200. With **M** or **B** exposure mode, the ISO is set for 400. The selected ISO speed is displayed when you press the shutter release button halfway.

Exposure Metering

The 5D Mark II's four metering modes each process the information hitting the sensor differently in an effort to achieve the best possible exposure.

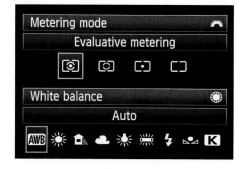

In order to produce the proper exposure, the camera's metering system has to evaluate the light. However, even today there is no light meter that produces a perfect exposure in every situation. Because different details of the subject reflect light in different amounts, the 5D Mark II's metering system has been designed with microprocessors and special sensors that give the system optimum flexibility and accuracy in determining exposure.

The camera offers four user-selectable methods of measuring light: Evaluative ⊚ , Partial ⊙ , Spot ⊡ , and Center-Weighted average ☐ . To select a metering mode, press ⊚·WB, then use the Main dial 🕮 to make the selection, viewing either the LCD panel on the top of the camera or the LCD monitor. When the metering mode is selected, press ⊚·WB or tap the shutter button to exit.

For an evenly-lit subject that fills the frame—no bright highlights or dark lowlights that could throw the exposure reading off—then the Center-Weighted average mode is a good metering selection.

Note: When the 5D Mark II is set for one of its two fully automatic modes, ☐ or CA , Evaluative metering is automatically chosen.

Note: You can also set the metering mode using the Quick Control screen. With the shooting settings displayed on the LCD monitor, press ⁙ and use it to highlight the current metering mode. Use ◯ or ⚙ to scroll through the Metering mode options, or you can press (SET) to bring up the metering options and then use either ◯ or ⚙ to make your selection. Tap the shutter release or (SET) to exit.

Evaluative Metering ◉

The 5D Mark II's Evaluative metering system divides the image area into 35 zones, "intelligently" compares them, and then uses advanced algorithms to determine exposure. Basically, the system evaluates and compares all the metering

zones across the image, noting things like the subject's position in the viewfinder (based on focus points and contrast), brightness of the subject compared to the rest of the image, backlighting, and much more. These zones come from a grid of carefully designed metering areas that cover the image frame, though there are fewer at the edges.

As with all Canon EOS cameras, the 5D Mark II's Evaluative metering system is linked to Autofocus. The camera actually notes which autofocus point is active and then emphasizes the corresponding metering zones in its evaluation of the overall exposure. If the system detects a significant difference between the main point of focus and the different areas surrounding this point, the camera automatically applies exposure compensation. (It assumes the scene includes a backlit or spot-lit subject.) However, if the area around the focus point is very bright or dark, the metering can be thrown off and the camera may underexpose or overexpose the image. When your lens is set to manual focus, Evaluative metering uses the center autofocus point.

It is difficult to capture perfect exposures when shooting extremely dark or light subjects, subjects with unusual reflectance, or backlit subjects. Because the meter theoretically bases its analysis of light on an average gray scene, when subjects or the scene differ greatly from average gray, the meter tends to overexpose or underexpose them. Luckily, you can check exposure information in the viewfinder, or check the image itself on the LCD monitor, and make adjustments as needed.

Note: With Evaluative metering, after autofocus has been achieved, exposure values are locked as long as the shutter button is partially depressed. If the lens is set for manual focus, however, meter readings cannot be locked in this manner. In that case, use the AE lock button ✱ .

The main advantage of Evaluative metering over Partial and Center-Weighted average metering is that the exposure is biased toward the active AF point, rather than the center

of the picture. Evaluative metering is also the only metering mode that automatically applies exposure compensation based on comparative analysis of the scene.

During flash photography the E-TTL II system makes use of the 35-zone metering sensor. Lens distance information is also used to calculate proper exposure.

Partial Metering ⊡

Partial metering covers about 8% of the frame on the 5D Mark II, using the exposure zone at the center of the viewfinder. This enables the photographer to selectively meter portions of a scene and compare the readings in order to select the right overall exposure. This can be an extremely accurate way of metering, but it requires some experience to do well. It is useful when shooting with strongly lit backgrounds. When you shoot with a telephoto lens, Partial metering acts like Spot metering.

Spot Metering ⊡

Use the Spot metering mode to further reduce the size of the metered area. In this mode, metering is weighted to the center area of the viewfinder, about 3.5% of the viewfinder. The circle you can see in the viewfinder indicates the area of the image covered. With difficult exposure situations you can use AE lock to take a spot meter reading and then reframe your composition and take the shot.

Center-Weighted Average Metering ⊡

Center-weighted average metering averages the reading taken across the entire scene. In computing the "average exposure," however, the camera puts extra emphasis or "weight" on the center of the frame. Since most early traditional SLR cameras used this method exclusively, some photographers have used Center-weighted average metering for such a long time that it is second nature and they prefer sticking with it. Others occasionally find it useful with scenes that change quickly around the subject.

To ensure proper exposure, you must also be attentive to the viewfinder eyepiece. This may sound odd, but if you shoot a long exposure on a tripod and do not have your eye to the eyepiece, there is a good possibility your photo will be underexposed. The 5D Mark II's metering system is sensitive to light coming through an open eyepiece. To prevent this, Canon has included an eyepiece shutter lever on the upper right of the viewfinder eyepiece. Engage this lever to cover the eyepiece, eliminating the problem of stray light entering the viewfinder.

Judging Exposure

The LCD monitor allows you to get an idea of your photo's exposure. In this way it's like using a Polaroid, although not as accurate. With a little practice, however, you can use this small image to evaluate your desired exposure. Recognize that it only gives an indication of what you will actually see when the images are downloaded into your computer (because of the monitor's calibration, size, and resolution).

The 5D Mark II includes two features, the Highlight alert and the histogram, that give you a good indication of whether or not each exposure is correct. These features can appear on the LCD monitor once an image is displayed there. Push **INFO.** repeatedly to cycle through a series of four displays. The display modes are: single image display; single image display with image size information and current/total number of images captured; shooting information display with histogram and extensive metadata about the image; and dual histogram display that combines the brightness histogram and RGB histogram.

Highlight Alert: The camera's Highlight alert is very straightforward. Overexposed highlight areas blink on the image displayed on the LCD monitor. These areas have so much exposure that only white is recorded, no detail. Although Highlight alert is useful to see what highlights are getting blown out, some photographers find the blinking a distraction.

Also, the alert is subject to interpretation—blinking highlights are simply information, and not necessarily bad. In some cases it may be necessary to let less important areas of a scene become washed out so that the most important parts of the subject are exposed correctly. However, if you discover that significant parts of your subject blink, the image is likely overexposed and you need to reduce exposure in some way. Turn on highlight alert using the Playback 2 menu ▣⁝ .

The Histogram: The 5D Mark II's histogram, though small, is an extremely important tool for the digital photographer. It is the graph that appears on the LCD monitor next to the image when selected with **INFO.** during review or playback. The 5D Mark II can display two different kinds of histogram: brightness and RGB. The brightness histogram allows you to judge the overall exposure of the image, while the RGB histogram focuses on the individual color channels.

The horizontal axis of the histogram represents the level of brightness—dark areas are at the left, bright areas are at the right. The vertical axis indicates the pixel quantity for the different levels of brightness. If the graph rises as a slope from the bottom left corner of the histogram and then descends towards the bottom right corner, all the tones in the scene are captured.

Consider the graph from left to right (dark to bright). If the graph starts too high on either end (for example, the histogram of a dark, shadowed subject on a bright, sunny day may appear as a slope that is cut off abruptly on one or both sides), the sensor was incapable of handling the areas darker or brighter than those points. The exposure data is cut off or "clipped" at the ends. Sometimes the histogram may be weighted towards either the dark or bright side of the graph (wider, higher "hills" appear on one side or the other). This is okay if the subject is mostly dark or bright, but if it is not, detail may be lost. The dark sections of your photo may fade to black (with increased noise), and brighter sections may appear completely washed out.

If highlights are important, be sure the slope on the right reaches the bottom of the graph before it hits the right side. If darker areas are important, be sure the slope on the left reaches the bottom before it hits the left side. At first, if you have trouble remembering which side is dark or light and you notice an unbalanced graph, just give the scene a change of exposure and observe which way the histogram changes. This is a really good way to learn to read and work with the histogram.

Some scenes are naturally dark or light. In these cases, most of the graph will be on the left or right, respectively. However, be careful of dark scenes that have all the data in the left half of the histogram. Such underexposure tends to overemphasize any sensor noise present. You are better off increasing the exposure, even if the LCD image looks bright enough. You can always darken the image in the computer, which will not tend to affect noise; however, lightening a very dark image usually has an adverse effect and results in added noise.

If the scene is low in contrast and the histogram is a rather narrow hill in the middle of the graph, change the 5D Mark II's Picture Style. In this case, boosting contrast will expand the histogram. Also, you can create a custom Picture Style setting with contrast change and tonal curve adjustments that consistently addresses such a situation. This can mean better information is captured—it is spread out more evenly across the tones—before the image is downloaded into your computer for image processing. In addition, this type of histogram is a good indicator of when to shoot using RAW. Results are best in RAW when the data has been stretched to make better use of the tonal range from black to white.

With the RGB histogram, you can check to see if any of the color channels is over-saturated. Similar to the Brightness histogram, the horizontal scale represents each color channel's brightness level. If more pixels are on the left, the color is less prominent and darker; to the right, the color is brighter and denser. If the histogram shows an abrupt cut-off

on either end of the histogram, the color information is either missing or over-saturated. In short, by checking the RGB histogram you evaluate the color saturation and white balance bias.

Exposure Modes

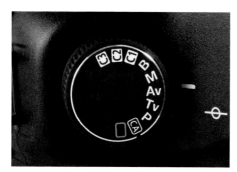

With the 5D Mark II, you can choose your level of control over the camera settings with the Mode dial.

The exposure modes offer control over camera exposure adjustments and thus encourage a more creative approach to photography. The disadvantage is that there are many possible adjustments, which is confusing at worst and time consuming at best. Exposure modes are set using the Mode dial on the upper left of the camera. The exposure mode choices are Program AE **P** , Shutter-Priority **Tv** , Aperture-Priority **Av** , Bulb **B** , and Manual Exposure **M** . There are two additional choices that control more than just exposure: Full Auto **□** , and Creative Auto **CA** . Lastly there are three Camera User settings that allow you to store a camera setup for quick recall.

Remember that **B** , **M** , **Av** , **Tv** , and **P** are strictly exposure modes. Settings like white balance, file type (RAW or JPEG), metering method, focus method, Picture Styles, ISO speed, and Drive mode still need to be set.

Program AE P

In Program AE (autoexposure), the 5D Mark II chooses the shutter speed and aperture combination. This gives the photographer less direct control over the exposure because the exposure settings are chosen arbitrarily (by the camera, not by you). However, you can "shift" the program by changing either the selected aperture or shutter speed, and the system will make a corresponding adjustment to the other setting in order to maintain the same exposure value. To shift the program, simply press the shutter button halfway to turn on the meter, then turn the Main dial � until the desired shutter speed or aperture value (respectively) is displayed on the LCD monitor or viewfinder. This "program shift" works for only one exposure at a time, making it useful for quick-and-easy shooting while retaining some control over camera settings. Program shift does not work with flash.

Note: Since the camera controls the exposure, you can't change the shutter speed without it affecting the aperture. So if you start with a shutter speed of 1/160 and an aperture of f/8, when you rotate � to the left you will change the shutter to 1/125. But the aperture will also change, in this case to f/10. In Program AE the 5D Mark II always balances a change in shutter speed with a change in aperture. In truth, when you rotate �, the parameter you change is the one that you are paying attention to! In other words, if you look at the aperture value when you rotate � you're changing the aperture; if you look at shutter speed you are changing that. Of course, in reality, you are changing both.

Program AE mode selects shutter speed and aperture values "steplessly." This means that any shutter speed or aperture within the range of the camera and lens is selected, not just those that are the standard full steps, such as 1/250 second or f/16. This has been common with most SLRs (both film and digital) for many years and allows for extremely precise exposure accuracy, thanks to the lens' electromagnetically controlled diaphragm and the camera's electronically timed shutter.

Shutter-Priority Tv

Tv stands for "time value" if that helps you remember the terminology. With this mode, you set the shutter speed (using the Main dial 🖱) and the camera sets the aperture. If you want a particular shutter speed for artistic reasons—perhaps a high speed to stop action or a slow speed for a blur effect—this is the setting to use. In this mode, even if the light varies, the shutter speed will not. The camera keeps up with changing light by adjusting the aperture automatically. If the aperture indicated in the viewfinder, the LCD panel or the LCD monitor is consistently lit (not blinking), the built-in camera exposure metering has picked a useable aperture. If the maximum aperture (lowest number) blinks, it means the photo will be underexposed and you need to select a slower shutter speed by turning the 🖱 until the aperture indicator stops blinking. (You can also remedy this by increasing the ISO setting.) If the minimum aperture (highest number) blinks, this indicates overexposure. In this case, set a faster shutter speed until the blinking stops, or choose a lower ISO setting.

Note: You can use the Quick Control screen to set shutter speed. With the shooting functions display visible on the LCD monitor, press straight down on ✜ . Then use ✜ like a joystick to highlight the current shutter speed. With shutter speed highlighted, use either ◉ or 🖱 to scroll through the shutter speed values. To exit, lightly tap the shutter release button or wait for the Quick Control screen to "time out." It is not necessary to press ⑤ to accept the selection.

The 5D Mark II offers a choice of speeds, from 1/8000 second up to 30 seconds (in Bulb mode) in 1/3-stop increments (1/2 stop increments with Custom Function I-1, see page 137). For flash exposures, the camera syncs at 1/200 second or slower. This is important to know, since slower shutter speeds can pick up ambient or existing light in a dimly-lit scene.

Let's examine the 5D Mark II's shutter speeds by designating them "fast," "moderate," and "slow." (These divisions are arbitrarily chosen, so speeds at either end of a division can really be designated into the groups on either side of it.)

Fast shutter speeds are 1/500-1/8000 second. It wasn't all that long ago that most film cameras could only reach 1/1000 second, so having this range of high speeds on a digital SLR is quite remarkable. The obvious reason to choose these speeds is to stop action. The more the action increases in pace or the closer it crosses directly in front of you, the higher the speed you need. As mentioned previously, the neat thing about a digital camera is that you can check your results immediately on the LCD monitor to see if the shutter speed has, in fact, frozen the action.

At these fast speeds, camera movement during exposure is rarely significant unless you try to handhold a super telephoto lens of 600mm (not recommended!). This means with proper handholding technique, you can shoot using most normal focal lengths (from wide-angle to telephoto up to about 300mm) with few problems from camera movement. One rule of thumb for handholding is to use a shutter speed that is the reciprocal of the focal length of the lens. For example with a 200mm lens, use a 1/200 shutter speed (or faster). But this might not work for everybody and in every situation. If you just climbed a steep grade or had several cups of coffee you might not be able to get a steady shot, even with a longer shutter speed.

Note: When using Canon's Image Stabilization lenses (IS) you can use slower shutter speeds for hand-held shots.

Besides stopping action, another important use of the high shutter speeds is to allow you to use your lens at its wide openings (such as f/2.8 or f/4) for selective focus effects (shallow depth-of-field). In bright sun, for example, you might have an exposure of 1/200 second at f/16 with an ISO setting of 200. You can get to f/2.8 by increasing your speed by five whole steps of exposure, to approximately 1/4000 second.

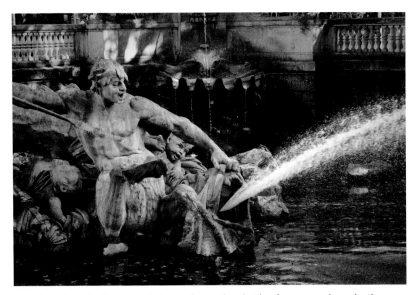

A faster shutter speed slows the action in the frame, such as in the above example. Compare this image to the one on page 178 to see the effect of fast vs. slow shutter speeds.

Moderate shutter speeds (1/60-1/250 second) work for most subjects and allow a reasonable range of f/stops to be used. They are the real workhorse shutter speeds, as long as there's no fast action. You have to be careful when hand-holding cameras at the lower end of this range—especially with telephoto lenses—or you may notice blur in your pictures due to camera movement during the exposure. Many photographers find that they cannot handhold a camera with moderate focal lengths (50-150mm) at shutter speeds less than 1/125 second without some degradation of the image due to camera movement. You can double-check your technique by taking a photograph of a scene while handholding the camera and comparing it to the same scene shot using a tripod.

A slower shutter speed allows the water to blur across the screen and depict movement, as opposed to the example on page 177 where the faster shutter speed freezes the water.

Slow shutter speeds (1/60 second or slower) require something to stabilize the camera. Some photographers may discover they can handhold a camera and shoot relatively sharp images at the high end of this range. Most, however, cannot get optimal sharpness from their lenses at these speeds without a tripod or some other stabilizing method. Slow shutter speeds are used mainly for low-light conditions and to allow the use of smaller f/stops (higher f/stop numbers) under all conditions.

A fun use of very slow shutter speeds (1/8 – 1/2 second) is to photograph movement, such as a waterfall or runners, or to move the camera during exposure, such as panning it across a scene. The effects are quite unpredictable, but practice and image review using the LCD monitor help. You can try different shutter speeds and see what they look like. This helps when you try to choose a slow speed appropriate for the subject because each speed blurs action differently.

You can set slow shutter speeds (up to 30 seconds) for special purposes such as capturing fireworks or moonlit landscapes. Canon has engineered the sensor and its accompanying circuits to minimize noise (a common problem of long exposures with digital cameras) and the 5D Mark II offers remarkable results with these exposures.

Note: In contrast to long film exposures, long digital exposures are not susceptible to reciprocity failure. The reciprocity effect comes with film because as exposures lengthen beyond approximately one second (depending on the film), the sensitivity of the film declines, resulting in the need to increase exposure to compensate. A metered 30-second film exposure might actually require double or triple that time to achieve the effect that is desired and may also result in inaccurate color rendition. Digital cameras do not have this problem. A metered exposure of 30 seconds is all that is actually needed.

Aperture-Priority Av

When you select **Av** (aperture value), you are in Aperture-Priority AE mode. In this autoexposure mode, you set the aperture—the f/stop or lens opening—using 🔆 and the camera selects the shutter speed for a proper exposure. This is one of the more popular automatic exposure settings among professional photographers.

Note: You can use the Quick Control screen to set aperture, too. With the shooting functions display visible on the LCD monitor, press straight down on ✛ . Then use ✛ like a joystick to highlight the current aperture. Once the aperture is highlighted, use either ◎ or 🔆 to scroll through the aperture values. To exit, lightly tap the shutter release button or wait for the Quick Control screen to "time out." It is not necessary to press (SET) to accept the selection.

Controlling depth of field is one of the main reasons photographers use Aperture-Priority AE mode. (Depth of field is the distance in front of and behind a specific plane of focus that is acceptably sharp.) While the f/stop, or aperture,

179

affects the amount of light entering the camera, it also has a direct effect on depth of field. A small lens opening (higher f/number) such as f/11 or f/16 increases the depth of field in the photograph, bringing objects in the distance into sharper focus when the lens is focused appropriately. Higher f/numbers are great for landscape photography.

Note: While small apertures get you a larger depth of field, there are still some distinct disadvantages. As the aperture opening gets smaller and smaller, diffraction leads to an overall softness of the picture. Many photographers stay away from the smallest apertures (f/22 and higher). Try taking some test shots that have lots of detail at various f/stop settings and then evaluate the image sharpness on the computer.

A wide lens opening with low f/numbers such as f/2.8 or f/4 decreases the depth-of-field. These lower f/numbers work well when you want to take a photo in which a sharp subject is portrayed against a soft, out-of-focus background. When you adjust aperture, if the shutter speed blinks in the viewfinder (or on the LCD panel or LCD monitor), it means the aperture setting you have selected requires a shutter speed that is beyond the range of the 5D Mark II. In other words, good exposure is not possible at that aperture. You must change either the aperture or the ISO speed setting.

You can see the effect of the aperture setting on the image by pushing the Depth-of-field preview button on the camera (located on the front of the lens housing beneath the lens release button). This stops the lens down to the selected aperture and reveals sharpness in the resulting darkened viewfinder. (The lens otherwise remains wide-open until the next picture is taken.) Using Depth-of-field preview takes some practice because the viewfinder darkens so much, but changes in focus can be seen if you look hard enough. You can also check focus in the LCD monitor after the shot (magnify as needed), since digital allows you to both review and/or delete your photos as you go. Live View shooting also allows you to check depth of field and focus (see page 207).

The Depth-of-field preview button, located on the lower left of the lens housing when you are holding the camera in shooting position, can give you an idea of what your image will look like at the current depth-of-field setting.

A sports or wildlife photographer might choose Av mode in order to stop action rather than to capture depth of field. To accomplish this, he or she selects a wide lens opening—perhaps f/2.8 or f/4—to let in the maximum amount of light. In Av mode, the camera automatically selects the fastest shutter speed possible for the conditions. Compare this with **Tv** mode. There you can set a fast shutter speed, but the camera may not be able to expose correctly if the light drops and the selected shutter speed requires an opening larger than the lens can provide. (The aperture value blinks in the viewfinder in such cases.) As a result, photographers typically select **Tv** only when they need a specific shutter speed. Otherwise they use **Av** for both depth of field and to gain the highest possible shutter speed for the circumstances.

Bulb **B**

The setting for Bulb Exposure allows you to control long exposures. With this option, the shutter stays open as long as you keep the shutter button depressed. Let go, and the shutter closes. A dedicated remote switch, such as the Canon RS-80N3, or a timer remote controller like the TC-80N3, is very helpful for long exposures. It allows you to keep the shutter open without touching the camera (which can cause movement). It attaches to the camera's remote terminal (on the left side). You can use the RC-1 or RC-5 wireless controllers for bulb exposures, as well. As long as you keep the remote switch depressed, the camera shows the elapsed time (in seconds) for your exposure. This can be quite helpful in knowing your exposure.

Since **B** is really a shutter speed setting, you still need to set aperture. Use 🔄 to set it. You can also use ⊙ if the power switch is set for **⌐** . Because the 5D Mark II has no idea how long you will hold down the shutter release button, the camera will not display any metering information.

Connect a remote controller to the 5D Mark II's remote switch input jack, located beneath the terminal cover.

At this point in digital camera technology, exposures beyond a few minutes start to have serious problems. Still, the 5D Mark II allows longer exposures than most cameras of this type. It is a good idea to consider using the Long Exposure noise reduction custom function (Custom Function II-1) to reduce image noise (see page 140). Remember that Long Exposure noise reduction doubles the apparent exposure time, so make sure you have enough battery power.

Manual M

Not an auto mode, the Manual exposure option is important for photographers who are used to working in full manual and also for anyone who faces certain tricky or highly creative exposure situations. (However, I suggest that everyone at least try out the automatic settings to see what they can do. This camera is designed to give exceptional autoexposures.) In Manual exposure, you set both the shutter speed (use the Main dial ☀) and aperture (use the Quick Control dial ◯ ; the power switch must be set for ⌐ or you won't be able to adjust the aperture).

You can use the camera's exposure metering systems to guide you through Manual exposure settings. The current exposure is visible on the scale at the bottom of the viewfinder information display, the LCD panel on the top of the camera and the LCD monitor on the back. "Correct" exposure is at the mid-point, and you can see how much the exposure settings vary from that point by observing the scale. It shows up to three stops over or under the mid-point, allowing you to quickly compensate for bright or dark subjects (especially when using Partial metering). When the pointer reaches the end of the scale, it blinks, indicating the exposure is off the scale. Of course, you can also use a hand-held light meter.

The following examples of complex metering conditions might require you to use M mode: panoramic shooting (you need a consistent exposure across the multiple shots taken, and the only way to ensure that is with Manual—white balance should be custom also, or at least preset, not AWB);

lighting conditions that change rapidly around a subject with consistent light (a theatrical stage, for example); close-up photography where the subject is in one light but slight movement of the camera dramatically changes the light behind it; and any conditions where you need a consistent exposure through varied lighting conditions.

Other Mode Dial Settings

In addition to the exposure settings mentioned above, the Mode dial offers some other options: two Automatic modes and Camera User Settings. These settings control a lot more that just exposure, but when you understand what they do you'll understand why they are located on a dial that normally controls exposure setting options.

Automatic Modes
There are two Automatic settings that can be useful when you first start to use your camera and are unsure of which settings to adjust. They can also be useful if you hand someone your camera and ask them to take a picture.

Full Auto □
As mentioned previously, the automatic modes do more than just set exposure. The Full Auto mode □ turns the 5D Mark II into a point-and-shoot camera, albeit one with incredible image quality. In Full Auto, the camera uses Auto ISO speed selection, sRGB color space, **AI FOCUS** with automatic AF point selection, evaluative metering ◉ , and single drive mode □ . In addition, Auto Lighting Optimizer and High ISO speed noise reduction are engaged.

You can still adjust the file size and format by pressing ❖ straight down to bring up the Quick Control screen and highlighting the current file size/format using ❖ . Press (SET) and then use ◯ or ⛯ to select the RAW and JPEG options you want to use for image files. You can also turn on the 10-second self-timer ⏲◔ the same way.

Creative Auto Ⓒ

This mode is similar to ☐ , but with the opportunity to make more adjustments to the 5D Mark II. You can use the Quick Control screen to adjust Background, Exposure, Picture Style, drive mode, and file size/format.

The "Background" and "Exposure" settings are unique to Ⓒ . The Background setting is another way of adjusting depth of field. You can make adjustments from "Blurred" to "Sharp." What this really does is adjust the aperture setting (f/stop) of the camera.

The Exposure setting operates the same way as exposure compensation (page 188). The center position on the range is no exposure compensation, the two positions to the right represent +2/3 and +1 1/3 stops of over-exposure adjustment and the two positions to the left indicate -2/3 and -1 1/3 stops of under-exposure.

The Picture Style setting is a little more limited than normal, offering just Standard 🅂 , Portrait 🄿 , Landscape 🄻 , and Monochrome 🄼 . You can't make any further adjustments to the Picture Style parameters like you can in non-automatic modes. In fact, if you make adjustments to Picture Styles before you enter Ⓒ mode, you won't see those adjustments to the Picture Styles—they will be set to their default values. (Read about Picture Styles on page 91.)

For drive mode, Ⓒ also allows you to access continuous shooting ⏹ , in addition to the 10-second self-timer ⏱ .

Camera User Settings 🄲🄵 , 🄲🄶 , 🄲🄷

With Camera User Settings you can quickly change your 5D Mark II to operate like a different camera. For example, you might shoot sports where you want high ISO speed, high ISO speed noise reduction, continuous drive, a user-defined picture style, JPEG file format, and a host of other settings. Set up the camera the way you like it and then register it as one of three user settings. In the future you can quickly recall all

The 5D Mark II's user settings allow you to save the camera settings you use often or for a specific shooting situation, such as shooting portraits.

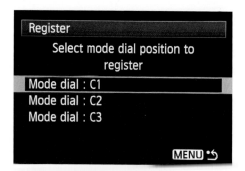

of those settings by turning one dial instead of jumping through a number of menus.

Before you register your settings, set up the 5D Mark II the way you want it to be. Then press MENU and select Setup menu 3 ⚙ . Highlight [Camera user setting] and press ⓢⒺⓣ . Highlight [Register] and press ⓢⒺⓣ again. Using ⊙ , select the Mode dial register (**C1** , **C2** , or **C3**) that you want to store the camera settings in and press ⓢⒺⓣ . Highlight [OK] and press ⓢⒺⓣ .

Note: You can still override settings when you use Camera User settings. For example, if you program **C1** to use continuous shooting drive mode ⊒ , you can quickly change that just as you normally would. The one thing you can't change is exposure mode, since that is controlled by the Mode dial and would take you out of the current Camera User setting.

AE Lock ✳

AE lock is a very useful tool when you use the autoexposure modes. Under normal operation, the camera continually updates exposure as you move the camera across the scene or as the subject moves. This can be a problem if the light across the area is inconsistent, yet remains constant on the subject. In this case, you can lock the exposure on the subject. AE lock is also helpful when a scene is primarily in one

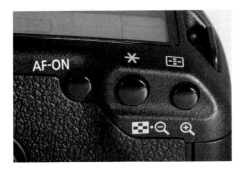

Press the ✳ button to hold an exposure reading. The reading is reset after you press the shutter button.

light, yet your subject is in another. In that circumstance, try to find a spot nearby that has the same light as your subject, point the camera at it and lock exposure, then move the camera back to the original composition. (If you have a zoom lens mounted, you can zoom in to a particular area of the scene, as well.)

The 5D Mark II's AE lock is similar to that used on most EOS cameras. The AE lock button ✳ is located on the back of the camera to the upper right, positioned for easy access by your right thumb. If you use the optional battery grip BG-E6, the AE lock button is also duplicated for shooting in a vertical orientation. If you use evaluative metering ⊚ , AE lock occurs at the AF point that was used to set focus unless you manually selected the AF point. Then it locks at the selected point. Other metering methods lock at the center AF point. If the lens is set for manual focus **MF** , the center AF point is used for AE lock.

To set AE lock, aim the camera where needed for the proper exposure, then push ✳ . The exposure is "locked" or frozen, even if you move the camera. An asterisk appears in the viewfinder on the bottom left of the information display until the exposure lock is released. If you want to lock exposure continuously across several images, keep holding down ✳ after locking exposure and while the shutter release button is pressed—release ✳ only after you have finished taking pictures.

AE lock does not function in the 5D Mark II's fully automatic modes, ☐ and ⎣CA⎦ . But AE lock can be used during Live View shooting of both stills and video.

Exposure Compensation

The exposure compensation feature is a good tool for capturing a challenging dynamic range in a difficult or extreme lighting situation.

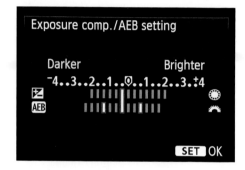

The existence of both exposure compensation and the LCD monitor (for image review) means you can quickly get good exposures without using Manual Exposure **M** mode. Exposure compensation cannot be used in **M** mode, but it makes the **P** , **Tv** , and **Av** modes much more versatile. Compensation is added (for brighter exposure) or subtracted (for darker exposure) in f/stop increments of 1/3 for up to +/- 2 stops (1/2 stop increments with Custom Function I-1, see page 137). This is a useful tool if you are dealing with difficult exposure situations where the proper exposure is close but you want to adjust it a little rather than trying for a different metering mode or exposure mode.

Exposure Compensation works quite easily with the Quick Control dial ⊙ . First make sure the power switch is set for ⌐ . Simply press the shutter button halfway to turn on the metering system, and then rotate the ⊙ to change the amount of exposure compensation. The exact exposure compensation appears on the scale at the center of the viewfinder information display, as well as on the top LCD panel and the LCD monitor.

Note: It is important to remember that once you set Exposure Compensation, it stays set even if you shut off the camera. When you turn on your camera, check your exposure setting as a regular habit (look at the exposure level indicator scale at the center of the viewfinder information display) to be sure the compensation is not inadvertently set for a scene that doesn't need it.

With experience, you will find that you use Exposure Compensation routinely with certain subjects. The meter wants to increase exposure on dark subjects and decrease exposure on light subjects to make them closer to middle gray, so Exposure Compensation may be necessary. For example, you may be photographing a high school soccer game with the sun behind the players. The camera wants to underexpose in reaction to the bright sunlight, but the shaded sides of the players' bodies may be too dark. You add exposure with the Exposure Compensation feature. Or maybe the game is in front of densely shaded bleachers. In this case the players would be overexposed because the camera wants to react to the darkness. Here, you subtract exposure.

The LCD monitor comes in handy when you experiment with Exposure Compensation. Take a test shot and check the photo and its histogram. If it looks good, go with it. If the subject is rendered too bright, subtract exposure; if it's too dark, add it. Again, remember that if you want to return to making exposures without using compensation, you must move the setting back to zero!

When you use the 5D Mark II in Full Auto mode ▢ , Exposure Compensation is not available. If you use the Creative Auto mode ⒸⒶ , Exposure Compensation is not available by using ◌ but a similar adjustment is available through the Quick Control screen. Press ⁘ straight down, then highlight the Exposure slider just above the Picture Style settings. Use ◌ or ⌂ to adjust the exposure compensation.

Autoexposure Bracketing (AEB)

The AEB function takes three images of the same scene with varying exposure readings to find the best exposure for the situation.

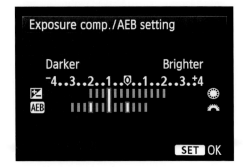

The 5D Mark II offers another way to apply exposure compensation—by using the Autoexposure Bracketing (AEB) control. AEB tells the camera to make three consecutive exposures that are different: (1) a standard exposure (it uses the current setting of the Exposure Compensation function as the standard); (2) one with less exposure; and (3) one with more. The difference between exposures can be set up to +/- 2 stops in stop increments of 1/3. (Custom Function I-1 allows you to change this to 1/2-stop increments; see page 137.) When you use AEB, the 5D Mark II changes the aperture in **Tv** mode and the shutter speed in both **Av** mode and **M** mode.

There are two ways to set AEB. The first is via **▢⁝** . Press MENU, select **▢⁝** , and highlight [Expo.comp./AEB] and press ⓢⒺⓣ . Use ◯ to set exposure compensation and 📻 to set bracketing by viewing the display on the LCD monitor. Press ⓢⒺⓣ to enter the setting into the camera.

A quicker way is through the Quick Control screen. Press straight down on ✛ to bring up the Quick Control screen. Use ✛ to highlight the [Exposure comp./AEB] setting parameter and then press ⓢⒺⓣ . This brings up a screen similar to the one mentioned immediately above. Use ◯ to adjust exposure compensation and 📻 to adjust bracketing. The big difference with changing AEB this way (besides not having to go through the menu system) is that

you don't have to press (SET) to enter the setting; the adjustment is set immediately.

Note: If Custom Function I-1 is set for 1/2-stop increments, you may see more dots on the top LCD panel or in the viewfinder. This is because the exposure scale is laid out in 1/3-stop increments and sometimes 1/2-stop indicators are between the hash marks.

As you shoot, a marker appears on the exposure level indicator on the right of the viewfinder information display. This marker indicates the exposure being used with the AEB sequence. When in Single shooting drive mode □ , you have to press the shutter button for each of the three shots. The exposure scale markers blink until you have taken all three shots in the series. In Continuous shooting drive modes ⑨ , the camera takes the three shots and stops. With the Self-timer, all three shots are taken. With Custom Function I–4 you can set whether AEB is cancelled when the camera is powered off, when camera settings are cleared, when the flash is ready, or when **B** exposure mode is selected.

AEB can help ensure that you get the best possible image files for later adjustment using image-editing software. A dark original file always has the potential for increased noise as it is adjusted, and a light image may lose important detail in the highlights. AEB can help you determine the best exposure for the situation. You won't use it all the time, but it can be very useful when the light in the scene varies in contrast or is complex in its dark and light values.

AEB is also important for a special digital editing technique called High Dynamic Range (HDR). HDR allows you to put multiple exposures together into one master image file to gain more tonal range from a scene. You can take the well-exposed highlights of one exposure and combine them with the better-detailed shadows of another. (This works best with 1/2-stop bracketing.). If you carefully shot these different exposures with your camera on a tripod, they will line up exactly so that when you put the images on top of one

The Highlight tone priority function limits the ISO range and makes it easier to capture bright highlights, such as you might find shooting subjects on or around the water in direct sunlight.

another as layers using image-editing software, the different exposures are easy to combine. (You may even want to set the camera to Continuous shooting drive ⊒ ; in this mode it takes the three photos for the AEB sequence and then stops.)

You can combine Exposure Compensation with AEB to handle a variety of difficult situations. But remember, while AEB resets when you turn off the camera, Exposure Compensation does not.

When you use the fully automatic modes □ and CA you cannot access AEB because the □ᶦ is not accessible. Because exposure compensation that allows AEB is not available on the Quick Control screen during fully automatic modes, AEB is not accessible via this method either.

Note: Custom Function I-5 can change the order of the bracket shots. Normally the first exposure is the "normal" exposure, followed by the underexposed shot and then the overexposed shot. With C.Fn I-5 you can change this order to underexposed, normal, and overexposed (see page 139).

Highlight Tone Priority

Highlight tone priority expands the range of tones available in the bright areas of the image. Highlights become less clipped and more detail is available. In shadow areas, however, Highlight tone priority may result in more noise. Use Custom Function II–3 to turn on Highlight tone priority. When turned on, the ISO range is lessened. For example, the EOS 5D Mark II drops to 200-3200. When Highlight tone priority is turned on, **D+** appears in the viewfinder, on the top LCD panel, and on the LCD monitor.

Highlight tone priority is a useful tool if you shoot scenes with a lot of bright tones and you want to keep as much detail as possible. This is not a process that happens once the image is captured. It actually changes the response curve of the image sensor. If you photograph weddings, consider this option for bringing out delicate features in a bride's white wedding gown.

Note: Highlight tone priority is disabled when you use the fully automatic modes ▢ and CA .

193

Live View Shooting

Canon introduced Live View shooting with the EOS-1D Mark III. This technology, which allows you to see an image on the LCD monitor before you shoot, has now rolled out to other Canon models, including the 5D Mark II. Live View shooting allows you to frame shots when it is difficult to look through the viewfinder. It also lets you check exposure, composition, color, and focus on a computer display. With the WFT-E4A wireless transmitter attached, all this can be done remotely, without having to be tethered to a computer.

Although other Canon models have Live View shooting, the 5D Mark II is the first Canon EOS camera to offer video recording, too. And because of the full-frame sensor and fast DIGIC 4 processor, the video that the 5D Mark II can record is high definition. When Live View shooting is turned on, the reflex mirror pops up, rendering the viewfinder unusable. A live image is displayed on the LCD monitor representing 100% coverage of the image to be recorded.

Live View/Movie func. set.	
LV func. setting	🗅+'🎥/🗅DISP
Grid display	Off
Silent shoot.	Mode 1
Metering timer	16 sec.
AF mode	Quick mode
Movie rec. size	1920x1080
Sound recording	On

Live View shooting functions are found under the Set-up 2 menu 🖌 *.*

↺ *Live View shooting can be a huge benefit in situations where you need to get the camera away from your face, such as holding it close to the ground to capture the kind of shot seen here. Photo © Mari-anne Skov Jensen*

195

To turn on Live View shooting, go to the Set-up 2 menu ♈ , highlight [Live View/Movie func. set.] and press ⑤ . Make sure [LV func. setting] is highlighted and press ⑤ to display the Live View function settings screen. At the top of the screen is the current status of the two main aspects of Live View functions: LV func. and Screen settings.

In the Live View function settings, choose whether you want to record stills or stills and video.

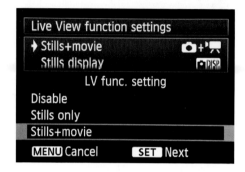

At its simplest, LV func. allows you to turn on Live View shooting and video recording:

- **[Disable]:** This turns off all Live View functionality. With Live View disabled, pressing 📷/ 🖱〰 while shooting does nothing.
- **[Stills only]:** When set for this option, 📷/ 🖱〰 starts up the Live View shooting mode. Press 📷/ 🖱〰 again to turn it off.
- **[Stills+movie]:** This setting enables Live View shooting and allows video recording. Press 📷/ 🖱〰 to engage Live View and then press ⑤ to begin video recording.

Once you have selected either [Stills only] or [Stills+movie] from LV func., the Screen settings display appears. Screen settings is an important feature to understand when you use the LCD monitor during Live View shooting.

- **[Stills display]** 📷DISP : When you shoot stills, this mode always displays a bright image on the LCD monitor, no matter what your current exposure setting is. Although

196

Once you decide on a Live View function, choose a Screen setting option.

this is useful for composing the scene, understand that the image displayed does not represent the actual exposure or depth of field that you have set. This means that if you are using exposure compensation, it is not represented in the image displayed. My advice here is don't try to use the image to set exposure. You can overcome this limitation and quickly see what the exposure will look like by pressing the Depth-of-field preview button on the front of the camera, just below the lens release button. This temporarily puts the camera in Exposure simulation mode ExpSIM .

- **[Exposure simulation]** ExpSIM : This mode presents a good approximation of what the captured image will look like. If the display cannot show a proper image that matches the current exposure setting, the ExpSIM icon blinks on the LCD monitor. You can also get a live histogram in this mode by pressing **INFO.** . One word of warning about the exposure simulation: it does not actually stop down the lens aperture to the current setting, so the true depth of field is not shown. To see the depth of field, press the Depth-of-field preview button.

- **[Movie display]** DISP : Although you can record movies in any of the three screen modes, this version gives you a better preview of the scene's composition. The 5D Mark II normally uses an aspect ratio of 3:2, which is typical for stills. High definition video has an aspect ratio of 16:9. If you don't use Movie display, the framing on the LCD monitor displays more of the scene than is recorded. Movie display adds a slightly transparent mask to help

you visualize the final framing. Even though you are in movie display mode, you can still shoot stills. When you shoot stills, this display mode also changes how the exposure is set. You won't be able to adjust aperture or shutter speed, but you can adjust exposure compensation by using ⊙.

Note: You can shoot movies using any of the above Screen settings—just press ⊛. In all but 🔲DISP there may be a change in image brightness as the 5D Mark II begins recording. The change in exposure may last as long as a second or two as the camera shifts from exposure simulation or still display to actually stopping down the lens to the right aperture. If you use movie display, the transition is negligible.

AF in Live View Still Shooting

You can access AF choices for Live View shooting with the AF•DRIVE *button.*

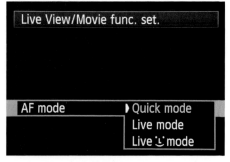

The AF sensor is built into the viewfinder area of the 5D Mark II. Since the viewfinder is blocked by the mirror during Live View mode for stills and video, autofocus must happen a different way. There are two ways to set autofocus for Live View shooting: use the Set-up 2 menu 🕂 , or use AF•DRIVE when you are already in Live View.

To set autofocus using the Set-up 2 menu 🕂 , highlight [Live View/Movie func. set.] with ⊙ or ✜ , then press ⊛ . In the submenu, use ⊙ to select [AF mode], then press ⊛ . (You can also use ✜ to highlight and select.) A choice list pops up. Use either ⊙ or ✜ to

198

select the mode you want to use. The current mode is displayed in blue. Press ⊕ or press straight down on ✛ to lock in your selection.

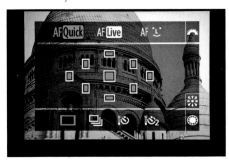

When in Live View mode, you can access the screen shown here by pressing the AF·DRIVE *button.*

You can also set the AF mode when the camera is already in Live View mode. Press AF·DRIVE to bring up the focus mode screen on the LCD monitor. Use 🖾 to select one of the three AF options. Press AF·DRIVE or lightly tap the shutter release button to exit. It is not necessary to press ⊕. In fact, when the AF options are displayed, ⊕ has no effect.

Note: It is important to understand that with any AF mode in Live View shooting, you must explicitly perform the AF function using **AF-ON** (described below). AF will not be performed simply by pressing the shutter release button.

• **Quick Mode AF** AFQuick : You might wonder why this is called Quick Mode since it takes a bit of time to achieve focus. In reality, the fastest way to achieve focus will most often be Quick Mode. It is also usually the most accurate. The method uses the same autofocus sensors that are used during non-Live View still photography. Remember that during Live View, the reflex mirror— reflex is the "R" in SLR—is in the up position so that light lands on the image sensor and creates an image. But because the AF sensors are located in the viewfinder, the reflex mirror must be in the down position so that the light hits the AF sensors. In other words, if you use AFQuick the Live View image is temporarily interrupted while the camera sets focus.

When you use **AFQuick**, you must select an AF point, just as you would if you were not using Live View shooting. To do so, press ^{AF·DRIVE} and use ✥ to select the AF point. If you press ✥ in the same direction twice, all AF points highlight and the 5D Mark II selects the AF point automatically. The AF point(s) selected are overlaid on the LCD monitor as gray points.

Note: The AF point selection carries over from non-Live View shooting. For example, if you have selected the center AF point during normal shooting, when you switch to Live View with **AFQuick** the selected AF point is the center point until you change it.

Once the AF point is selected, the 5D Mark II must use that point to autofocus. Press and hold **AF-ON**. The mirror flips down, interrupting the Live View image on the LCD monitor. The camera then sets focus and confirms the focus with a beep (unless the beep was disabled in **◘ⁱ**). Once focus is set, the mirror flips back up and you can see the Live View image again. If you continue to hold down **AF-ON**, the AF point used to set focus is highlighted in red.

The magnifying frame shown here lets you choose what part of the image you want to enlarge in order to check the image's focus.

You can check the focus. A rectangular magnifying frame can be moved anywhere in the scene with ✥ . Once in place, press ▦/⊕ to magnify the image in that frame. Press once to magnify 5x, press again to magnify 10x, and press a third time to return to normal view. Once focus has been set, press the shutter to take the picture.

- **Live Mode AF** **AF Live** : In this mode, the 5D Mark II sets focus by evaluating the image coming from the sensor. The camera uses contrast detection to examine edges in the scene, continually measuring the image while focus is adjusted. This feedback loop takes a bit longer to set focus but it does not interrupt the Live View image.

When you use **AF Live** , first set the Live Mode focus point. When the 5D Mark II is in **AF Live** , the white frame overlay becomes the AF point. Use ⚬ to move the AF point to the area of the image you want in focus. For quicker and more accurate results, pick an area with high contrast images. You can move the AF point around more than 60% of the image with ⚬ . If you press straight down on ⚬ , you can reset the AF point to the center of the screen.

With Live Mode AF, the AF point appears as a small vertical rectangle that can be postitioned using the Multi-controller.

Note: You can tell the difference between the magnifying frame in **AF Quick** and the AF point in **AF Live** even though they are both white rectangular boxes. The magnifying frame is larger and has a horizontal aspect ratio. The AF point is smaller and vertical.

Once the AF point is in position, press and hold AF-ON to start the AF process. The camera indicates that focus is achieved by beeping and turning the AF point green. If the camera fails to find focus, the AF point turn reds and there is no beep. You can magnify the image using ⊞/⊕ to more critically view the sharpness of the focus. Press ⊞/⊕ once to magnify 5x, twice for 10x, and a third time to return to normal view. Once AF is set, the picture can be taken.

- **Face Detection AF AF ⌣:** The last Live View AF mode uses face detection technology built into the DIGIC 4 chip. The 5D Mark II can detect up to 35 different faces in the scene. Once detected, the camera chooses either the largest or the closest face in the scene and sets the AF point at that location.

When using Face detection AF, the camera can recognize multiple faces. This is indicated by the arrows displayed on the left and right edge of the detection point(left). If there is a single face detected, the point displays without arrows (right).

When **AF ⌣** is selected, simply frame the scene and the camera detects the faces. A special face detection AF point ⌐ ⌐ appears over the largest or the closest face on the LCD monitor. If there are multiple faces in the scene, the face detection AF point changes to ◀ ▶ . Use ✦ to move the AF point to a different face.

Once a face has been selected, press and hold AF-ON to engage the autofocus. When focus is achieved, the face detection AF point turns green and the camera beeps. If focus cannot be achieved, the AF point turns red. Once focus has been set the picture can be taken. (In Face Detection focus mode, you cannot magnify the live image to evaluate the focus.)

Note: If a face cannot be detected in the scene when you press and hold **AF-ON**, the Live Mode AF point appears in the center of the screen and is used for focus. Although you will not be able to reposition the AF point in **AF ☺**, you can temporarily leave it by pressing ✦ straight down. The camera will switch to **AF Live** so you can reposition the AF point. Press ✦ straight down again to return to Face Detection AF mode **AF ☺**. This is a useful technique to remember if you want to quickly switch between Live View and Face Detection AF.

Face detection is an impressive technology but it is not perfect. Faces that are at an angle to the camera, that are tilted, that are too dark or too bright, and those that are too small, will be difficult to detect. Don't expect the face detection AF point to always completely overlay the face. Also if the lens is way out of focus to begin with, the camera will have difficulty detecting faces. If the lens supports manual focusing (via turning the focus ring) while the lens is in AF mode, manually set the focus. Once the Live View image is in better focus, the 5D Mark II may detect faces.

AF ☺ in Live View only occurs near the center area of an image. If the camera detects a face near the edge of the frame, the face detection AF point turns gray. If you attempt autofocus at that time, the center Live View AF point is used instead.

Note: The RS-80N3 and TC-80N3 remote switches do not have an **AF-ON** button. The Live View AF modes do not work when you use a remote switch.

Manual Focus MF

Manual focus is still a good option for Live View shooting. Whether the 5D Mark II is in **AF Quick**, **AF Live**, or **AF ☺**, as soon as you switch the manual focus switch on the lens, the camera displays a magnification frame. One of the best ways to ensure accurate focus is use ✦ to position the frame over the area of your scene that you want in focus. Then press ⊞/⊕ to magnify the image either 5x or 10x. Use the focus ring of the lens to set focus, then press ⊞/⊕ to restore the normal image size.

Focus in Video Recording

Video recording on the 5D Mark II is done via Live View shooting, so the AF modes for video recording are similar to those for Live View still shooting. You can use Quick Mode AF AF|Quick before you start shooting video, but once recording starts AF|Quick is no longer accessible. Live Mode AF AF|Live can be used during video shooting just like with Live View still shooting: use ⊕ to move the AF point, then press and hold **AF-ON** to set focus. Face Detection AF **AF** ⚘ works during video recording the same way it does for still shooting, too.

Don't expect Live Mode or Face Detection AF to be as smooth as if you had a Hollywood-style focus puller—the person whose sole job on a movie set is to adjust lens focus when the camera moves, gently pulling focus from one setting to another. The 5D Mark II is designed to achieve focus as quickly as possible. Since there is a feedback loop, the focus setting "hunts" a little when it gets close to the right setting. Also, the brightness level of the scene may change while focus is set.

For best results, consider using manual focus when recording video. It is the quietest and fastest method to achieve focus. And, with a gentle touch, it can be done while recording.

Exposure in Live View

ISO

During Live View still shooting, the ISO speed setting oper-
ates the same way as during normal shooting: Press ISO·⚡
and use 🎚 to select the ISO speed from the display on
the LCD monitor. (You cannot use the Quick Control screen
to select ISO since the Quick Control screen does not dis-
play in Live View.) The only caveat is that you cannot have
the Live View Screen Setting set to [Movie display]. Choose
[Stills display] or [Exposure simulation] instead. (If [Movie
display] is selected, you cannot display the ISO screen to
adjust ISO speed.)

Note: When Highlight tone priority has been activated (Cus-
tom Function II-3), it is indicated by a text overlay below the
ISO speed choices. It is also indicated by **D+** at the bot-
tom of the LCD monitor during Live View still shooting.

When you shoot video you don't have any direct control
over the ISO setting. The ISO speed initially starts at ISO 100
and can increase up to 12,800 automatically. Even if you
have the camera in non-movie display (Stills or Exposure
simulation), the current ISO is ignored when you start
recording video.

Exposure Modes in Live View and Video

When you capture stills during Live View shooting, the
P , **Av** , **Tv** , **M** , and **B** exposure modes
operate the same way as during non-Live View shooting,
provided the Live View screen setting is not set for Movie
display 📷DISP . In 📷DISP the 5D Mark II automatically sets
ISO speed, aperture, and shutter speed.

Note: It is important that you understand how the Live View
screen setting affects what you see on the LCD monitor (see
page 195).

When you record video, the 5D Mark II controls exposure. The Mode dial is ignored and the shutter speed is set in a range from 1/30 to 1/125. You can try to lock down different apertures using Auto Exposure lock ✱ before you start recording, but there is no option to explicitly set a particular aperture.

Metering

Metering during Live View shooting is preset to Evaluative metering ◉ . It is linked to the Live View AF point and cannot be changed. However, you can still use all of the exposure and drive modes. Adjust ISO, aperture, shutter speed, and exposure compensation just as you would when shooting normally (provided the camera is not in 🎥DISP). When you use a Speedlite, E-TTL II metering uses the normal meter in the viewfinder, so the mirror must pop down briefly.

Metering in Live View and Video

When you shoot stills with Live View, you cannot access the metering settings. If you press ◉•WB, it brings up white balance choices, not metering options. In Live View, when shooting stills, the camera is automatically set for evaluative metering mode ◉ . It is important that you understand how to set the Live View screen settings (Stills display 📷DISP , Exposure simulation Exp.SIM , or Movie display 🎥DISP ; see page 196). With the proper setting you won't be surprised when the image captured differs from the Live View image.

Note: If you use Continuous drive mode 🔳 , the exposure for all of the images shot is locked to the first image captured.

When you record video, the 5D Mark II doesn't allow you to set a metering mode. Video exposure metering is automatically set for Center-weighted average metering □ . There is one exception: if you use Face Detection AF (see page 202). When a face is detected, the metering is evaluative and it is linked to the face detection AF point.

Checking the depth of field with the Depth-of-field preview button when shooting in Live View mode is actually better than the preview when in normal shooting mode. In Live View, the Depth-of-field preview is brighter than it is when activated during normal view shooting.

Depth of Field in Live View and Video

One 5D Mark II feature that is improved with Live View shooting is Depth-of-field preview. Normal Depth-of-field preview results in a dim viewfinder, making it difficult to see the image. With Live View shooting, as long as the exposure is set for a reasonably correct exposure, when you press the Depth-of-field preview button you see a brighter display that allows you to better check depth of field.

Exposure Compensation in Live View and Video

When you shoot stills in Live View in normal exposure modes, exposure compensation operates normally. If the Mode dial is set for one of the fully automatic modes, ☐ or [CA] , exposure compensation is not available. Since there is no Quick Control screen during Live View, you can't access exposure compensation via that method either. Note that exposure compensation as currently set for non-Live View shooting carries over into Live View shooting (except for fully automatic modes).

During video recording, exposure compensation is the only way to affect image exposure. You can't specifically set aperture, ISO speed, or shutter speed.

AEB works the same when shooting Live View stills although it can't be accessed via the Quick Control screen. It does not function with video recording.

Note: Heat can be a problem when you use the Live View shooting function. Thermal build-up on and near the image sensor causes the function to shut down. This is particularly true when you shoot under hot studio lights or outdoors in direct sun. If heat becomes a problem, this temperature icon ▓ is displayed. While you can keep shooting, image quality may suffer so it is best to turn off Live View shooting for a while.

Grid Display

Although you can change the viewfinder's focus screen during normal shooting, it won't help you during Live View shooting when you cannot use the viewfinder. Instead, Canon has provided two grid options. Grids can be used to assist in leveling the camera and for help in composition.

Grid 1 looks like a tic-tac-toe game board and is useful as a guide for rule-of-thirds shooting. The rule of thirds divides the frame into nine areas, based on three equal horizontal spaces and three vertical spaces. It recommends that you should place the main focus of your scene at one of the four

intersections of the grid. This is also a good grid overlay that reminds you not to put horizons smack dab in the middle of the frame. But not all pictures have to follow the rule of thirds; it is just a starting point.

Grid 2 is a denser grid of five vertical lines and three horizontal lines. This is a good tool when you need to make sure that the 5D Mark II is level and square to the scene you are photographing. For example, you might use it when you photograph a building.

Note: Grids are only displayed on the LCD monitor and are not embedded in the image. The grid is not displayed when you record video.

Silent Shooting

Since a good deal of the noise that an SLR makes comes when the mirror flips up, Live View shooting offers a quieter shooting experience: Silent shoot. The only thing you hear is when the shutter is triggered and then reset after the image is captured. The 5D Mark II offers Silent shoot options to further quiet the shutter:

- **Mode 1:** Mode 1 is the default setting for Live View shooting. This isn't the quietest mode but it is much quieter than non-Live View shooting. You hear the electronic shutter open for the image and reset after the image is captured. It allows you to shoot in continuous mode at about 3 fps. (When you shoot continuously the LCD monitor goes dark.)
- **Mode 2:** Mode 2 is the quietest shooting mode. By separating the picture taking into two parts—opening the shutter and resetting the shutter—the 5D Mark II lets you control when the noise occurs. When you first press the shutter release button the electronic shutter opens and closes (the picture is taken); if you continue holding down the shutter release button, the shutter will not be reset. The shutter resets only when you release the button. So you could take a picture in one room, leave, and reset the shutter in another room. Even if you don't think

you need to be quiet, experiment with this mode. You'll see how much of the camera's sound is caused not by taking a picture, but by getting ready for the next one.

Note: Continuous shooting 🖵 is not available when Live View is set for Mode 2 silent shooting. If the camera is set for 🖵 , it functions as if it is set for ▢ . If you use a remote control, the camera operates as if it is in Mode 1.

- **Disable:** Disable only really needs to be set in one of two scenarios. If you use an extension tube, Mode 1 and Mode 2 may lead to poor exposures. Disable is also appropriate when you use one of Canon's tilt-shift lenses (TS-E), but only when you use it for vertical shift. Disable is a bit louder than Mode 1—you'll hear what sounds like the shutter firing twice, but it only takes one picture.

Note: When you use a Canon flash, Silent shooting reverts to [Disable]. If you are using a non-Canon flash, you'll most likely need to set Silent shooting to [Disable] in order to get the flash to fire.

Metering Timer

Live View shooting often differs from non-Live View shooting: The camera might be tethered to a computer (or wirelessly connected); the camera may be powered via the AC adapter; it might be used in a studio, where images are evaluated for longer periods of time. The 5D Mark II offers an extended AE lock timer when you shoot with Live View. The metering timer ranges from 4 seconds to 30 minutes, so you can now hold an exposure setting for half an hour, compared to the 4 seconds that occurs with non-Live View shooting. (You can change the metering timer in the Set-up 2 menu 🔧 .)

Movie Recording

Recording Video in 10 Basic Steps

There are ten things you should do to successfully record video with your 5D Mark II. These steps are important because the process of recording video can be very different than that of shooting stills. These are just a starting point. As you get used to the camera, you'll develop your own steps.

1. **Make sure you have plenty of power.** If you use batteries, make sure they are charged and make sure you have spares. Running Live View and recording video can use up battery power quickly. Better yet, use the optional AC adapter (ACK-E6).

2. **Use a UDMA (high-speed) Compact Flash card.** For optimum performance when recording high definition video, make sure that you format the card in the 5D Mark II. If you shoot stills and record video, consider using different cards for each scenario. This also helps organize files when you download to the computer.

3. **Enable video recording and set Screen settings to Movie display:** Go to ▶︎ , select [Live View/Movie func. set.] and press ⊛ . Highlight [LV func. setting] and press ⊛ again. Select [Stills+movie] and press ⊛ . For Screen settings choose [Movie display]. Although you can record movies in the other two screen settings, the first few seconds of the recording will exhibit exposure changes as the camera sets up for video recording. (See page 196.)

4. **Pick the video resolution:** Go to ▶︎ , select [Live View/Movie func. set.] and press ⊛ . Highlight [Movie rec. size] and press ⊛ . From the drop-down selection, choose either 1920x1080 (high definition) or 640x480 (standard definition).

5. **Attach an external microphone:** Use a stereo-mini plug (3.5mm) to connect an external microphone to the

external mic jack located underneath the terminal cover. The built-in microphone is mono and picks up sounds from camera operations—focus motors, image stabilizer, etc. (See page 215.)

6. **Select a picture style:** Press ⊟▴ and use ⚙ to choose from Standard ⊟▴S , Portrait ⊟▴P , Landscape ⊟▴L , Neutral ⊟▴N , Faithful ⊟▴F , Monochrome ⊟▴M , or one of the three User-defined Picture styles ⊟▴1 . Use ⊙ to make adjustments—Sharpness, Contrast, Saturation, and Color tone—to the selected Picture Style. (See pages 91-96.)

7. **Make a white balance (WB) selection:** If in doubt, use AWB , but the Live View display on the LCD monitor can help you choose the best white balance setting. To set, press ⊙·WB to display the current white balance setting on the LCD panel and the LCD monitor. Use ⊙ to scroll through the white balance options: Auto white balance AWB , Daylight ☀ , Shade ⛰ , Cloudy ☁ , Tungsten ☀ , White Fluorescent ☰ , Flash ⚡ , Custom ⊾ or Color temperature K (see pages 98-104). An easy way to "dial in" white balance is to use K . Once K is selected, view the LCD monitor and use ⚙ to adjust the specific color temperature.

8. **Choose a focus mode:** Decide if you want to set focus manually or via one of the three special Live View AF modes. If you opt for AF, set the mode by pressing the AF·DRIVE button on the top right of the 5D Mark II. Set the lens focus switch to AF to make sure your lens is in AF mode. Use ⚙ and view the top LCD panel or the LCD monitor to choose from Quick Mode AF AFQuick , Live Mode AF AFLive , or Face Recognition AF AF ꭧ. (See page 198.)

9. **Set focus:** The 5D Mark II does not automatically set focus before video recording. Press and hold AF-ON until you receive a confirmation that focus has been achieved. Depending on the AF mode you have set, this

might involve momentary loss of the Live View display on the LCD monitor.

10. **Make a test recording:** Once you have pressed ⬛ / ⎙~ to engage Live View, press ⓈⒺⓉ to start recording. Since you can't monitor audio from the 5D Mark II's "audio/video" out terminal while you record video, make sure that you do a test recording. Listen to the recorded audio to make sure it sounds good and look at the video to check exposure. Exposure can be adjusted by using ◯ before and during recording.

Video Recording Parameters

The 5D Mark II is the first Canon EOS camera that can record video and audio. There are four parameters that are important in any digital video specification: resolution, frame rate, scanning type, and compression.

Resolution: Much like still photography, digital video is captured in pixel form. But with video you don't talk in terms of megapixels because video doesn't have the equivalent of printers that can print at various sizes and resolutions. Instead, video is locked into displays that have fixed pixel counts. Rather than say that a camera has 15 megapixels, you specify exactly how many pixels there are in the horizontal and vertical direction.

There are two digital video resolution options in the 5D Mark II: 1920x1080 and 640x480. 1920x1080 is one of the two resolutions that comprise high definition video (1920x1080 and 1280x720). 640x480 is close to the standard definition digital video specification (which is typically 720x486). It is typical in the "biz" to refer to the resolution by its vertical dimension, so the 5D Mark II is considered a 1080 camera.

Note: The 5D Mark II is a true 1080 camera. Some camcorders (including high-level professional cameras costing thousands more) use pixels that are not square. The actual count of the pixels is 1440x1080, which is later stretched out to create the 1920-wide image.

Video playback controls appear at the bottom of the screen to allow you to play, fast forward, rewind, and pause video playback.

Frame Rate: The second parameter is frame rate. This should not to be confused with shutter speed or maximum burst rate. It is the number of frames that the camera can capture per second. In the case of the 5D Mark II, the camera records 30 frames per second (fps) in either of the resolution modes. This frame rate is useable for video systems in North America but the files need to be converted for use in other locations where frame rates are typically only 5 fps.

Scanning Type: Another parameter important in video is the scanning type. There is nothing similar to it in still cameras. In the early days of television, bandwidth was a big problem. Transmitting lines of video (think of a line of video as a row of pixels) every 30th of a second required a lot bandwidth. Using lots of bandwidth meant fewer television channels, so a system was devised to transmit every other line of video at 1/60 of a second. This interlace scanning scheme

has been used for decades and it fit in very nicely with televisions based on CRTs. With the advent of computers and computer displays like LCDs, the concept of interlace scanning became problematic. LCDs are more efficient if they get each line sequentially, rather than every other one. LCDs use a type of scanning that is called progressive. The 5D Mark II is a progressive scanning device so the high definition output is sometimes referred to as 1080p—"p" for "progressive." There are other video recorders that are 1080i ("i" for "interlace").

Compression: Lastly, because video—particularly high definition video—takes up a lot of space on memory cards and hard drives, it is usually compressed. Just like the JPEG compression the 5D Mark II uses for still images, the video compression is high quality—don't think web movie compression. In video parlance the compression is referred to as a codec, which stands for compressor/decompressor. The 5D Mark II uses an MPEG4 compression that is most commonly referred to as h.264. There are a variety of quality levels of h.264, from very low file size/image quality, to large file size and high image quality. This camera uses a very high quality version of h.264 for both resolutions (1920x1080 and 640x480). The image quality is well suited for commercial shooting.

Audio

The 5D Mark II's built-in microphone is located directly beneath the "5D" logo on the front of the camera.

Audio is recorded simultaneously with the video. The 5D Mark II records two digital audio channels (stereo) at a sampling rate of 44.1kHz which is the same rate used for

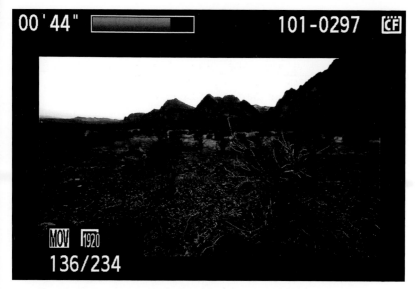

The 5D Mark II can recording video for up to 12 minutes in HD and 24 minutes in standard definition, creating the maximum 4GB file.

audio CDs. It uses a linear PCM audio format, which is uncompressed. The audio can be recorded via the built-in mic (located on the front of the camera underneath the 5D logo) or from an external audio source plugged into the external mic jack. You can also turn off audio recording if it is not needed.

The built-in mic is mono and picks up a lot of the camera noise, like focus motors, stabilization, lens zooming, and any adjustments you make to a camera control. So, really, the built-in mic isn't the answer for good audio recording. It is more for background recording, where audio isn't that important. The external mic connection (located on the left side of the camera) is a stereo mini jack (3.5mm). It is important that a stereo plug is used; otherwise you may end up with a noisy recording or no audio at all. The mic input supports condenser or dynamic micro-

216

phones but it does not supply power for microphones that require phantom power (+48V).

Recording Length

The 5D Mark II maintains the industry standard specification for Compact Flash cards so that the files from the camera can be accessed in all standard CF devices. The format of the card is FAT32. Because of this, there is a limitation on file size. The maximum size for a single file is 4GB. In HD recording on the 5D Mark II, this translates to approximately 12 minutes. For standard definition it is approximately 24 minutes.

For best results, use a high-speed UDMA CF card that is rated to at least 8MB/sec. If the card you are using is slow, a buffer capacity icon will appear on the LCD monitor. As the buffer fills up, waiting to write to the card, the icon indicates when the buffer is close to reaching capacity.

Hard-drive cards like MicroDrive are not recommended for Live View mode. These cards are more susceptible to heat build-up. 🌡 may appear and the 5D Mark II will shut down Live View.

Flash

Electronic flash is not just a supplement for low light; it can also be a wonderful tool for creative photography. Flash is highly controllable, its color is precise, and the results are repeatable. However, the challenge is getting the right look. Many photographers shy away from using flash because they aren't happy with the results. This is because on-camera flash can be harsh and unflattering, and taking the flash off the camera used to be a complicated procedure with less than sure results.

Because the Canon EOS 5D Mark II is targeted for professional photographers, it does not have a built-in flash. Its sophisticated metering system works well with flash, however, and the LCD monitor gives instantaneous feedback. This alleviates the guesswork. With digital, when you take a picture, you know immediately whether or not the lighting is right. You can then raise or lower the light level, change the angle, soften the light, color it, and more. Just think of the possibilities:

Fill Flash—Fill in harsh shadows in all sorts of conditions and use the LCD monitor to see exactly how effective the fill flash is. Often, you'll want to dial down an accessory flash to make its output more natural looking.

Using an external flash accessory can seem intimidating to photographers new to using a digital SLR, but it is a limitless tool allowing you to add to and manipulate the light in your photography. Understanding how to use the external flash is an important and handy skill to have. Photo © Marianne Skov Jensen

Off-Camera Flash—When you put a flash on a dedicated flash cord, the flash can be moved to positions away from the camera, yet still work automatically. If you use the LCD monitor, you can see exactly what the effects are so you can move the flash up or down, left or right, for the best light and shadows on your subject.

Close-Up Flash—This used to be a real problem, except for those willing to spend some time experimenting. Now you can see exactly what the flash is doing to the subject. This works great with off-camera flash, as you can "feather" the light (aim it so it doesn't hit the subject directly) to gain control over its strength and how it lights the area around the subject.

Multiple Flash—Modern flash systems have made exposure with multiple flashes easier and more accurate. Plus, many manufacturers have created cordless systems. In the past, the flash units were not on continuously and they could be hard to place so that they lit the subject properly. Not anymore. With the 5D Mark II, it is easy to set up the flash and take a test shot. Then preview the picture and make changes if you need to. In addition, the 5D Mark II lets you use certain EX-series flash units (and independent brands with the same capabilities) that offer wireless exposure control. This is a good way to learn how to master multiple-flash setups.

Colored Light—Many flashes look better when they are used with a slight warming filter, but that is not what this tip is about. With multiple light sources, you can attach colored filters (also called gels) to the various flashes so that different colors light different parts of the photo. (This can be a very trendy look.)

Balancing Mixed Lighting—Architectural and corporate photographers have long used added light to fill in the dark areas in a scene so it looks less harsh. Now you can double-check the light balance on your subject using the LCD monitor. You can even be sure the added light is the right color by attaching filters to the flash to mimic or match lights (such as a green filter to match fluorescents).

This portrait shows the effects of well-balanced flash in a mixed lighting situation—fluorescent backlight and fill flash for the subject—shown as a black-and-white image. Luminance principles are the same for color or black-and-white photography, and the result is an interesting, well-lit portrait. Photo © Marianne Skov Jensen

Flash Synchronization

The 5D Mark II is equipped with an electromagnetically timed, vertically traveling focal-plane shutter that forms a slit to expose the sensor as it moves across it. One characteristic of focal-plane shutters is that at shutter speeds faster than the flash sync speed, the entire surface of the sensor will not be exposed during the flash. So if you use flash with a shutter speed that is higher than the maximum flash sync speed, you get only a partially exposed picture. However, at shutter speeds below the maximum, the whole sensor surface will be exposed at some point to accept the flash.

The EOS 5D Mark II's maximum flash sync speed is 1/200 second. This sync speed is for portable Speedlites. For larger studio units, consider the sync speed to be 1/60 to 1/30.

Always test sync speed if you are unsure. If you use a Canon EX-series flash in Tv or M mode and set the exposure to a speed faster than the maximum, the camera will automatically reset the speed to 1/200.

The camera offers high-speed sync with EX-series flash units that allows flash at all shutter speeds. High-speed sync works by using a series of multiple flashes as the shutter curtains move across the image sensor. High-speed sync must be activated on the flash unit itself and is indicated by an H symbol on the flash unit's LCD panel. See the flash manual for specific information on using high-speed flash sync.

The 5D Mark II has a PC terminal to connect to flash units that use a sync cord. While you don't have to worry about sync cord polarity, do not connect the 5D Mark II to a flash that requires 250V or greater. A flash mounted in the hot shoe can also connect to the PC terminal. If you use the PC terminal to connect to an external flash, the sync speed is 1/125.

Guide Numbers
When shopping for a flash unit, compare guide numbers. A guide number (GN) is a simple way to state the flash unit's power. It is computed as the product of aperture value and subject distance and is usually included in the manufacturer's specifications for the unit. High numbers indicate more power; however, this is not a linear relationship. Guide numbers act a little like f/stops (because they are directly related to f/stops!); for example, 56 is half the power of 80, and 110 is twice the power of 80. Since guide numbers are expressed in feet and/or meters, distance is part of the guide number formula. Guide numbers are usually based on ISO 100 film, but this can vary, so check the film-speed reference (and determine whether the GN was calculated using feet or meters) when you compare different units. If the flash units you compare have zoom-head diffusers, make sure you compare the guide numbers for similar zoom-head settings.

Flash Metering

The 5D Mark II uses an evaluative autoexposure system, called E-TTL II, with improved flash control over earlier models. (It is based on the Canon E-TTL II system introduced in the EOS-1D Mark II.) To understand the 5D Mark II's flash metering, you need to understand how a flash works with a digital camera using automatic exposure. The camera causes the flash to fire twice for the exposure. First, a preflash fires to analyze exposure, then the flash fires during the actual exposure, creating the image. During the preflash, the camera's evaluative metering system measures the light reflected back from the subject. Once it senses that the light is sufficient, it cuts off the flash and takes the actual exposure with the same flash duration. The amount of flash hitting the subject is based on how long the flash is "on"— close subjects will receive shorter flash bursts than more distant subjects. This double-flash system works quite well, but you may also find that it causes some subjects to react by closing their eyes during the real exposure. However, they will be well exposed!

You can lock the flash exposure by pressing the FE (Flash Exposure) lock button ✵ . The FE lock causes the camera to fire a preflash so that it calculates the exposure before the shot. It also cancels the preflash that occurs immediately before the actual photograph, reducing the problem of people reacting to the preflash that occurs a split-second before the actual exposure.

To use the FE lock, attach a flash unit, turn it on, and then lock focus on your subject by pressing the shutter button halfway. Next, aim the center of the viewfinder at the important part of the subject and press the FE lock button ✵ . ⚡* appears in the viewfinder. Now reframe your composition and take the picture. FE lock produces quite accurate flash exposures. Make sure that the ⚡ part of the ⚡* in the viewfinder is not blinking. If it is blinking proper exposure will not be achieved—you'll need to adjust your exposure settings and try again.

Flash exposure compensation is helpful especially when using flash to fill in shadows—a technique commonly referred to as fill flash. In the above example, fill flash is used to add a little light to the dark areas on the statue.

Using the same principle as FE lock, you can make the flash weaker or stronger. Instead of pointing the viewfinder at the subject to set flash exposure, point it at something light in tone or at a subject closer to the camera. This causes the flash to give less exposure. For more light, aim the camera at something black or far away. With a little experimenting and by reviewing the LCD monitor, you can quickly establish appropriate flash control for particular situations.

You can also use the 5D Mark II's flash exposure compensation feature to adjust flash exposure by up to +/- 2 stops in 1/3-stop increments (or 1/2-stop increments if set using Custom Function I – 1, see page 137). It operates in similar fashion to the regular exposure compensation. Press ISO·🔆, then use ⊙ to adjust the flash exposure compensation. The exposure level indicator in the viewfinder displays the current flash exposure compensation setting.

Note: If you have already set flash exposure compensation directly on the flash unit, it supersedes any flash exposure compensation set on the 5D Mark II.

For the most control over flash, use the camera's M (Manual Exposure) setting. Set an exposure that is correct overall for the scene, and then turn on the flash. (The flash exposure will still be E-TTL automatic.) The shutter speed—as long as it is equal to or slower than the maximum flash sync speed—controls the overall light from the scene (and the total exposure). The f/stop controls the exposure of the flash. So to a degree, you can make the overall scene lighter or darker by changing shutter speed with no direct effect on the flash exposure. (Note, however, that this does not work with high-speed flash.)

Flash with Camera Exposure Modes

Flash photography can be used for any photo where supplementary light is needed. All you have to do is turn on the flash unit—the camera does the rest automatically. Speedlite EX flash units should be switched to E-TTL and the ready light should be on, indicating that the flash is ready to fire. While shooting, you must pay attention to the flash symbol ⚡ in the viewfinder to be sure that the flash is charged when you are ready to take your picture.

Full Auto ☐
Flash synchronization, between 1/60 and 1/200, is automatically selected by the camera depending on ambient light. Aperture is also set by the camera depending on the light level in the scene. Flash exposure compensation is not available. Automatic fill flash in outdoor photography is available.

Creative Auto CA
Flash operation is the same as with Full Auto ☐

Program AE P

The 5D Mark II sets flash synchronization shutter speeds of 1/60 – 1/200 second automatically in P mode and the camera selects the correct aperture. Flash exposure compensation ⚡ is available.

Shutter-Priority AE Tv

This mode is a good choice in situations where you want to control the shutter speed, but also use flash. In Tv mode, you set the shutter speed before or after a dedicated accessory flash is turned on. All shutter speeds between 1/200 second and 30 seconds synchronize with the flash. With a Canon EX-Series E-TTL Flash in Tv mode, synchronization with longer shutter speeds is a creative choice that allows you to control the ambient light background exposure. A portrait of a person at dusk in front of a building with its lights on shot with conventional TTL flash would illuminate the person correctly but would cause the background to go dark. However, using Tv mode, you can control the exposure of the background by changing the shutter speed. (A tripod is recommended to keep the camera stable during long exposures.) Flash exposure compensation ⚡ is available.

Aperture-Priority AE Av

When you use this mode, you can balance the flash with existing light, giving you control of depth of field in the composition. When you select the aperture, you can also influence the range of the flash. Select the aperture by turning the Main dial ⌒ and watching the external flash's LCD panel until the desired range appears. The camera calculates the lighting conditions and automatically sets the correct flash shutter speed for the ambient light. Flash exposure compensation ⚡ is available.

Manual Exposure M

Going manual gives you the greatest number of choices in modifying exposure. The photographer who prefers to adjust everything manually can determine the relationship of ambient light and electronic flash by setting both the aperture and shutter speed. Any aperture on the lens and all shutter

speeds between 1/200 second and 30 seconds can be used. If a shutter speed above the normal flash sync speed is set, the 5D Mark II switches automatically to 1/200 second to prevent partial exposure of the sensor.

M mode also offers a number of creative possibilities for using flash in connection with long shutter speeds. You can use zooming effects with a smeared background and a sharply rendered main subject, or photograph objects in motion with a sharp "flash core" and indistinct outlines.

Note: Canon Speedlites can be used for auto focus assistance in low-light situations. Using Custom Function III – 5 (see page 146), you can enable a low power firing of the flash to help illuminate the scene so the auto focus system operates properly. If you turn off the actual firing of the flash the Speedlite is transformed into a low-light focusing aid.

Canon Speedlite EX Flash Units

Canon offers a range of accessory flash units in the EOS system called Speedlites. While Canon Speedlites don't replace studio strobes, they are remarkably versatile. These highly portable flash units can be mounted in the camera's hot shoe or used off camera with a dedicated cord. The 5D Mark II is compatible with the EX-series of Canon Speedlites. The EX-series flash units range in power from the Speedlite 580EX II, which has a maximum ISO 100 GN of 190 in feet (58 in meters), to the small and compact Speedlite 220EX, which has an ISO 100 GN of 72 in feet (22 in meters). Speedlite EX-series flash units offer a wide range of features to expand your creativity. They are designed to work with the camera's microprocessor to take advantage of E-TTL exposure control, extending the abilities of the 5D Mark II considerably.

I also strongly recommend Canon's off-camera shoe cord, OC-E3, an extension cord for your flash. When you use this cord, the flash can be moved away from the camera for more interesting light and shadow. You can aim light toward

the side or top of a close-up subject for variations in contrast and color. If you find that you get an overexposed subject, rather than dialing down the flash (which can be done on certain flash units), just aim the flash away from the subject a little so it doesn't get hit so directly by the light or move the flash farther away. That is often a quick fix for overexposure of close-ups.

The Canon Speedlite 580EX II attached to the 5D Mark II

Canon Speedlite 580EX II

Introduced with the EOS 1D Mark III, the 580EX II replaced the popular 580EX. This top-of-the-line flash unit offers outstanding range and features adapted to digital cameras. Improvements over the 580EX include a stronger quicklocking hot shoe connection, stronger battery door, dust

and water resistance (particularly when used with the 5D Mark II), a shorter recycling time (nearly 20% faster), and an external metering sensor. The tilt/swivel zoom head on the 580EX II covers focal lengths from 14mm to 105mm, and it swivels a full 180° in either direction. The zoom positions (which correspond to the focal lengths 24, 28, 35, 50, 70, 80, and 105mm) can be set manually or automatically (the flash reflector zooms with the lens). In addition, this flash "knows" what size sensor is used with a digital SLR and it varies its zoom accordingly. With the built-in retractable diffuser in place, the flash coverage is wide enough for a 14mm lens. It provides a high flash output with an ISO 100 GN of 190 in feet (58 in meters) when the zoom head is positioned at 105mm. The guide number decreases as the angular coverage increases for shorter focal lengths, but is still quite high with a GN of 145 at 50mm, or GN 103 at 28mm.

When the 580EX II is mounted on the 5D Mark II there is two way communication between the camera and the Speedlite. Alongside sensor size information and lens focal length, white balance information is sent to the camera. While the flash white balance preset (see page 101) works well, variations in power can cause changes in the color temperature of the light output by the Speedlite. The 580EX II communicates these changes to the 5D Mark II.

Much like the exposure bracketing found on the 5D Mark II, the 580EX II offers flash exposure bracketing or FEB. With this setting you can shoot 3 photographs with varying flash output +/- 3-stops in 1/2 or 1/3 stop increments. Unlike flash exposure compensation, flash exposure bracketing is a function of the 580EX II and won't be indicated in the 5D Mark II viewfinder when it is engaged. It will be displayed on the LCD on the back of the Speedlite.

The illuminated LCD panel on the 580EX II provides information on all settings: Flash function, reflector position, working aperture, and flash range in feet or meters. The flash also includes a Select dial for easier selection of these

At first glance, the Canon Speedlites look small, but looks can be deceiving. This jet was entirely lit with just two Speedlights: one unit functions as the master flash, and one as the slave unit.

settings. When you press the 5D Mark II's Depth-of-Field Preview button (on lower right of the lens mount housing), a one-second burst of light is emitted. This "modeling" flash allows you to judge the effect of the flash. The 580EX II also has 14 user-defined Custom Functions that are totally independent of the camera's Custom Functions (for more information, see the flash manual).

Because the flash display is relatively small, various settings like Custom Functions have been reduced to number codes. Setting various flash modes can require button pressing sequences that are not intuitive. However, when you attach the 580EX II to the 5D Mark II, you can adjust many of the flash settings using the larger camera LCD. You can set the flash mode, shutter sync, flash exposure compensation, flash exposure bracketing, flash metering, and all the Custom Functions.

With Speedlite Custom Functions, the camera menu (located in 🍴 and labeled as [External Speedlite control]) spells out each of the settings, making it easy to customize your flash settings instead of relying on a manual to decode the functions. You can also adjust the flash zoom head setting and wireless E-TTL setting from the camera. This allows you to enable master flash settings, change wireless channels and adjust the flash ratio of master-and-slave Speedlites.

When you adjust a function it remains in the Speedlite's memory even when you remove it from the camera. So if you have multiple Speedlites you can quickly use the 5D Mark II as a programming device for all of your flashes. This new way of controlling the flash from the camera makes flash upgrades to the new series II Speedlites an attractive option.

The 580EX II can function as either a master flash or a slave unit when used in combination with other Speedlites. It also has a PC terminal for use with PC cords. For external power, its power pack, LP-E4, has been developed for dust and water-resistance.

While the E-TTL function built in to the 580EX II is a great tool for getting accurate exposures, new to this Speedlite is an automatic flash exposure sensor. For years flash units have had on-board sensors that control flash output. But with the advent of TTL metering on-board flash sensors have disappeared. The 580EX II has brought this technology back. While some might consider this "old school," it is a useful option when the Speedlite is not attached to the camera.

Canon Speedlite 430EX II
Much like the 580EX II improved on the 580EX, the 430EX II, introduced in June of 2008, improves on the 430EX. While the GN stays the same—141/43 (ISO 100 in feet/meters) the recycle time has decreased by 20%. It is also quieter than the 430EX and can be controlled from the 5D Mark II just like the 580EX II. It offers E-TTL flash control, wireless E-TTL operation, flash exposure compensation, and high-speed synchronization. It does not offer flash exposure bracketing.

New to this version is the white balance compensation found in the 580EX II. The tilt/swivel zoom reflector covers focal lengths from 24 to 105mm and swivels 180 degrees in each direction. The zoom head operates automatically for focal lengths of 24, 28, 35, 50, 70, 80, and 105mm. A built-in wide-angle pull-down reflector makes flash coverage wide enough for a 14mm lens.

An LCD panel on the rear of the unit makes adjusting settings easy, and there are six Custom Functions that are accessible. Just like the 580EX II, you can control most of the settings and custom functions from the 5D Mark II menus. Since the 430EX II supports wireless E-TTL, it can be used as a remote (slave) unit. A new quick release mounting system makes it easy to securely attach the 430EX II to the 5D Mark II.

Canon Speedlite 430EX

The 430EX is less complicated, more compact, and less expensive than the top models. It offers E-TTL flash control, wireless E-TTL operation, flash exposure compensation, and high-speed synchronization. The 430EX flash unit provides high performance with an ISO 100 GN of 141 in feet (43 in meters) with the zoom reflector set for 105mm (somewhat weaker than the 580EX II, but still quite powerful). The tilt/swivel zoom reflector covers focal lengths from 24 to 105mm. The zoom head operates automatically for focal lengths of 24, 28, 35, 50, 70, 80, and 105mm. A built-in, wide-angle pull-down reflector makes flash coverage wide enough for a 17mm lens. An LCD panel on the rear of the unit makes adjusting settings easy, and there are six Custom Functions that are accessible. Since the 430EX supports wireless E-TTL, it can be used as a slave unit.

Other Speedlites

The Speedlite 220EX is an economy alternative EX-series flash. It offers E-TTL flash and high-speed sync, but does not offer wireless TTL flash or flash exposure bracketing. The 5D Mark II does offer flash exposure compensation with the 220EX.

If you use older Canon Speedlites (EZ/E/EG, for example) in TTL or A-TTL mode, the flash will fire at full output, so shoot in Aperture Priority or Manual mode. If the Speedlite has a Manual mode, use it.

Close-Up Flash

There are also two specialized flash units for close-up photography that work well with the EOS 5D Mark II. Both provide direct light on the subject.

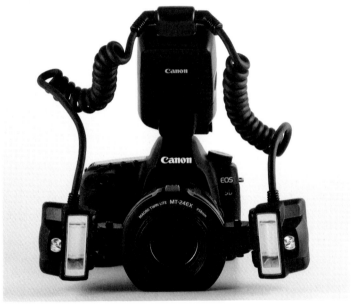

Macro Twin Lite MT-24EX attached to the 5D Mark II

Macro Twin Lite MT-24EX

The MT-24EX uses two small flashes affixed to a ring that attaches to the lens. These can be adjusted to different positions to alter the light. They can also be used at different strengths, so one can be used as a main light and the other as

a fill light. If both flash tubes are switched on, they produce an ISO 100 GN of 72 in feet (22 in meters), and when used individually the guide number is 36. The MT-24EX does an exceptional job with directional lighting in macro shooting.

Macro Ring Lite MR-14EX

Like the MT-24EX, the MR-14EX uses two small flashes affixed on a ring. It has an ISO 100 GN of 46 in feet (14 in meters) and both flash tubes can be independently adjusted in 13 steps from 1:8 to 8:1. The MR-14EX is a flash that encircles the lens and provides illumination on axis with it. This results in nearly shadowless photos because the shadow falls behind the subject compared to the lens position; however, there will be shadow effects along curved edges. The MR-14EX is often used to show fine detail and color in a subject, but it cannot be used for varied light and shadow effects. This flash is commonly used in medical and dental photography so that important details are not obscured by shadows.

The power pack for each of these specialized flash units fits into the camera's hot shoe. In addition, both macro flash units offer some of the same technical features as the 580EX II, including E-TTL operation, wireless E-TTL flash, and high-speed synchronization.

Note: When the 5D Mark II is used with older system flash units (such as the EZ-series), the flash unit must be set to manual, or TTL will not function. For this reason, Canon EX Speedlite system flash units are recommended for use with this camera.

Bounce Flash

Direct flash can often be harsh and unflattering, causing heavy shadows behind the subject or underneath features such as eyebrows and bangs. Bouncing the flash softens the light and creates a more natural-looking light effect. The Canon Speedlite 580EX II, 430EX II, and 430EX accessory

flash units feature heads that are designed to tilt so that a shoe-mounted flash can be aimed at the ceiling to produce soft, even lighting. The 580EX II and 430EX II also swivel 180° in both directions, so the light can be bounced off something to the side of the camera, like a wall or reflector. However, the ceiling or wall must be white or neutral gray, or it may cause an undesirable color cast in the finished photo.

Wireless E-TTL Flash

With the Wireless E-TTL feature, you can use up to three groups of Speedlite 580EX IIs, 430EX IIs, 430EXs, or the now discontinued 580EXs, 550EXs, and 420EXs, for more natural lighting or emphasis. (The number of flash groups is limited to three, but the number of actual flash units is unlimited.) The master Speedlite unit and the camera control exposure. When you use the 580EX II, you can set it to be the master (controlling all the other flashes) or a slave. The 430EX II and the 430EX can only be used as a remote (slave) unit.

Other wireless flash options include the Macro Twin Lite MT-24EX and the Macro Ring Lite MR-14EX. There is also a special wireless transmitter, ST-E2, that can be mounted on the 5D Mark II. This unit controls all of the wireless functions of the remote flashes just like a 580EX II does, but it does not light the scene. The ST-E2 system uses infrared light pulses to communicate with the slave flashes, so, like the rest of the Speedlites, it needs to have line of sight with every remote flash unit.

To operate wireless E-TTL, a Speedlite 580EX II (or the ST-E2, 580EX, or 550EX) is mounted in the flash shoe on the camera and the unit is set so that it functions as a master unit. Next, the slave units are set up in the surrounding area. The light ratio of slave units can be varied manually or automatically. With E-TTL control, several different Speedlite 420EXs, 430EXs, 430EX IIs, 550EXs, 580EXs and 580EX IIs can be controlled at once.

Lenses and Accessories

The Canon EOS 5D Mark II belongs to an extensive family of Canon EOS compatible equipment, including lenses, flashes, and other accessories. With this wide range of available options, you can expand the capabilities of your camera quite easily should you want to. Canon has long had an excellent reputation for its lenses, and several independent manufacturers offer quality Canon-compatible lenses as well.

The EOS 5D Mark II can use Canon's EF lenses, ranging from wide-angle to telephoto zooms, as well as prime, or single-focal-length lenses, from very wide to extreme telephoto. The 5D Mark II cannot accept the EF-S series lenses.

Choosing Lenses

The focal length and design of a lens has a huge effect on how you photograph. The correct lens makes photography a joy; the wrong one makes you leave the camera at home. One approach for choosing a lens is to determine if you are frustrated with your current lenses. Do you constantly want to see more of the scene than the lens allows? Then consider a wider-angle lens. Is the subject too small in your photos? Then look into acquiring a telephoto lens.

Certain subjects lend themselves to specific focal lengths. Wildlife and sports action are best photographed using focal lengths of 300mm or more, although nearby action can be managed with 200mm. Portraits look great when shot with

A good quality lens can make a huge difference in your photography, both in terms of precision (as seen here with this specific depth-of-field effect) and speed.

Canon offers a wide range of lenses that cover any shooting style, feature preference, and budget considerations.

focal lengths between 80 and 100mm. Interiors often demand wide-angle lenses such as 20 or 24mm. Many people also like wide-angle lenses for landscapes, but telephotos can come in handy for distant scenes. Close-ups can be shot with nearly any focal length, though skittish subjects such as butterflies might need a rather long lens.

Many digital sensors are not "full frame" (meaning they are smaller than a frame of 35mm film), so they crop the area seen by the lens, essentially creating a different format. Effectively, this magnifies the subject within the image area and results in the lens acting as if it has been multiplied by a factor of, for example, 1.3 compared to 35mm film cameras. But the 5D Mark II sensor is full frame so there is no focal length multiplier (or field of view cropping factor).

Zoom vs. Prime Lenses

When zoom lenses first came on the market, they were not even close to a single-focal-length lens in sharpness, color rendition, or contrast. Today, you can get superb image quality from either type. However, there are some important differences. The biggest is maximum f/stop.

Zoom lenses are rarely as fast (e.g. rarely have as big a maximum aperture) as single-focal-length (prime) lenses. A 28-200mm zoom, for example, might have a maximum aperture at 200mm of f/5.6, yet a single-focal-length lens might be f/4 or even f/2.8. When zoom lenses come close to a single-focal-length lens in f/stops, they are usually considerably bigger and more expensive than the single-focal-length lens. Of course, they also offer a whole range of focal lengths, which a single-focal-length lens cannot do. There is no question that zoom lenses are versatile.

EF-Series Lenses

Canon EF lenses include some unique technologies. Canon pioneered the use of tiny autofocus motors in its lenses. In order to focus swiftly, the focusing elements within the lens need to move with quick precision. Canon developed the lens-based ultrasonic motor for this purpose. This technology makes the lens motor spin with ultrasonic oscillation energy instead of the conventional drive-train system (which tends to be noisy). This allows lenses to autofocus nearly instantly with no noise while using less battery power than traditional systems. Canon lenses that utilize this motor are labeled USM. (Lower-priced Canon lenses have small motors in the lenses too, but they don't use USM technology and can be slower and noisier.)

Canon was also a pioneer in the use of image-stabilizing technologies. Image Stabilizer IS lenses use sophisticated motors and sensors to adapt to slight movement during exposure. It's pretty amazing—the lens actually has vibration-detecting gyrostabilizers that move a special image-stabilizing lens group in response to movement of the lens. This dampens movement that occurs from handholding a camera and allows much slower shutter speeds to be used. IS also

allows big telephoto lenses (such as the EF 500mm IS lens) to be used on tripods that are lighter than would normally be used with non-IS telephoto lenses.

The IS technology is part of many zoom lenses and does a great job overall. However, IS lenses in the mid-focal length ranges have tended to be slower zooms matched against single-focal-length lenses. For example, compare the EF 28-135mm f/3.5-5.6 IS lens to the EF 85mm f/1.8. The former has a great zoom range, but allows less light at maximum aperture. At 85mm (a good focal length for people), the EF 28-135mm is an f/4 lens, more than two stops slower than the f/1.8 single-focal-length lens when both are shot "wide-open" (typical of low light situations). While you could make up the two stops due to the IS technology, that also means you must use two full shutter speeds slower, which can be a real problem in stopping subject movement.

L-Series Lenses

Canon's L-series lenses use special optical technologies for high-quality lens correction, including low-dispersion glass, fluorite elements, and aspherical designs. UD (ultra-low dispersion) glass is used in telephoto lenses to minimize chromatic aberration, which occurs when the lens can't focus all colors equally at the same point on the sensor (or on the film in a traditional camera), resulting in less sharpness and contrast. Low-dispersion glass focuses colors more equally for sharper, crisper images.

Fluorite elements are even more effective (though more expensive) and have the corrective power of two UD lens elements. Aspherical designs are used with wide-angle and mid-focal length lenses to correct the challenges of spherical aberration in such focal lengths. Spherical aberration is a problem caused by lens elements with extreme curvature (usually found in wide-angle and wide-angle zoom lenses). Glass tends to focus light differently through different parts of such a lens, causing a slight overall softening of the image even though the lens is focused sharply. Aspherical lenses use a special design that compensates for this optical defect.

This image was taken with an EF 24mm f/1.4L II USM lens.

With the introduction of the 5D Mark II, Canon introduced a new EF 24mm f/1.4L II USM lens that replaces the original EF 24mm f/1.4L USM lens and is the fastest wide-angle L series lens. This new lens features a complete optical re-design that includes two high-precision aspherical lens elements, along with two Ultra-low Dispersion (UD) elements. Combined, the lens elements minimize chromatic aberration and increase image quality, particularly on the periphery. A recently developed Subwavelength Structure Coating has been applied to the interior surface of the first lens element to reduce ghosting and flare, particularly from off-angle sources. The lens uses internal focusing so the front of the lens does not rotate. This helps when you use polarizing filters or graduated filters.

DO-Series Lenses

Another Canon optical design is the DO (diffractive optic). This technology significantly reduces the size and weight of a lens without sacrificing quality, and is therefore useful for big telephotos and zooms. The lenses produced by Canon in this series are a 400mm pro lens that is only two-thirds the size and weight of the equivalent standard lens, and a 70-300mm IS lens that offers a great focal length range while including image stabilization.

Macro and Tilt-Shift Lenses

Tilt-shift lenses can simulate the focus effects traditionally associated with 4x5 view cameras, and allow the photographer to experiment with alternative optical effects.

Canon also makes some specialized lenses. Macro lenses are single-focal-length lenses optimized for high sharpness throughout their focus range, from very close (1:1 or 1:2) magnifications to infinity. These lenses range from 50mm to 180mm.

Tilt-shift lenses are unique lenses that shift up and down or tilt toward or away from the subject. They mimic the controls of a view camera. Shift lets the photographer keep the back of the camera parallel to the scene and move the lens to get a tall subject into the composition—this keeps vertical lines vertical and is extremely valuable for architectural photographers. Tilt changes the plane of focus so that sharpness can be changed without changing the f/stop. Focus can be extended from near to far by tilting the lens toward the subject, or sharpness can be limited by tilting the lens away from the subject.

Independent Lens Brands
Independent lens manufacturers also make some excellent lenses that fit the 5D Mark II. I've seen quite a range in capabilities from these lenses. Some include low-dispersion glass and are stunningly sharp. Others may not match the best Canon lenses, but offer features (such as focal-length range or a great price) that make them worth considering. To a degree, you get what you pay for. A low-priced Canon lens probably won't be much different than a low-priced independent lens. On the other hand, the high level of engineering and construction found on a Canon L-series lens can be difficult to match.

Filters and Close-Up Lenses

Many people assume that filters aren't needed for digital photography because adjustments for color and light can be made on the computer. By no means are filters obsolete! They actually save a substantial amount of work in the digital darkroom by allowing you to capture the desired color and tonalities for your image right from the start. Even if you can do certain things on the computer, why take the time if you can do it more efficiently while shooting?

Of course, the LCD monitor comes in handy once again. By using it, you can assist yourself in getting the best from your filters. If you aren't sure how a filter works, simply try it

and see the results immediately on the monitor. This is like using a Polaroid, only better, because you need no extra gear. Just take the shot, review it, and make adjustments to the exposure or white balance to help the filter do its job. If a picture doesn't come out the way you would like, discard it and take another right away.

Attaching filters to the camera depends entirely on your lenses. Usually, a properly sized filter can either be screwed directly onto a lens or fit into a holder that screws onto the front of the lens. There are adapters to make a given size filter fit several lenses, but the filter must cover the lens from edge to edge or it will cause dark corners in the photo (vignetting). A photographer may even hold a filter over the lens with his or her hand.

Note: While the 5D Mark II includes Peripheral illumination correction, don't expect to correct an improperly sized filter.

There are a number of different types of filters that perform different tasks:

Polarizers

This important outdoor filter should be in every camera bag. Its effects cannot be duplicated exactly with software because it actually affects the way light is perceived by the sensor.

A polarizer darkens skies at 90° to the sun (this is a variable effect), reduces glare (which will often make colors look better), removes reflections, and increases saturation. While you can darken skies on the computer, the polarizer reduces the amount of work you have to perform in the digital darkroom. The filter can rotate in its mount, and as it rotates, the strength of the effect changes. While linear polarizers often have the strongest effect, they can cause problems with exposure and often prevent the camera from autofocusing. Consequently, you are safer using a circular polarizer with the 5D Mark II.

Neutral Density Gray Filters

Called ND filters, this type is a helpful accessory. ND filters simply reduce the light coming through the lens. These filters come in different strengths, each reducing different quantities of light. They give additional exposure options under bright conditions, such as a beach or snow (where a filter with a strength of 4x is often appropriate). If you like the effects when slow shutter speeds are used with moving subjects, a strong neutral density filter (such as 8x) usually works well. Of course, the great advantage of the digital camera is that you can see the effects of slow shutter speeds immediately on the LCD monitor so you can modify your exposure for the best possible effect.

Graduated neutral density filters are useful for mixed exposures like the image shown (right), where the sky would normally be overexposed and/or detail lost in the shadow areas. The ND grad filter limits the amount of light from the sky and allows the detail in the shadows to come through more clearly (left).

Graduated Neutral Density Filters

Many photographers consider this filter an essential tool. It is half clear and half dark (gray). It is used to reduce bright

areas (such as sky) in tone, while not affecting darker areas (such as the ground). The computer can mimic its effects, but you may not be able to recreate the scene you wanted. A digital camera's sensor can only respond to a certain range of brightness at any given exposure. If a part of the scene is too bright compared to the overall exposure, detail will be washed out and no amount of work on the computer will bring it back. While you could capture two shots of the same scene at different exposure settings and combine them on the computer, a graduated ND might be faster and is a must if there are moving objects in your scene.

UV and Skylight Filters

Though many amateur photographers buy these, pros rarely use them. The idea behind them is to give protection to the front of the lens, but they do very little visually. Still, they can be useful when photographing under such conditions as strong wind, rain, blowing sand, or going through brush.

If you use a filter for lens protection, a high quality filter is best, as a cheap filter can degrade the image quality of the lens. Remember that the manufacturer made the lens/sensor combination with very strict tolerances. A protective filter needs to be literally invisible, and only high-quality filters can guarantee that.

Close-Up Lenses

Close-up photography is a striking and unique way to capture a scene. Most of the photographs we see on a day-to-day basis are not close-ups, making those that do make their way to our eyes all the more noticeable. It is surprising to me that many photographers think the only way to shoot close-ups is with a macro lens. The following are four of the most common close-up options:

- **Close-focusing zoom lenses with a macro or close-focus feature:** Most zoom lenses allow you to focus up-close without accessories, although focal-length choices may become limited when using the close-focus feature. These lenses are an easy and effective way to start shooting

close-ups. Keep in mind, however, that even though these may say they have a macro setting, it is really just a close-focus setting and not a true macro as described below in option four.

- **Close-up accessory lenses:** You can buy lenses that screw onto the front of your lens to allow it to focus even closer. The advantage is that you now have the whole range of zoom focal lengths available and there are no exposure corrections. Close-up filters can do this, but the image quality is not great. More expensive achromatic accessory lenses (highly-corrected, multi-element lenses) do a superb job with close-up work, but the original lens limits their quality.

- **Extension tubes:** Extension tubes fit in between the lens and the camera body of an SLR. This allows the lens to focus much closer than it could normally. Extension tubes are designed to work with all lenses for your camera (although older extension tubes may not work on the 5D Mark II). Be aware that extension tubes cause a loss of light.

- **Macro lenses:** Though relatively expensive, macro lenses are designed for superb sharpness at all distances and they focus from mere inches to infinity. In addition, they are typically very sharp at all f/stops.

Sharpness is a big issue with close-ups, and this is not simply a matter of buying a well-designed macro lens. The other close-up options can also give superbly sharp images. Sharpness problems usually result from three factors: limited depth of field, incorrect focus placement, and camera movement.

The closer you get to a subject, the shallower depth of field becomes. You can stop your lens down as far as it will go for more depth of field or you can use a lens with a wider angle, but depth of field will still be limited. Because of this, it is critical to be sure focus is placed correctly on the subject. If the back of an insect is sharp but its eyes aren't, the photo will appear to have a focus problem. At these

This shot, taken with Canon's TS-E45mm f/2.8 lens, shows the interesting visual effects you can get from a tilt-shift lens. Photo © Andre Bergeron

close distances, every detail counts. If only half of the flower petals are in focus, the overall photo will not look sharp. Autofocus up close can be a real problem with critical focus placement because the camera often focuses on the wrong part of the photo.

Of course, you can review your photo on the LCD monitor (or use the Live View function) to be sure the focus is correct before leaving your subject. You can also try manual focus. One technique is to focus the lens at a reasonable distance, then move the camera toward and away from the subject as you watch it go in and out of focus. This can really help, but you may find that taking multiple photos is the best way to guarantee proper focus at these close distances. Another good technique is to shoot using Continuous

drive mode ⬚ and fire multiple photos. You will often find at least one shot with the critical part of your subject in focus. This is a great technique when you are handholding or when you want to capture moving subjects.

When you are focusing close, even slight movement can shift the camera dramatically in relation to the subject. The way to help correct this is to use a high shutter speed or put the camera on a tripod. Two advantages to using a digital camera during close-up work are the ability to check the image to see if you are having camera movement problems, and the ability to change ISO settings from picture to picture—enabling a faster shutter speed if you deem it necessary. See page 164 for more about ISO speed.

Close-Up Contrast
The best looking close-up images are often ones that allow the subject to contrast with its background, making it stand out and add some drama to the photo. Although maximizing contrast is important in any photograph where you want to emphasize the subject, it is particularly critical for close-up subjects where a slight movement of the camera can totally change the background.

There are three important contrast options to keep in mind:

• **Tonal or brightness contrasts:** Look for a background that is darker or lighter than your close-up subject. This may mean a small adjustment in camera position. Backlight is excellent for this since it offers bright edges on your subject with lots of dark shadows behind it.

• **Color contrasts:** Color contrast is a great way to make your subject stand out from the background. Flowers are popular close-up subjects and, with their bright colors, they are perfect candidates for this type of contrast. Just look for a background that is either a completely different color (such as green grass behind red flowers) or a different saturation of color (such as a bright green bug against dark green grass).

- **Sharpness contrast:** One of the best close-up techniques is to work with the inherent limit in depth of field and deliberately set a sharp subject against an out-of-focus background or foreground. Look at the distance between your subject and its surroundings. How close are other objects to your subject? Move to a different angle so that distractions are not conflicting with the edges of your subject. Try different f/stops to change the look of an out-of-focus background or foreground.

Viewfinder Accessories

Focusing Screens

The focusing screen in the 5D Mark II can be replaced. Canon offers 3 focusing screens that can be installed in the viewfinder. Changing the focusing screen can help if you prefer to do manual focusing more than autofocusing or would like to add grids to help with composition. Note that it is necessary, when you replace the focusing screen, to let the 5D Mark II know which screen you are using. Use Custom Function IV-5 and choose from one of three options (see page 152).

Note: These Eg series focusing screens are new to the 5D Mark II. You cannot use focusing screens that were developed for older EOS cameras.

The focusing screens are:
- **Eg-A–Standard Precision Matte screen.** This is the screen that is included with the 5D Mark II. If you need to replace the original screen because of damage, this is the one.
- **Eg-D–Precision Matte with grid.** This screen is similar to the Eg-A Standard Precision Matte screen except that it has vertical and horizontal grids that help ensure the composition is oriented properly.
- **Eg-S–Super Precision Matte screen.** In critical focusing situations the Eg-S offers more accuracy. If you use lenses faster than f/2.8, the standard Eg-A Standard Precision Matte

screen is not able to show the true depth of field. The Eg-S Super Precision Matte screen uses more powerful microlenses that are able to more accurately represent the depth-of-field. This allows for more precise control of focus. The downside of using this screen is that the image in the viewfinder is slightly darker when you use slower lenses.

Additional Viewfinder Accessories
If you shoot in environments like the cold outdoors or in warm, humid areas, the viewfinder may fog up. An anti-fog eyepiece addresses this problem. Made with an advanced-process glass that contains a thin membrane of moisture-absorbing high-tech polymer, it minimizes condensation or fogging.

While the 5D Mark II comes with the standard Canon adjustable diopter that gives you a range from -3.0 to +1 of diopter correction, you can purchase 7 different individual dioptric adjustment lenses that range from –4 to +3. Older dioptric adjustment lenses will not work on the 5D Mark II; the 5D Mark II requires the Eg-series. The Eg-series come with their own frame and eyecup.

Lastly, if you shoot with the 5D Mark II low to the ground or in situations where it is difficult to place your eye against the viewfinder, the Canon Angle Finder C may help. This is a great accessory for shooting in awkward positions. As an added benefit, the Angle Finder offers an additional 2.5x magnification of the viewfinder image to help with focusing.

Other Accessories

Wireless File Transmitter
A new accessory for the 5D Mark II, the WFT-E4A allows you to wirelessly control the camera and remotely view its Live View images. With a range of up to 492 feet depending on conditions, the WFT-E4A lets you wirelessly transfer and back up your images. (The WFT-E4A uses the 802.11b/g wifi standard.)

The transmitter attaches to the side of the camera and has both USB 2.0 and Ethernet connections. The USB connector allows you to connect a large USB hard drive so that you can record images directly to the drive. Wireless or wired, the WFT-E4A can connect to a computer using FTP, HTTP, or PTP connection protocols. In addition you can use the Canon EOS Utility software to remotely control the EOS 5D Mark II for tethered shooting, including Live View and focus control. (See page 269 for more about the EOS Utility software.)

The USB connector also allows you to connect a GPS (Global Positioning System) device so that you can embed the exact longitude and latitude into the EXIF data in each image. This GPS data appears below the histogram on the LCD.

Shutter Control

Besides shooting tethered to a computer, there are five options for remote control of the shutter: the RS-80N3, the TC-80N3, the LC-5, the RC-1 and the RC-5.

The RS-80N3 is a simple remote shutter release with a locking mechanism so you can keep the shutter open for extremely long exposures. It works similarly to the shutter button—press it halfway for metering and focus. The RS-80N3 comes with an attached 2.6-foot (80 cm) cable that plugs into the left side of the 5D Mark II. It uses the N-3 type remote connector.

The TC-80N3 takes the RS-80N3 a step further in that it offers several more options for controlling the shutter. You may program a long exposure by actual minutes and seconds—with a maximum length of nearly 100 hours. The TC-80N3 can also be used as a custom self-timer with a range of 1 second to almost 100 hours. If you are interested in shooting time-lapse sequences you can use the TC-80N3 as an intervalometer, setting up exposures on a regular interval between shots, from 1 second to 99 hours, 59 minutes 59 seconds. Lastly, you can use an exposure count mode with the other modes to specify a limit to the number of exposures taken. The TC-80N3 also uses the N-3 type connector.

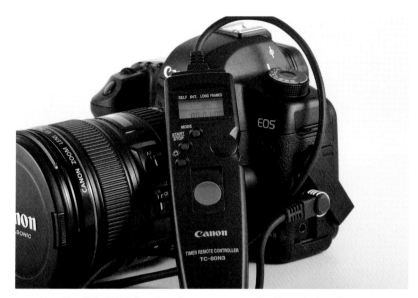

Use the RS-80N3 for timed exposures and other shots where you want to limit camera movement; a shutter remote can prevent the unwanted effects of camera shake during a slow shutter exposure.

Both the RS-80N3 and the TC-80N3 can be extended by 33 feet (10 m) using the ET-1000N3 extension cord.

The LC-5 Wireless Controller couples a hot-shoe mounted transmitter with a hand-held transmitter to allow for wireless control of the 5D Mark II. The working distance is approximately 330 feet (100 m). It offers four control modes: single exposure, test, continuous drive, and a delay mode. The test mode lights up a red LED on the receiver so that without firing a shot you can verify that the wireless system is working. Continuous mode is like pressing and holding the camera's shutter button. In delay mode the shutter triggers about three and a half seconds after you press the remote shutter button. In order to prevent interference with other LC-5s, the unit has three operation channels to choose from.

A more affordable wireless option is either the RC-1 or RC-5 wireless remote controller. Each of these controllers

has a working distance of about 16 feet. The remote sensor on the 5D Mark II is on the front of the camera so you must be able to point the remote at the front of the camera. The RC-5 triggers the shutter after a 2-second delay while the RC-1 can shoot with a 2-second delay or immediately. In addition you can also use the RC-1 to start and stop video recording when the 5D Mark II is in the Live View mode when the drive mode is set for ▮⟳$_2$.

Image Verification
The Original Data Security Kit OSK-E3 allows for verification of the authenticity of images taken by the 5D Mark II. This is useful in forensic applications where you need to establish that images have not been modified. Besides the image, metadata, including any GPS data, can be independently verified. Custom function IV-6 must be set in order to append verifying information to the image files. Another of the OSK-E3's features is the ability to encrypt the data after image capture so that interception of images transmitted wired or wirelessly can be prevented. This encryption also helps prevent modification of images after capture.

Tripods and Camera Support

A successful approach to getting the most from a digital camera is to be aware that camera movement can affect sharpness and tonal brilliance in an image. Even slight movement during the exposure can cause the loss of fine details and the blurring of highlights. These effects are especially glaring when you compare an affected image to a photo that has no motion problems. In addition, affected images will not enlarge well.

You must minimize camera movement in order to maximize the capabilities of your lens and sensor. A steady hold on the camera is a start. Fast shutter speeds, as well as the use of flash, help to ensure sharp photos, although you can get away with slower shutter speeds when using wider-angle lenses. When shutter speeds go down, however, it is advisable

to use a camera-stabilizing device. Tripods, beanbags, monopods, mini tripods, shoulder stocks, clamps, and more all help. Many photographers carry a small beanbag or a clamp pod with their camera equipment for those situations where the camera needs support but a tripod isn't available.

Check your local camera store for a variety of stabilizing equipment. Remember that a tripod can last a lifetime, so a good quality tripod is an excellent investment. When buying one, extend it all the way to see how easy it is to open, then lean on it to see how stiff it is. Both aluminum and carbon fiber tripods offer great rigidity. Carbon fiber is much lighter, but also more expensive. A new option that is in the middle range of price and performance between aluminum and carbon fiber is basalt. Basalt tripods are stronger than aluminum but not quite as light as carbon fiber.

The head is a very important part of the tripod and may be sold separately. There are two basic types for still photography: the ball head and the pan-and-tilt head. Both designs are capable of solid support and both have their passionate advocates. The biggest difference between them is how you loosen the controls and adjust the camera. Try both and see which seems to work better for you. Be sure to do this with a camera on the tripod because the added weight changes how the head works. Make sure that the tripod and head you choose can properly support the weight of the 5D Mark II and all the lenses you will be using.

When shooting video, it is often necessary to pan the camera left or right or tilt the camera up and down to follow action. Some "photo" heads allowing panning, but many might not have a panning handle that allows you to operate the head while looking at the LCD monitor. If your tripod head has panning, it probably doesn't have the ability to tilt smoothly while recording video. Consider adding a video head to your tripod. Look for a "fluid" video head that will offer smooth movement in all directions. Make sure that the head is not oversized for the 5D Mark II and the lenses and lens accessories that you plan to use.

Camera to Computer

There are two main ways of transferring digital files from the memory card into the computer. One way is to insert the card into an accessory known as a media card reader. Card readers connect to your computer through the USB or FireWire ports and can remain plugged in and ready to download your images or videos. The second way is to download images directly from the 5D Mark II using a USB interface cable (included with the camera at the time of purchase).

FireWire (also called iLink or 1394) is faster than USB but might not be standard on your computer. There are several types of USB: USB 1.0, 2.0, and 2.0 Hi-Speed. Older computers and card readers will have the 1.0 version, but new devices are most likely 2.0 Hi-speed. This new version of USB is much faster than the old. However, if you have both versions of USB devices plugged into the same bus, the older devices will slow down the speed of the faster devices.

The advantage of downloading directly from the camera is that you don't need to buy a card reader. However, there are some distinct disadvantages. For one, cameras generally download much more slowly than card readers (given the same connections). Plus, a camera has to be unplugged from the computer after each use, while the card reader can be left attached. In addition to these drawbacks, downloading directly from a camera uses its battery power (and shortens battery life by using up charge cycles) in making the transfer (or you need to plug it into AC power).

A card reader is often the more preferable image transfer option as opposed to direct download from the camera, especially when you must transfer the larger, hi-def video files. Photo © Andre Bergeron

A card reader is a safer, more reliable image transfer choice.

The Card Reader

A card reader can be purchased at most camera or electronics stores. There are several different types, including single-card readers that read only one particular type of memory card, or multi-readers that are able to utilize several different kinds of cards.

After your card reader is connected to your computer, remove the memory card from your camera and put it into the appropriate slot in your card reader.

Note: If you use UDMA cards (see page 73) and want a faster transfer speed, your card reader must be UDMA compatible. If the card reader is not UDMA compatible, it will still transfer the files but it won't take advantage of the speed improvement that UDMA offers.

The card usually appears as an additional drive on your computer (on Windows XP and Mac OSX operating systems—for other versions you may have to install the drivers that come with the card reader). When the computer recognizes the card, it may also give instructions for downloading. Follow these instructions if you are unsure about opening and moving the files yourself, or simply select your files and drag them to the folder or drive where you want

them (a much faster approach). Make sure you "eject" the card before removing it from the reader. On Windows, right click on the drive and select Eject; on a Mac, drag the drive to the trash.

Card readers can also be used with laptops, though PC card adapters may be more convenient when you're on the move. As long as your laptop has a PC card slot, all you need is a PC card adapter for the appropriate type of memory card. Insert the memory card into the PC adapter, and then insert the PC adapter into your laptop's PC card slot. Once the computer recognizes this as a new drive, drag and drop images from the card to the hard drive. The latest PC card adapter models tend to be faster but are also more expensive than card readers.

Archiving

Without proper care, your digital images and movies can be lost or destroyed. Many photographers back up their files with a second drive, either added to the inside of the computer or as an external USB or FireWire drive. This is a popular and somewhat cost-effective method of safeguarding your data.

Hard drives and memory cards do a great job at recording image files and movie clips for processing, transmitting, and sharing, but are not great for long-term storage. Hard drives are designed to spin; just sitting on a shelf can cause problems. This type of media has been known to lose data within ten years. And since drives and cards are getting progressively larger, the chance that a failure will wipe out thousands of images and movies rather than "just one roll or tape" is always increasing. Computer viruses or power surges can also wipe out files from a hard drive. Even the best drives can crash, rendering them unusable. Plus, we are all capable of accidentally erasing or saving over an important photo or movie. Consider using redundant drives for critical data backup.

For more permanent backup, burn your files to optical discs: CD or DVD (recommended). A CD-writer (or "burner") used to be the standard for the digital photographer, but image files are getting too big and high definition movie files are just about out of the question. DVDs can handle about seven times the data that can be saved on a CD, but even standard DVDs are becoming inconvenient for larger file sizes. Blu-ray discs (see below) may be the solution.

There are two types of DVDs (and CDs) that can be used for recording data: R designated (i.e. DVD-R) recordable discs; and RW designated (i.e. DVD-RW) rewritable discs. DVD-R discs can only be recorded once—they cannot be erased. DVD-RWs, on the other hand, can be recorded on, erased, and then reused later. If you want long-term storage of your images, use -R discs rather than -RWs. (The latter is best used for temporary storage, such as transporting images to a new location.) The storage medium used for -R discs is more stable than that of -RWs (which makes sense since the DVD-RWs are designed to be erasable).

As mentioned above, a new format, Blu-ray, is starting to be an option. This system uses a different colored laser (blue-violet) to read data. The use of a higher frequency light source means more data can be written to the disc. A single layer Blu-ray disc can hold about 25GB of data, which is more than five times as much data as a single layer DVD. A dual layer Blu-ray disc can hold 50GB. This technology is quite new, however, so be aware that there may be some growing pains.

Optical discs take the place of negatives in the digital world. Set up a DVD binder for your digital "negatives." You may want to keep your original and edited images on separate discs (or separate folders on the same disc).

As mentioned above, stay away from optical media that is rewriteable like DVD-RW or for Blu-ray BD-RE. You want the most reliable archive. At this point rewritable discs, while convenient, are not as reliable for archiving. Also avoid any

One of the most important aspects of digital photography is archiving your images. Optical media such as DVDs, CDs, and even the newer Blu-ray discs (BD) have currently taken the place of negatives, but there are other—and sometimes better—options for storing images.

options that let you create multiple "sessions" on the disc. This feature allows you to add more data to the disc until it is full. For the highest reliability, write all of the data to the disc at once.

Buy quality media. Inexpensive discs may not preserve your photo-image files as long as you would like them to. Read the box. Look for information about the life of the disc. Most long-lived discs are labeled as such and cost a little more. And once you have written to the disc, store and handle it properly.

For the most robust form of backup you could use the system that corporate IT departments around the world use: data tape. There are various formats and vendors to choose from, but basically tape drives are the most reliable archiving format in this day and age. Unfortunately, data tape does not use a random access format. A computer can't access a

tape drive like it would a hard drive. It has to read a directory and then search through the tape to find a file. It can be a slow process, but the error correction and redundancy more than make up for the slowness when you access a file.

Working with Still Images

How do you edit and file your digital photos so they are accessible and easy to use? To start, it helps to create folders specific to groups of images (i.e., Outdoors, Sports, State Fair, Furniture Displays, etc.). You can organize your folders alphabetically or by date inside a "parent" folder. The organization and processing of images is called workflow. (If you want to start a heated conversation among digital photographers, ask them about workflow!)

Be sure to edit your stills to remove extraneous shots. Unwanted files stored on your computer waste storage space on your hard drive. They also increase the time you must spend when you browse through your images, so store only the ones you intend to keep. Take a moment to review your files while the card is still in the camera. Erase the ones you don't want, and download the rest. You can also delete files once they are downloaded to the computer by using a browser program (described below).

Here's how I deal with digital still files. (Later on in this chapter I will discuss movies.) First, I set up a filing system. I use a memory card reader that shows up as a drive on my computer. Using the computer's file system, I open the memory card as a window or open folder (this is the same basic view on both Windows and Mac computers) showing the images in the appropriate folder. I then open another window or folder on the computer's hard drive, and create a new subfolder labeled to signify the photographs on the memory card, such as Place, Topic, Date. I also create all of these folders in a specific location on my hard drive—I use a folder called Digital Images. Inside Digital Images I have folders by year, and within those, the individual shoots (you could use

locations, clients, whatever works for you). This is really no different than setting up an office filing cabinet with hanging folders or envelopes to hold photos. Consider the Digital Images folder to be the file cabinet, and the individual folders inside to be the equivalent of the file cabinet's hanging folders.

Next, I select all the images in the memory card folder and drag them to the new folder on my hard drive. This copies all the images onto the hard drive and into my "filing cabinet." It is actually better than using a physical filing cabinet because, for example, I can use browser software to rename all the photos in the new folder, giving information about each photo, for example using the title TriburgFeb09.

I also set up a group of folders in a separate "filing cabinet" (a new folder at the level of Digital Images) for edited photos. In this second filing cabinet, I include subfolders specific to types of photography, such as landscapes, close-ups, people, etc. Inside these subfolders, I can break down categories even further when that helps to organize my photos. I place copies of original images that I have examined and decided are definite keepers, both unprocessed (direct from the camera) and processed images (keeping such files separate). Make sure these are copies (don't just move the files here), as it is important to keep all "original" photo files in the original folder that they went to when first downloaded.

Image Browser Programs

While the CS4 version of Adobe Photoshop has an improved Bridge that can help organize photos, there are currently a number of other programs that help you view and organize your images.

Note: As manufacturers update their applications, they may add numbers to the application name, such as Photoshop CS4, Lightroom 2, or Final Cut Pro 6. For simplicity, in the rest of this chapter I refer to the basic name, without the version number.

Abode Lightroom is more than just a browser program. Lightroom allows you to edit and organize images, and even convert RAW image files into TIF or JPEG for print or web.

ACDSee is a superb program with a customizable interface and keyboard tagging of images. It also has some unique characteristics, such as a calendar feature that lets you find photos by date (though the best-featured version is Windows only). Another very good program with similar capabilities is Microsoft's Expression Media (with equal features on both Windows and Mac versions).

Apple's Aperture uses a digital "loupe" to magnify your images while browsing (it is only available for the Mac). It is more than just a browser in that it offers full image editing too. Check out Canon's Digital Photo Professional, included with the software that comes with the 5D Mark II. It is the only software that is able to utilize Canon's Dust Delete Detect system.

Adobe's Lightroom is also an option. Although its official name is Photoshop Lightroom, I like to leave off Photoshop because it can intimidate photographers. Like Aperture, Lightroom is a little more than just a browser. It has full image processing tools and tools for printing pictures, making slide shows and building web pages. The concept behind Lightroom (and Aperture) is to build an application that is specifically designed for photographers, rather than a program that has a lot of tools for other uses.

All of these browser programs include some database functions (such as keyword searches) and many operate on both Windows and Mac platforms. These programs allow you to quickly look at photos on your computer, edit them, rename them one at a time or all at once, read all major files, move photos from folder to folder, resize photos for e-mailing, create simple slideshows, and more.

An important function of browser programs is their ability to print customized index prints. You can then give a title to each of the index prints and list additional information about the photographer, as well as the photo's file location. The index print is a hard copy that allows easy reference (and visual searches). If you include an index print with every DVD you burn, you can quickly see what is on the DVD and find the file you need. A combination of uniquely labeled file folders on your hard drive, a browser program, and index prints help you maintain a fast and easy way to find and sort images.

Image Processing

Of course, you can process the 5D Mark II's JPEG files in any image-processing program. One nice thing about JPEG is that it is one of the most universally recognized formats. Any program on any computer that recognizes image files will recognize JPEG. That said, it is important to understand that the original JPEG file is more like a negative than a slide. Sure, you can use it directly, just like you could have

the local mini-lab make prints from negatives. But JPEG files can be processed to get more out of them.

RAW and sRAW are important formats because they increase the options for adjustment of your images. In addition, Canon's RAW file, CR2, offers increased flexibility and control over the image. When shooting RAW, you have to work on every image, which changes your workflow. This is why photographers who sometimes, but not always, need to work with RAW will use the 5D Mark II's ability to record RAW and JPEG at the same time.

A big advantage to the 5D Mark II RAW file is that it captures more directly what the sensor sees. It holds more information (14 bits vs. the standard 8 bits per color) and stronger correction can be applied to it (compared to JPEG images) before artifacts appear. This can be particularly helpful when there are difficulties with exposure or color balance. (Keep in mind that the image file from the camera holds 14 bits of data even though it is contained in a 16-bit file—so while you can get a 16-bit TIFF file from the RAW file, it is based on 14 bits of data.)

While RAW files offer more capacity for change, you can still do a lot with a JPEG file to optimize it for use. I shoot a lot of JPEG when it fits my workflow, and no one complains about the quality of my images.

Note: EOS 5D Mark II RAW files are about 26MB so they fill memory cards quite quickly. With larger file sizes comes an increase in processing and workflow times.

Canon offers two ways to convert CR2 files to standard files that can be optimized in an image editor like Photoshop: a file viewer utility (ZoomBrowser EX for Windows or Image Browser for Mac) and the Digital Photo Professional software. In addition, Photoshop, Lightroom, Aperture, and Capture One have RAW processing built-in. Each application has its own RAW processing engine that interprets the images, so there is a slight difference between programs in the final result.

You must process any RAW file that you want for future use; the RAW file format is not a viewable image format. Therefore, if you shoot RAW images, you should have a reliable and user-friendly RAW conversion software package to process the files into a viewable format such as TIF or JPEG.

Note: If you have an older version of any of these programs, you probably need to update your software in order to open the latest version of the RAW CR2 files. Unfortunately, the older versions of some image editing applications are no longer updated to handle the new RAW files.

The File Viewer Utility

Canon's ZoomBrowser EX (Windows)/Image Browser (Mac) supplied with the camera is easy to use. It is a good "browser" program that lets you view and organize RAW and JPEG files. It will convert RAW files, though it is a pretty basic program and doesn't offer some of the features available in other RAW processing software. Even so, it does a very good job of translating details from the RAW file into TIFF or JPEG form. Once converted, any image-processing program can read the new TIFF or JPEG. TIFF is the preferred file format because it is uncompressed; JPEG should only be

Digital Photo Professional (DPP) is Canon's proprietary RAW file conversion software, designed specifically to work with Canon's CR2 RAW files. One advantage of DPP is that it uses the Dust Delete Detection Data to remove sensor spots from image files.

used if you have file space limitations. The image browsers supplied with the 5D Mark II are much faster than earlier versions. In addition, the supplied software disc includes EOS Utility, a remote capturing control that lets you work your camera remotely when it is attached to the computer.

Digital Photo Professional Software

Once an optional program and now included with the 5D Mark II, Digital Photo Professional (DPP) was developed to bring Canon RAW file processing up to speed with the rest of the digital world. This program has a brand-new processing engine. It can be used to process both CR2 files and JPEG files. The advantage to processing JPEG files is that DPP is quicker and easier to use than Photoshop, yet is still quite powerful. For fast and simple JPEG processing, DPP works quite well.

I believe if you are going to shoot RAW, DPP is a must-use program. It is fast, full-featured and gives excellent results. One big advantage that DPP offers over any other RAW processing program is the ability to use Dust Delete Detection Data that is embedded in the RAW file (see page 81). It can also read the aspect ratio information embedded in the image files so it can crop images automatically.

EOS Utility

EOS Utility is the connection software used to download images directly from the 5D Mark II, and it is the browser and editing software for remote or "tethered" shooting.

This application serves as a gateway for several operations with the 5D Mark II and accessories. First, it is used to download images (all images or just those selected) when the camera is connected via USB to the computer.

EOS Utility is also used for remote or "tethered" shooting. When you start up this feature, you can fire the shutter, choose exposure mode, and adjust shutter speed, aperture, ISO, white balance, metering mode and file recording type. There is limited access to menus: you can set picture style, personal white balance, JPEG quality and white balance

269

shift in the Shooting menu displayed on the computer. In the Setup menu on the computer you can give the camera an owner's name, change the date and time, enable Live View and update the firmware.

Access to the My Menu setup while tethered is a fast way to set up your My Menu. Even if you never shoot tethered, consider hooking up the camera to set up the My Menu. Instead of scrolling through seemingly endless options on the small 5D Mark II LCD monitor, use the remote camera control to point and click your way through choices.

While tethered, you can turn on Live View shooting for a powerful studio-style, image-preview shooting setup. An instant histogram and the ability to check focus help during tethered Live View. You have the choice of capturing the images to the computer, or to the computer and the memory card in the 5D Mark II. As you capture each picture, it can open automatically in Digital Photo Professional or in the image editor of your choice.

EOS Utility also offers the option of timed shooting. The computer acts as an intervalometer, taking a picture every few seconds (from 5 seconds to 99 hours and 59 seconds). You can also do a bulb exposure from 5 seconds to 99 hours and 59 seconds.

Note: Live View, timed or bulb shooting will, in most cases, require the computer and camera to operate off AC power.

Picture Style Editor

Introduced with the 5D Mark II, the Picture Style Editor lets you create your own styles. When you import a RAW image, you are able to adjust its overall tone curve much as you would in an image editor. You can also adjust the normal picture style parameters of sharpness, contrast, color saturation, and color tone.

But the Picture Style Editor's most powerful feature is the ability to change individual colors in the image. Use an

eyedropper tool to pick a color and then adjust the hue, saturation and luminance values of the color. You can pick multiple colors and also choose how wide or how narrow a range of colors (around the selected color) are adjusted. These custom picture styles can then be uploaded to the 5D Mark II using the EOS utility. You can also download new picture styles that have been created by Canon engineers at: http://www.usa.canon.com/content/picturestyle/file/index.html

Direct Printing

With certain compatible Canon printers, you can control printing directly from the 5D Mark II. Simply connect the camera to the printer using the dedicated USB cord that comes with the 5D Mark II. Compatible Canon printers provide access to many direct printing features, including:

- Contact sheet style 35-image index prints
- Print date and filename
- Print shooting information
- Face brightening
- Red-eye reduction
- Print sizes (printer dependent), including 4 x 6 in (10.2 x 15.2 cm), 5 x 7 in (12.7 x 17.8 cm), 8.5 x 11 in (21.5 x 27.9 cm)
- Support for other paper types
- Print effects and image optimization: Natural, Vivid, B/W, Cool Tone, Warm Tone, Noise Reduction

Note: Because of the wide variety of printers, it is possible not all the printing features mentioned in this chapter are on your printer. For a detailed list of options available when the 5D Mark II is connected to your Canon printer, consult your printer's manual.

The 5D Mark II is PictBridge compatible, meaning that it can be connected directly to PictBridge printers from several manufacturers. Most new photo printers are PictBridge compatible. When you use a PictBridge printer, use the USB cord

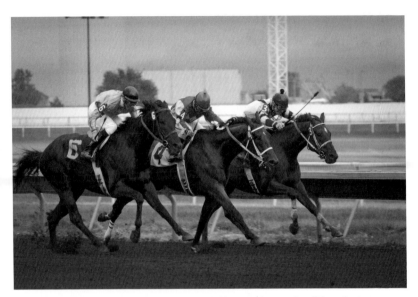

The direct printing function provides a range of editing features (such as Red-eye reduction) for quick camera-to-print workflow. Direct printing can even work with Canon's CR2 RAW or sRAW files.

that comes with the camera. (More information on Pict-bridge can be found at: www.canon.com/pictbridge/)

Note: Both RAW and sRAW files can be used for the direct printing options mentioned in this section, but movies cannot be printed.

To start the printing process, first make sure that both the camera and the printer are turned off. Connect the camera to the printer with the camera's USB cord (the connections are straightforward since the plugs only work one way). Turn on the printer first, then the camera—this lets the camera recognize the printer so it is prepared to control it. (Some printers may turn on automatically when the power cable is connected.) Depending on the printer, the camera's direct printing features may vary.

Press Playback ▶ and the 📷 / 🖶 will light up to indicate the camera is successfully connected to the printer. ⌐ in the upper left also indicates the printer is connected. Use the Quick Control dial ⊙ to select an image on the LCD monitor that you want to print. Press ⟨SET⟩ and the Print Setting screen appears, listing such printing choices as image optimization, whether to imprint the date, the number of copies, trimming area, and paper settings (size, type, borders or borderless).

Trimming is a great choice because it allows you to crop your photo right in the LCD monitor before printing, tightening up the composition if needed. To trim, first use ⊙ or ✶ to select [Trimming] and press ⟨SET⟩. Use ⊞/⊕ and ⊟·⊕ to adjust the size of the crop, use the Multi-controller ✶ to adjust the position of the crop. Use INFO. to rotate the crop 90°. Use ⊙ to rotate the image within the crop. Press ⟨SET⟩ to accept the crop setting.

Note: Depending on the printer, trimming and printing the date may not be available.

You can also adjust print effects to print images in black and white—in a neutral tone, cool tone, or warm tone. Other effects include noise reduction, face brightening and red-eye correction. You can also choose to use a natural or vivid color setting.

Continue using the Quick Control dial ⊙ and ⟨SET⟩ to select other settings. These choices may change, depending on the printer; refer to the printer's manual if necessary.

Once you have selected the options you want, then use the Quick Control dial ⊙ to select [Print] and press ⟨SET⟩ to start printing. The LCD monitor confirms that the image is being printed and reminds you not to disconnect the cable during the printing process. Wait for that message to disappear before disconnecting the camera from the printer. If you wish to use the same settings for additional prints, use the Main dial 🖽 to move to the next picture, then simply press ⟨SET⟩ to print the next image.

Note: The amount of control you have over the image when you print directly from the camera is limited solely by the printer. If you need more image control, print from the computer.

If you shoot a lot of images for direct printing, do some test shots and set up the 5D Mark II's Picture Styles (see page 91) to optimize the prints before shooting the final pictures. You may even want to create a custom setting that increases sharpness and saturation just for this purpose.

Digital Print Order Format (DPOF)

Another of the 5D Mark II's printing features is DPOF (Digital Print Order Format). This allows you to decide which images to print before you actually do any printing. Then, if you use a printer that recognizes DPOF, the printer automatically prints just the images you have chosen. DPOF is also a way to select images on a memory card for printing at a photo lab. After the images on your CF card are selected using DPOF, drop it off at the photo lab—assuming their equipment recognizes DPOF (ask before you leave your card)—and they will know which prints you want.

DPOF is accessible through the Playback 1 menu ▶ under [Print order]. You can choose several options: Select [Set Up] to choose Print type ([Standard], [Index], or [Both]), [Date] ([On] or [Off]), and [File No.] ([On] or [Off]). Once you've set your print options, press **MENU** to return to Print Order. From there you have three ways to select images to print: [all], [by folder], or by selecting images manually. To select images manually, highlight [Sel.Image], press ⑤ET and then use the Quick Control dial ◯ to scroll through your images. Press ⑤ET for each image you want to print. If you want to print more that one copy of the current image, after pressing ⑤ET rotate ◯ to increase the print count.

Once you have selected all the images, connect the camera to the printer. A Print button appears on the Print

Order screen. Use the Quick Control Dial ⊙ to high-light, and then press ⊛ . Set up image optimization and paper settings, then select [OK] and press ⊛ to start the printing process.

Note: RAW, sRAW, and movie files cannot be selected for DPOF printing. If you shoot RAW+JPEG or sRAW+JPEG, then you can use DPOF. The JPEG versions of the files will be printed.

Working with Movies

Workflow for movies can be a bit different from that used for still images. File sizes can be extremely large and some editing programs work best if the files are in the right place. Generally movie clips need to be edited together vs. a single image that may stand alone as a single photograph. In other words video clips are often "program" based; a single clip won't have the impact that a single photograph does. In addition, video may be scripted or storyboarded.

My workflow for video is very much project-based. It also requires a concerted effort to think about archiving even before I start editing the project. Once I have finished recording, I create a project folder on a high-speed external drive. Depending on the size of the drive, that folder might be in a folder that includes the year or the month so I can keep projects separate. For example, I might have a structure of 2009/February/Cat_Sanctuary/. Once the file structure is in place, I copy my footage into the new folder.

Depending on the software application I choose for video editing, I may then view each file and rename the files. If I were doing interviews, I would rename the file with the person's last name and then a "take number," such as Kara01, Kara02, etc. If I use an editing application like Final Cut Pro, I might leave the file name alone and do all of the descriptive data entry in the editing program.

The nice part about changing the name at the file level is that it is more descriptive. You can search within the file system, rather than opening up an editing application. On the other hand, the advantage of changing the name in the editing program is that you can use longer names and you can include information like take number, comments, camera angle, script notes, whether a clip is good or bad, etc., in columns next to the file name (depending on your editing software).

Note: Once you bring the files into your editor and you start to edit, don't use the file system to change the names of the movies. The files may become unlinked from your project. Also, don't move them from the folders that they are in, as this could break the link too. Although there are ways to relink files, they don't always work.

Once I have the file names set, I copy the folder to my archive drive, tape, or—if the folder is small enough—an optical disc (Blu-ray). (See Archiving on page 259.) This way I have a working copy on the high-speed drive and an untouched copy for archive. When you edit video, you don't change pixels on the original files; to revise a project, all you need is the project file and the original movies the project is linked to.

Viewing Your Files
Canon's ZoomBrowser EX (Windows)/Image Browser (Mac), supplied with the 5D Mark II, can play back the individual movie clips but you can't edit the clips into a sequence. If you merely want to view your files, QuickTime player is a good (and free!) application. The Pro version of QuickTime lets you trim clips and even build a rough sequence, but it is not very intuitive and does not foster a lot of creativity. For that, you need a real editing application.

Note: If you are on the Windows platform you may need to install QuickTime in order to view your movie clips. Download the Windows version at www.apple.com/quicktime/. For simple playback of movies, it is not necessary to buy the QuickTime Pro version or download iTunes with QuickTime. Download just the "plain" version of QuickTime.

Adobe Premier is a video editing application available for Windows and Mac platforms, and can edit video files natively in the h.264 codec.

Software and Hardware

There is quite an assortment of video editing applications for both Windows and Mac computer platforms and for all budgets. On the Windows side, there is Adobe Premiere and Premiere Elements, Sony Vegas, Pinnacle Studio, Corel VideoStudio X2. For Mac users, there is Adobe Premiere, Avid's Media Composer and Xpress Pro, Media 100, and Apple's iMovie, Final Cut Express, and Final Cut Studio.

Costs for the software alone range from "included with your computer" to nearly $2,500. If you do simple cuts and dissolves and not much in the way of effects, layering or complicated projects, the less expensive options can work. The more expensive applications give you more options for the output of your finished project—compression for the web or authoring Blu-ray discs.

Manipulating HD video is very taxing on a computer. These are essentially large image files that are flying by at 30 fps, so you need a computer that can handle it. Bulk up on RAM and processor speed—as much as you can afford—or be patient with rendering times.

Several of the editing applications—Premiere or Final Cut Pro, for example—can edit natively in the h.264 codec. The h.264 is a highly efficient algorithm. It reduces both file size and the data rate needed to record the movie. Unfortunately, it takes a great deal of computing power to make this happen. You may find that your computer, which worked fine running Photoshop and editing RAW files, might struggle just to play back a single movie file without stuttering frames. Generally this is caused either by a slow disc drive or by a slow processor (CPU).

Will editing natively in the h.264 codec work for you? It all depends on the application you are using, your computer's horsepower and your tolerance for the process. I have edited with h.264 on a laptop in a hotel room, where I could only play the original files without jerkiness. The minute I put the clips into a sequence, the computer couldn't keep up. Fortunately, my editing experience helped me mark "in" and "out" times for each clip and I instinctively knew how the sequence would play. I checked my edits afterwards when I exported the sequence—a process that took over half an hour. In this instance I could tolerate the slow times and uncertainty because I needed to travel light. But that's me; how you tolerate that kind of workflow could be very different.

Since h.264 is not really optimized as an editing format, there are several workarounds to overcome the need for the fastest computer and the most RAM. One method is to "transcode" the file to another codec. "Transcoding a file" means making a copy and recompressing it. If your computer is slowing down, try a codec that is uncompressed or one that is more suitable for editing (like XDCAM-HD or Apple's ProRes). One problem with transcoding is that the

color space or dynamic range might change; some highlights might change; detail could disappear; and/or colors might shift. Make sure you compare the transcoded file to the original. Another issue may be rendering times if you need to output back to an h.264 file. If this is the case, you should perform some test renders so you know how long it will take. You don't want to be surprised if your final project takes three hours to render, especially if it was supposed to be completed an hour ago.

Another option to reduce processor load is to edit in a low-resolution proxy mode. Proxies are to movies, what thumbnails are to photos. They are low-resolution video clips. This is the technique that Corel Video Studio Pro X2 uses. It converts the high-definition movies to smaller movies that are easier to use during the editing process. Once the edit is complete, the software links up to the original high-definition files for output.

Movie Output

When you have finished editing, you'll have to output the movie. It is important to consider this process before you begin editing. When you work with still images, you have fewer output options: prints or digital files for computer display. (Of course there are others but these two are the usual ones.) When you work with video, it may appear there are only a few options, but they can quickly multiply.

For example, say you are asked to deliver to a web site. Once you start asking questions, you'll be surprised at the complexity. First, there is window size: most places can't take the full 1920x1080 file and may ask for 1/2 size or 1/4 size. Then there is the file type: Do they want h.264, Windows Media (.wmv), Flash, Quicktime? How about the file size? This is not the same as the window size. Internet delivery is highly dependent on connection bandwidth and the amount of compression you apply to a movie directly affects how much bandwidth is needed. Finally there is frame rate. Some sites can play back your 30-frame-per-second movie; others require half that rate.

Note: There isn't one "best" solution. Each website or host has its own requirements that, unfortunately, may constantly change. It is important that you do your research before you start shooting, so you know what you need to deliver. In fact, you may have to deliver multiple versions of the file.

If you want to deliver on optical disc, there are two options. First, you can compress your finished program into a codec that is supported on Blu-ray. You then author a Blu-ray disc that can play on a set top Blu-ray player. Many of the applications above can do this, or can tie into disc-authoring programs from the same manufacturer. Of course this requires your computer to have a Blu-ray drive that can write discs.

A second option is to create a high definition file that you burn onto a regular DVD. You then play the DVD in an advanced DVD player that is capable of playing HD files. Although this is not a common feature on DVD players, there are some are out there that can do it. Before Blu-ray burners were available, this was one of the few ways to play back HD content in the field.

Whatever you have to deliver, the more you can control the compression, the better looking the final result will be. It is not uncommon for a file to be compressed more than one time. But while it's not uncommon, that doesn't make it good practice. Just as when you work with image files, you want to avoid multiple steps of compression.

Movie files can be very big. Longer clips are measured in gigabytes, not megabytes. The file size means longer times to upload, download, archive, and transfer from one location to another.

Index